POSTCARDS FROM ROUTE 66

POSTCARDS FROM ROUTE 66

The Ultimate Collection from America's Main Street

JOE SONDERMAN

Voyageur Press

First published in 2014 by Voyageur Press, a member of Quarto Publishing Group USA
400 First Avenue North, Suite 400, Minneapolis, MN 55401 USA

© 2014 Voyageur Press

All images are from the author's collection unless noted otherwise.

All rights reserved. With the exception of quoting brief passages for the purposes of review, no part of this publication may be reproduced without prior written permission from the Publisher.

The information in this book is true and complete to the best of our knowledge. All recommendations are made without any guarantee on the part of the author or Publisher, who also disclaims any liability incurred in connection with the use of this data or specific details.

We recognize, further, that some words, model names, and designations mentioned herein are the property of the trademark holder. We use them for identification purposes only. This is not an official publication.

Voyageur Press titles are also available at discounts in bulk quantity for industrial or sales-promotional use. For details write to Special Sales Manager at Quarto Publishing Group USA 400 First Avenue North, Suite 400, Minneapolis, MN 55401 USA.

To find out more about our books, visit us online at www.voyageurpress.com.

ISBN-13: 978-0-7603-4611-2

Library of Congress Cataloging-in-Publication Data

Sonderman, Joe.

 Postcards from Route 66 : the ultimate collection from America's main street / Joe Sonderman.
 pages cm
 ISBN 978-0-7603-4611-2 (hardback)
 1. United States Highway 66--History--Pictorial works. 2. Postcards--United States Highway 66. 3. Automobile travel--United States--History--Pictorial works. 4. Roadside architecture--United States--History--Pictorial works. 5. Historic buildings--United States Highway 66--Pictorial works. 6. United States--History, Local--Pictorial works. I. Title.
 HE356.U55S65 2014
 917.80022'2--dc23
 2013042866

Acquisitions Editor: Dennis Pernu
Project Editor: Liz Taylor
Design Manager: Cindy Samargia Laun
Cover Designer: Gavin Duffy
Design and Layout: Karl Laun

Printed in China

10 9 8 7 6 5 4 3 2 1

CONTENTS

Introduction 6
1. Illinois 12
2. Missouri 44
3. Kansas 94
4. Oklahoma 102
5. Texas 144
6. New Mexico 172
7. Arizona 222
8. California 268
 Index 302

INTRODUCTION

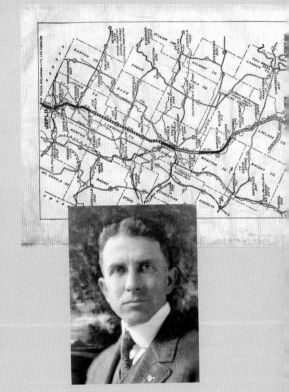

Cyrus Avery

ROUTE 66 is arguably the most famous road in the world. But it was never just a road—roads take you to a destination. Route 66 *is* a destination. It's for those who think that getting there is at least half the fun. It's for those who take the time to admire the landscape and to meet people. If you want to savor life, it begins at the interstate's off-ramp.

U.S. Route 66's beginnings can be found on old Indian trails and early overland wagon routes, such as Beale's Wagon Road, the Santa Fe Trail, and the California and Overland Trails. Early railroads closely followed these routes and were the dominant way to travel until cars became more commonplace. The number of registered automobiles in the United States grew from just 500,000 in 1910 to almost 10 million by 1920. During this decade motorists, commercial agricultural interests, and other business groups launched a movement for better roads. Congress passed the Federal Aid Road Act of 1916, providing the first federal assistance to states for road building.

Meanwhile promoters were developing a tangled web of roads across the United States. Their highway "associations" gave roads important-sounding names and painted color-coded stripes on fence posts, telegraph poles, or any visible surface. Drivers followed the myriad colors to travel the "Lincoln Highway," the "Dixie Highway," and the "Old Spanish Trail." In 1917 an association mapped out the Ozark Trail's route from St. Louis to Romeroville, New Mexico. From there it joined the National Old Trails Road to Los Angeles, and the future Route 66 took shape.

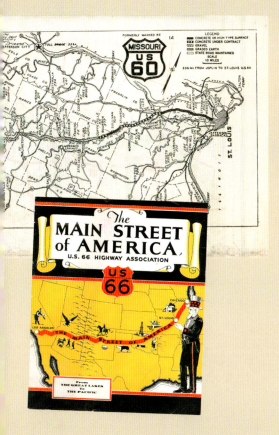

By 1920 the situation was out of hand. Some of the independent highway associations made money from "contributions" by merchants to have the highway routed past their businesses, and drivers were sent miles out of their way. Many of the routes overlapped, and poles and posts were often painted from top to bottom with a confusing rainbow of colors. The promoters often spent little of the money on actual road improvements or maintenance.

In 1925 the American Association of State Highway Officials approved a numbering system calling for east to west federal highways to be assigned even numbers, and north to south routes to be given odd numbers. The most important east to west routes would end in zero, and the primary north to south routes would end in one or five. The important-sounding "60" was assigned to the highway between Chicago and Los Angeles.

Maps went to press in Missouri showing Route 60 linking St. Louis and Joplin. But Kentucky governor William J. Fields had other plans. Governor Fields was upset that no routes ending in "0" passed through his state. He persuaded federal officials to assign the number 60 to the highway running between Newport News, Virginia, and a point near Springfield, Missouri. The highway connecting Chicago and Los Angeles was to be designated U.S. Route 62. Of course this didn't set too well with officials in Missouri and Oklahoma. Missouri State Highway Commission chief engineer A. H. Piepmeier and Cyrus Avery, chairman of the Oklahoma Department of Highways, said they would accept only the number 60 for the Chicago to Los Angeles route. Angry telegrams flew.

Avery, often referred to as "The Father of Route 66," and Piepmeier continued their battle with the governor of Kentucky into April 1926. At a meeting in Springfield, Missouri, it was noted that the catchy sounding number "66" was still unclaimed. On April 30, 1926, they agreed to accept it as the number for the Chicago to Los Angeles route. (Springfield can thus lay claim to being the birthplace of Route 66.)

On November 11, 1926, the 96,000-mile Federal Highway System routes were approved. Within a few months representatives from several states along Route 66 founded the U.S. Highway 66 Association to promote the roadway. At the association's first meeting in Tulsa, in February 1927, Avery coined the name "The Main Street of America" for use in promotional materials.

At this time Route 66 was a great highway in name only. Only 800 miles were paved, with only 64 miles of pavement between the Texas line and California. The other 1,221 miles had mixed surfaces, ranging from bricks and gravel to dirt and mud. Illinois and Kansas were the only states where Route 66 was completely paved. The U.S. 66 Highway Association immediately went to work. Billboards went up, maps went out, and press releases flowed. But it was good, old-fashioned foot power that gave Route 66 national acclaim.

In 1928 the association teamed with flamboyant promoter C. C. "Cash and Carry" Pyle to stage a transcontinental footrace. It would prove to be one of the most grueling athletic events of all time. The runners would travel from Los Angeles to Chicago along 66, then swing toward the finish line in New York City. On March 4, 1928, 275 runners started in the "Bunion Derby," with an army of reporters following close behind. Pyle planned to charge communities along the route to host the footrace, complete with sideshow attractions, including the world's largest coffeepot and the first portable radio station. But many of his deals fell through, and Pyle failed to provide adequate food and shelter for the runners, while he traveled in comfort aboard a custom motor coach. There were just fifty-five runners left when Andy Payne, from the Route 66 town of Foyil, Oklahoma, crossed the finish line on May 26. He made the 3,400-mile run in 87 days, or about 573 hours of actual time on the road. Payne won $25,000, C. C. Pyle lost a pile of money, and Route 66 reaped the publicity.

At first travelers simply camped beside the road where they pleased. But local farmers soon had their fill of the "tin can tourists." Some communities, eager for the business the travelers would bring, began sponsoring free campgrounds. The camps, however, soon gave way to modern tourist courts and motels, complete with lavish architecture and signs as businesses competed for the tourist dollar.

The images of choking, black dust clouds and overloaded jalopies are enduring symbols of Route 66 during the 1930s, as thousands fled drought and crop failure in the region dubbed the "Dust Bowl." John Steinbeck's 1939 novel, *The Grapes of Wrath*, immortalized "Highway 66 [as] the main migrant road. 66—the long concrete path across the country, waving gently up and down on the map, from Mississippi to Bakersfield. . . . 66 is the mother road, the road of flight." But Route 66 also provided an economic lifeline for those who stayed to operate cafes, tourist courts, and gas stations. Government relief programs also put men to work improving the highway.

In 1937, the last gap in Route 66 was paved with asphalt, in Oldham County, Texas. During the war the movement of troops and equipment and the construction of military bases and airfields spurred improvements to the highway. But leisure travel was severely limited by shortages and rationing, and the U.S. Route 66 Association faded away.

The post–World War II era is considered the golden age of Route 66. Roadside hucksterism was at its height, and establishments tried hard to set themselves apart from the competition. Entrepreneurs turned to roadside reptile ranches, basket weaving, rock curios, or concocted legends about outlaw Jesse James.

A hit song made Route 66 an even bigger pop culture icon. Songwriter Bobby Troup was on a trip west with his wife, Cynthia, when she suggested he write a song about Route 40. Troup said that would be silly, because they would soon be traveling on Route 66. Just outside St. Louis, Cynthia whispered "get your kicks on Route 66." Troup began working on the song during the drive, and Nat King Cole recorded it on March 16, 1946. Since then it has been recorded by dozens of other artists.

In 1947 the U.S. Highway 66 Association was reorganized and operated by Jack and Gladys Cutberth out of their home in Clinton, Oklahoma. They promoted Route 66 as "The Shortest, Fastest Year-'Round Best Across the Scenic West," and they were able to boast "800 miles of 4-lane Highway." In 1952 a cross-country promotional caravan dedicated 66 as "The Will Rogers Highway," in honor of the comedian and philosopher who never met a man he didn't like. The tour coincided with the release of the movie *The Story of Will Rogers*.

Even as businesses along 66 continued to revel in the postwar boom, change was in the air. The modern highway brought safety and convenience for the motorists, but had dire consequences for those who depended on the roads for their livelihood. The big chains, franchises, and road improvements were forcing mom-and-pop motel, café, and gas station owners out of business.

During World War II General Dwight David Eisenhower also saw how good roads were vital for national defense, and he saw construction as a way to stimulate the economy. When Eisenhower was president Congress passed his Federal Highway Aid Act in 1956. On August 2, 1956, Missouri became the first state to award a contract under the new law, for work on four-lane Route 66 in Laclede County.

While the interstate began replacing narrow, and often dangerous, two-lane roads, a whole new generation was just discovering their allure. In 1960 the television series

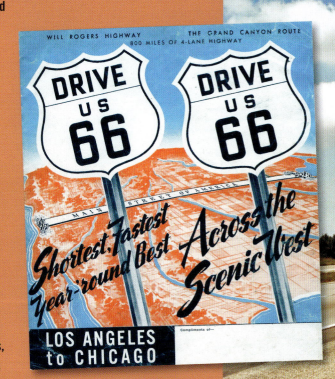

Route 66 beamed images of the Mother Road into the nation's living rooms. The show was one of the first series to leave Hollywood behind for locations across the country. The theme song by Nelson Riddle also became a big pop hit.

In 1962 Missouri took the lead in asking federal highway officials to designate Interstates 55, 44, 40, 15, and 10 as Interstate 66 from Chicago to Los Angeles. The request was denied because these interstates used a different numbering system. Thus I-66 was given to a short and nondescript stretch of highway in the Virginia suburbs of Washington, D.C.

The Highway Beautification Act of 1965 further crippled small roadside businesses, regulating the billboards they needed to compete with the chains on the interstate. The big companies with money and political power managed to find loopholes in the law. The small businesses were squeezed out, and today's billboards are even larger and just as numerous.

October 13, 1984, marked the opening of I-40 around Williams, Arizona—the last community on Route 66 to be bypassed. In 1985 Route 66 was officially decertified. The Mother Road, however, didn't die. Nostalgia buffs and roadside rebels continued to seek out the tourist traps, motels, and gas stations that still held on for life on 66.

Angel Delgadillo, a barber in Seligman, Arizona, gathered a group of business owners who formed the Route 66 Association of Arizona in February 1987. With Angel, dubbed the "Guardian Angel of Route 66," their efforts sparked a revival that spread along the entire highway. In 1990 Michael Wallis published *Route 66: The Mother Road*. His wonderful prose and pictures captured the romance of the road and inspired even more people to take the next exit and discover America at a slower pace. Route 66 has since inspired more preservation efforts, countless books, and websites. Today people come from all over the world to experience the magic of Route 66. It's still there, waiting to be found at the next exit.

CHAPTER 1

ILLINOIS

ROUTE 66 BEGINS ITS JOURNEY WEST in Chicago. It originally started at Michigan and Jackson Boulevards, but the terminus was moved to Lake Shore Drive at the entrance to Grant Park in 1937. In 1953 Jackson became one-way eastbound, so westbound 66 traffic was moved to Adams Street. Leaving Chicago, Route 66 travels through many towns, each with its own unique history and character.

Cicero, birthplace of Ernest Hemingway, was once the headquarters of gangster Al Capone. Passing through Joliet, a bustling city, the route crosses the Kankakee River and opens up onto the great prairie. This route was the old Pontiac Trail and then State Highway 4. Route 66 parallels the railroad here into the heart of communities such as Gardner, Dwight, Pontiac, Chenoa, and Lexington. The Route 66 Hall of Fame and Museum is in Pontiac.

Normal is the birthplace of the Steak 'n Shake Restaurant chain, and neighboring Bloomington is "The Hub of the Corn Belt." South of Bloomington maple "sirup" can be purchased at Funk's Grove. The Dixie Travel Plaza at McLean was once the Dixie Trucker's Home, which opened in 1928 when Route 66 was in its infancy. Atlanta is next with its charming main street and the historic

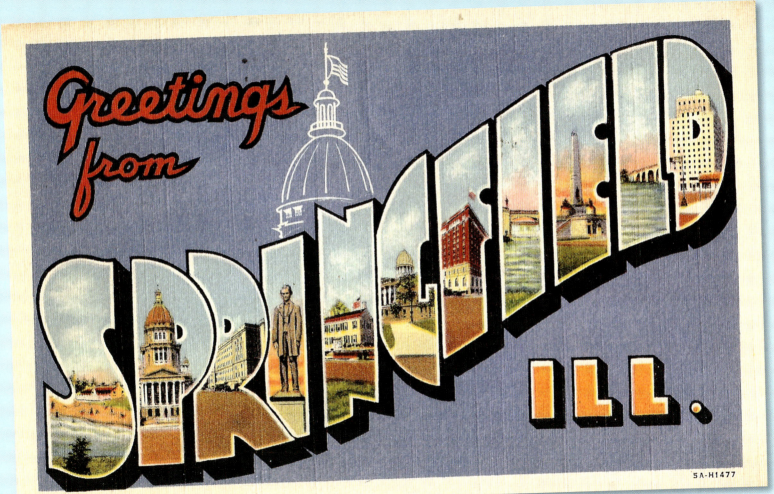

Palms Grill; followed by Lincoln, which was the first community named after the great president while he was still alive.

Springfield was Abraham Lincoln's home and is his final resting place. His life is celebrated at the Abraham Lincoln Presidential Library and Museum. In Springfield the Cozy Dog is a Route 66 icon. A "Cozy Dog" is a hot dog on a stick, dipped in batter and fried. This was also the home of Bob Waldmire, beloved Route 66 artist and free spirit who died in 2009. The original roadway of Route 66 between Springfield and Staunton offers some sections paved with brick.

The Our Lady of the Road shrine, established in the late 1950s, keeps watch over travelers near Raymond, reminding us that Route 66 could be a dangerous highway.

The Ariston Café in Litchfield may be the oldest restaurant still in operation on Route 66, serving customers since 1935. Rich Henry's Rabbit Ranch in Staunton offers real bunnies as well as Volkswagen Rabbits burrowed into the ground in imitation of the Cadillac Ranch in Texas.

At Edwardsville the scenery begins to give way to the suburbs again, with the recommended route turning west through Mitchell. In Al Capone's heyday the Luna Café offered gambling and ladies of the evening. Then it's not far to the mighty Mississippi River and the historic old Chain of Rocks Bridge, once the gateway to Missouri.

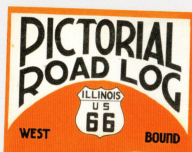
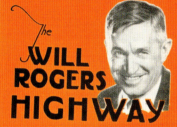

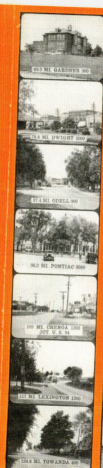

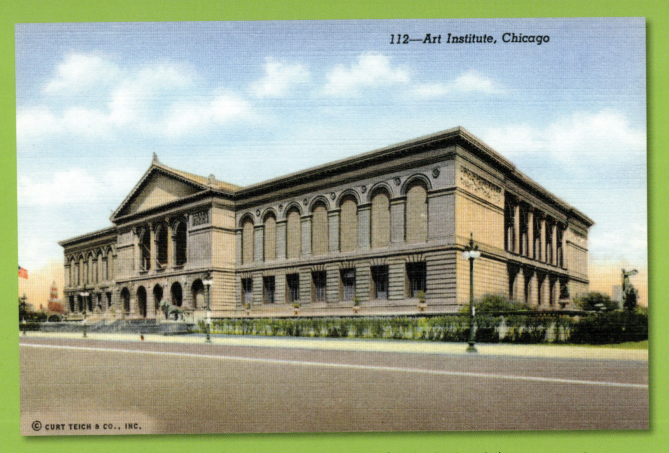

The Art Institute of Chicago was constructed for the 1893 World's Fair on top of rubble from the Great Chicago Fire of 1871.

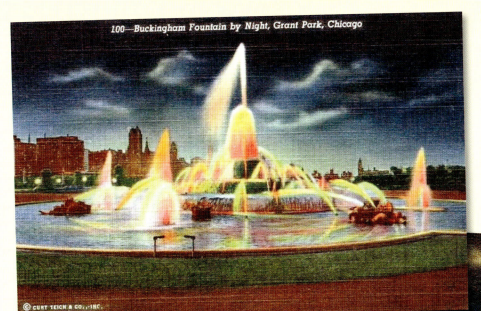

Buckingham Fountain in Grant Park was dedicated in 1927 and modeled after the Latona Basin at the Palace of Versailles.

Union Station, between Jackson Boulevard and Adams Street on both sides of Canal Street, was constructed in 1924.

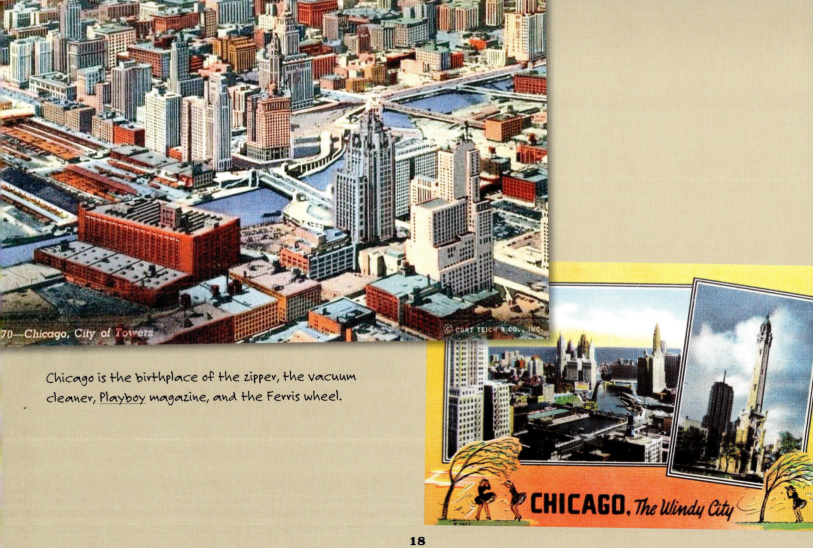

Chicago is the birthplace of the zipper, the vacuum cleaner, Playboy magazine, and the Ferris wheel.

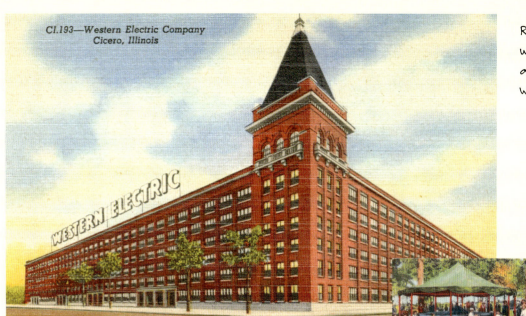

Route 66 continues through Cicero, where today only the tower remains at the former site of the massive Western Electric Hawthorne Works.

Fairyland Park stood on the old site of a Gypsy camp, and was in operation from 1938 to 1977.

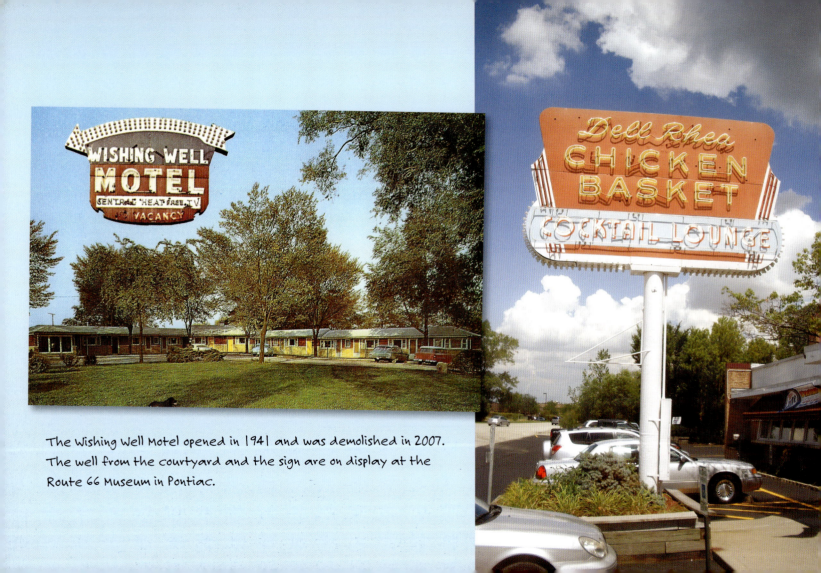

The Wishing Well Motel opened in 1941 and was demolished in 2007. The well from the courtyard and the sign are on display at the Route 66 Museum in Pontiac.

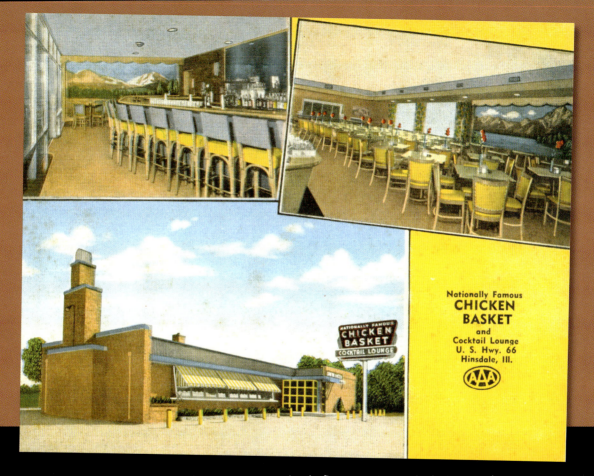

To attract business in the winter, Irv Kolarik flooded the roof of the Chicken Basket and hired ice-skaters.

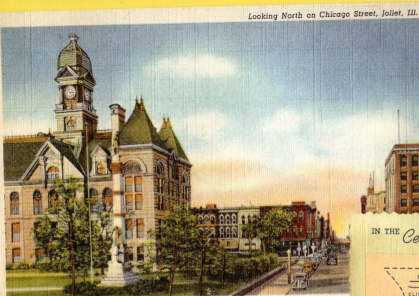

Joliet was originally named "Juliet" (this was probably a corruption of the name of explorer Louis Jolliet). The city's name was changed in 1845.

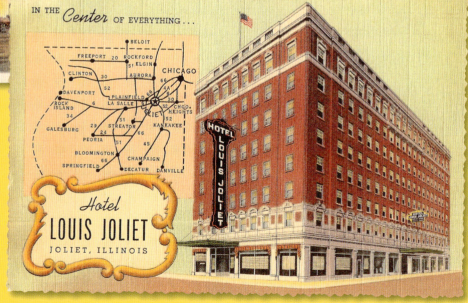

In 1940 Route 66 was moved to pass through Plainfield, and the route by the Hotel Louis Joliet became Alternate 66.

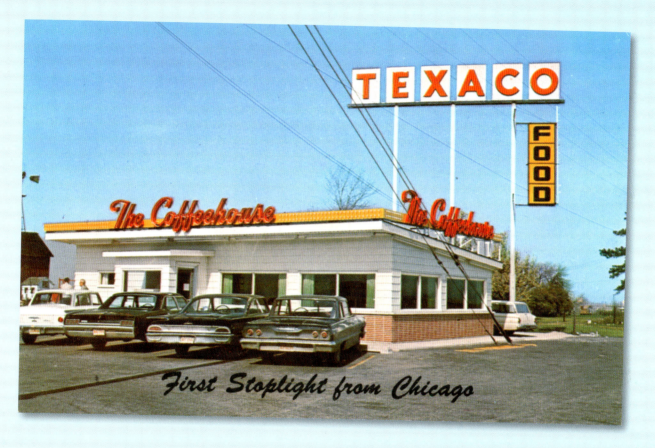

At the "First Stoplight from Chicago," where Route 66 met Illinois Route 47 at Dwight, The Coffeehouse was part of a small chain.

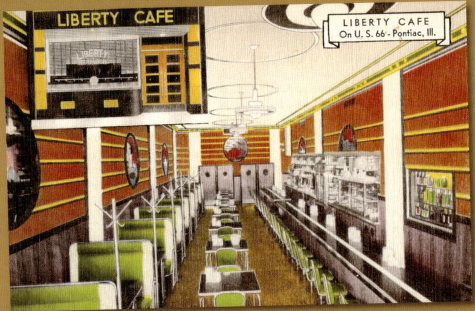

The former Liberty Café Building in Pontiac is now the International Walldog Mural & Sign Art Museum.

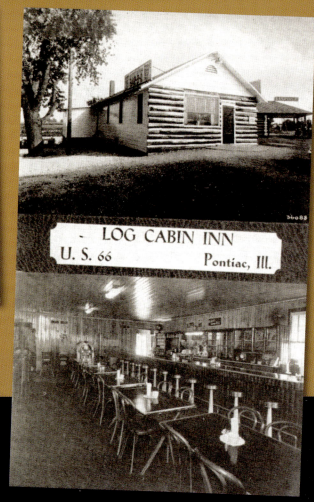

Joe and Victor Selotti used cedar phone poles to build the Log Cabin Inn in 1926. They turned the building around to face the new highway in the 1940s, and little has changed since.

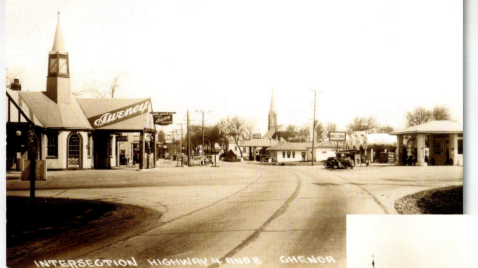

This view of Chenoa is from when the highway was still Illinois Route 4.

Steve's, originally the Wahl Brothers Café, was the first air-conditioned restaurant on Route 66 in Illinois.

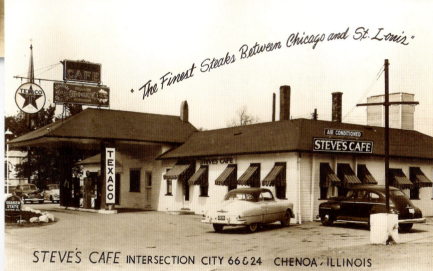

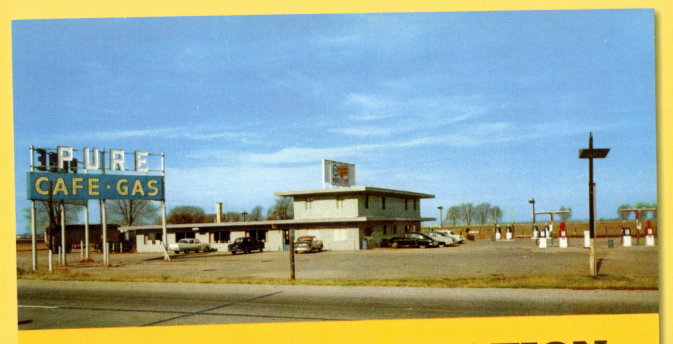

The Pure Truck Stop at Towanda opened in 1952 and closed after the construction of Interstate 55 in 1977.

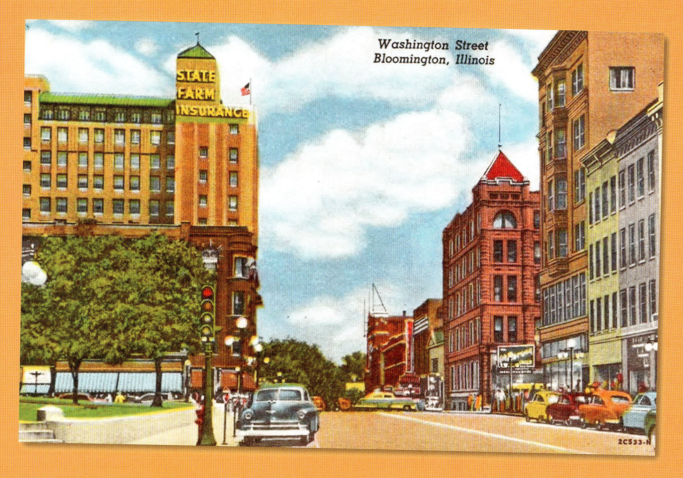

Route 66 ran through downtown Bloomington, past the landmark State Farm Insurance headquarters.

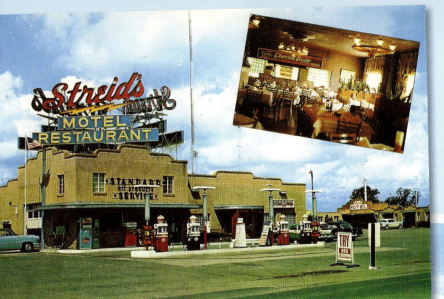

Paul Streid's restaurant was located on the 1941 Beltline route, an early expressway, around Bloomington.

Included on the postcard of the Hotel Illinois is the system of paved state highways that were in place before Route 66 was commissioned.

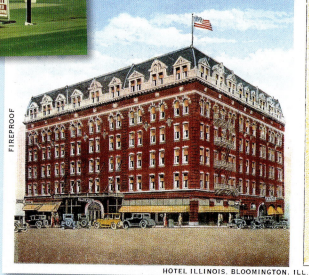

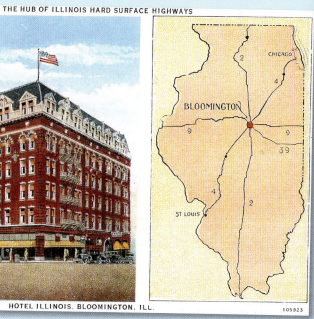

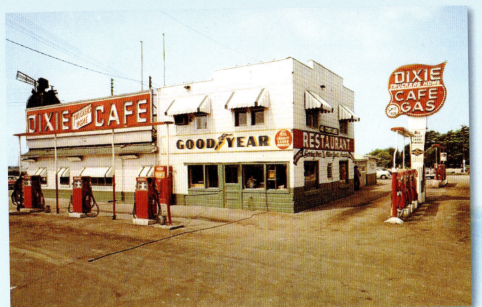

J. P. Walters and his son-in-law John Geske opened the Dixie Trucker's Home in McLean in 1928. Fire destroyed this building in 1965.

The Dixie was family owned until 2003. Renovated in 2012 it is now owned by the Road Ranger chain of gas stations and travel centers.

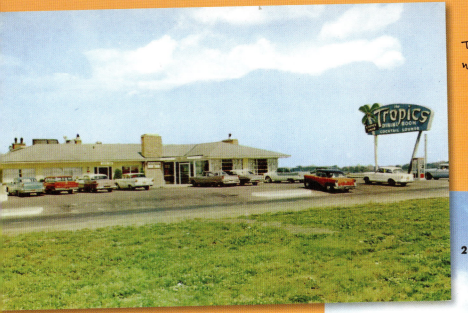

The Tropics served travelers in Lincoln—the only town named after the president while he was still alive.

Springfield's western-themed Lazy A Motel, built in 1949, still stands today and is used as apartments.

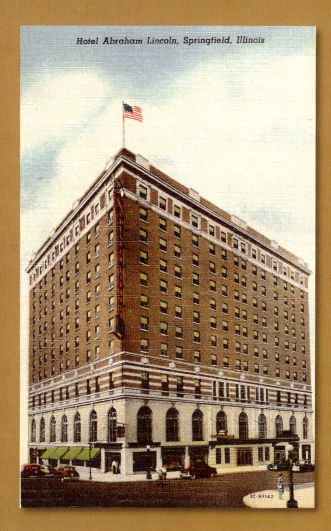

The Hotel Abraham Lincoln opened in 1925 in Springfield; it was demolished in 1978.

Springfield was originally named for South Carolina senator John Calhoun. The name was changed in 1832, and the state capital was moved here from Vandalia in 1837.

Abraham and Mary Todd Lincoln lived in this home at 8th and Jackson Streets from 1844 to 1861.

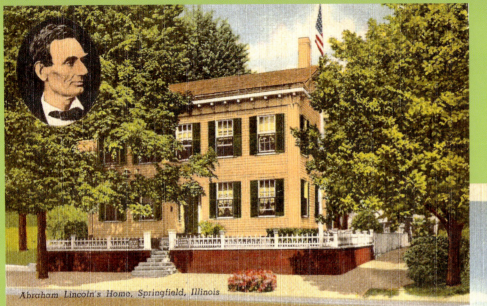

The Illinois State Capitol building is 74 feet taller than the U.S. Capitol.

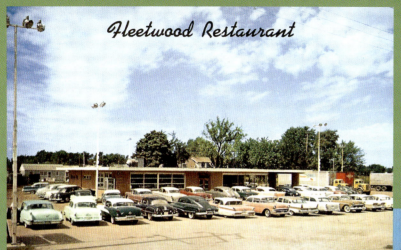

The Fleetwood Restaurant, famous for its broasted chicken, was in business from 1957 to 1993.

The Bel Aire Motel still stands on the post-1930 alignment of Route 66 via 6th Street.

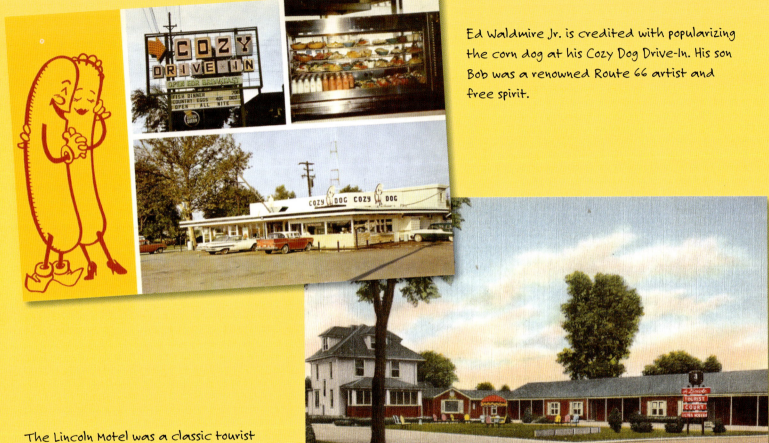

Ed Waldmire Jr. is credited with popularizing the corn dog at his Cozy Dog Drive-In. His son Bob was a renowned Route 66 artist and free spirit.

The Lincoln Motel was a classic tourist court. It was demolished in 1996 and the Cozy Dog moved to this location.

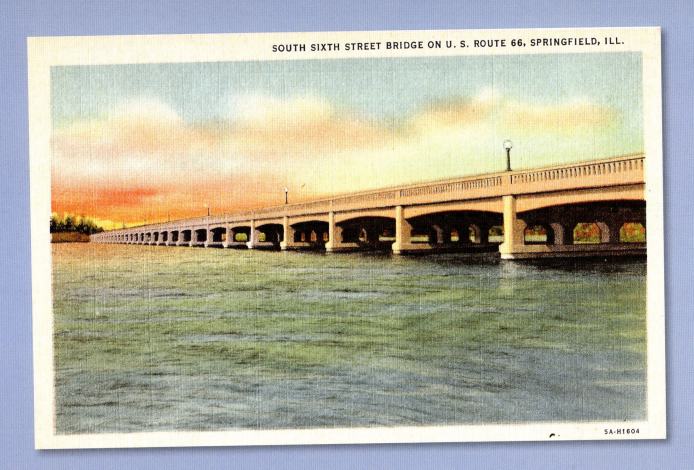

The South Sixth Street Bridge, created in 1933, carried Route 66 over Lake Springfield.

Art's Motel and Restaurant, including the original signage, can still be found near Divernon.

The Stuckey's chain, famous for pecan log rolls, had a location near Litchfield.

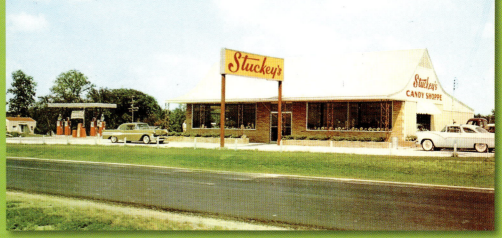

The 66 Hotel Court offered no-frills accommodations in Litchfield.

The 66 Subway Café, named for an underpass on the highway, once competed with the famous Ariston Café.

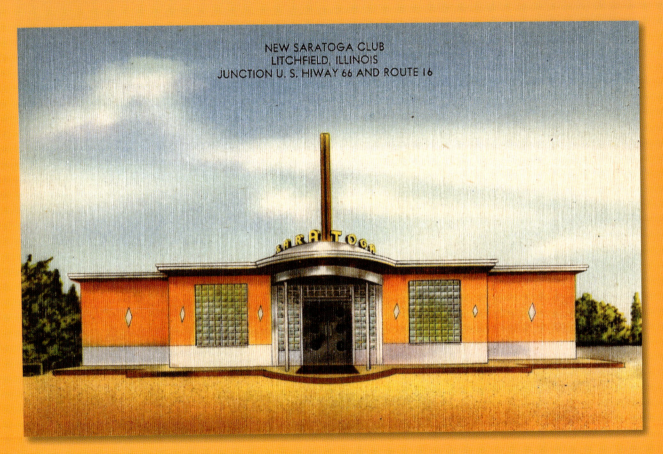

Lowell "Hydie" Orr's Saratoga Club was called the most beautiful restaurant between Chicago and St. Louis.

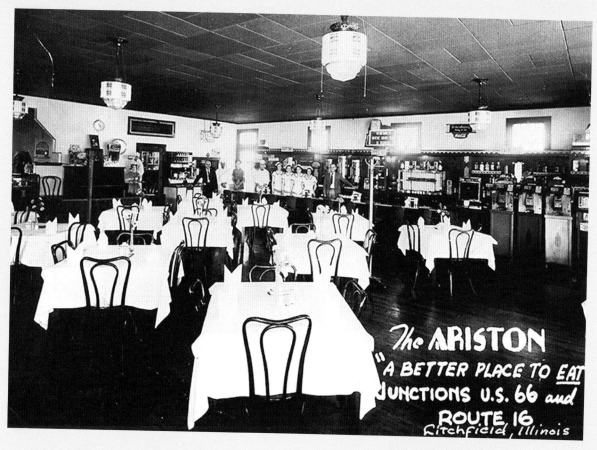

Pete Adams opened the Ariston in Litchfield in 1935, and the family still offers traditional fare there today.

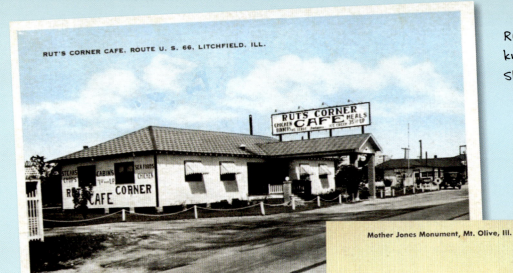

Russell "Ruts" Brawley's café was known for its slot machines; today it's Shaw's Club 66 Bar and Grill.

A monument to labor activist Mary "Mother Jones" Harris stands in the Union Miner's Cemetery in Mount Olive.

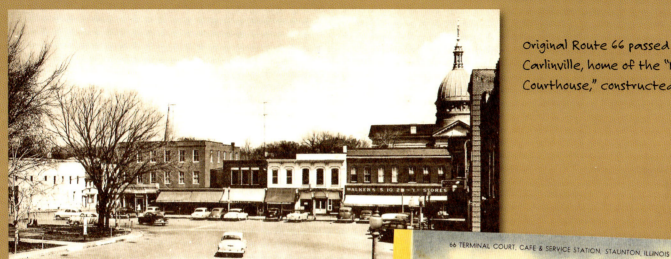

Original Route 66 passed through Carlinville, home of the "Million Dollar Courthouse," constructed in 1870.

The 66 Terminal Court once stood on the four-lane route just north of Staunton.

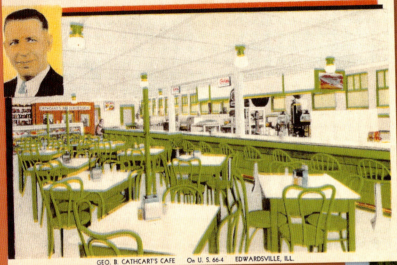

George Cathcart's Café at Edwardsville could seat 250 people and offered around-the-clock service.

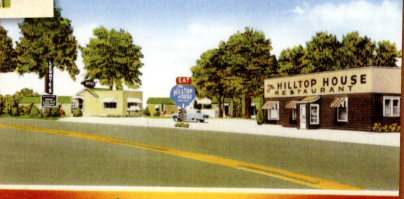

Patrons at Orville and Virginia Legate's motel could catch their dinner in a big lake on the grounds.

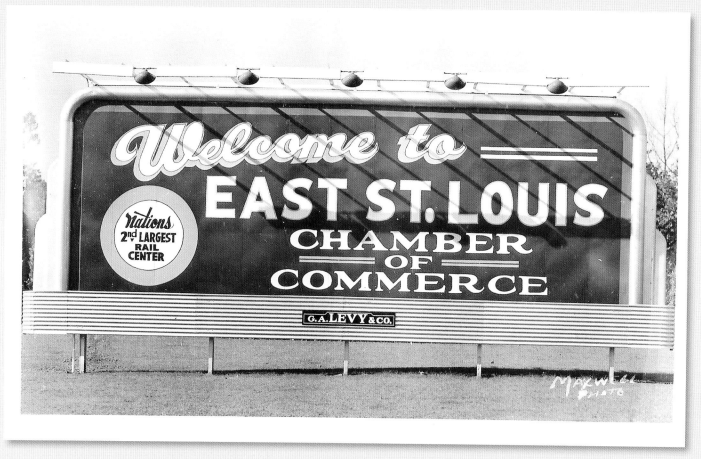

East St. Louis, the fourth largest city in Illinois, was once a hub of industry and railroads.

CHAPTER 2

MISSOURI

ROUTE 66 IN MISSOURI is partly a network of trails used long ago by Native Americans. It was known as the "Wire Road" after the telegraph lines were erected in 1858. The Wire Road became part of the Ozark Trails route in 1917 and was designated State Route 14 when the state highway system was laid out in 1922.

In its formative years Route 66 crisscrossed through St. Louis. The route originally followed Manchester Road west, and its most famous stretch left the city on Watson Road. Another path crossed the Chain of Rocks Bridge, skirting north of the city and dropping south on Lindbergh Boulevard through Kirkwood.

West of St. Louis no trace remains of the community of Times Beach, a former summer resort that was wiped off the face of the earth by floods and chemical contamination. The cleaned up site is now Route 66 State Park. Next in Stanton billboards and barns advertise Meramec Caverns as the "Greatest Show under the Earth."

Along the road Bourbon provides a popular photo opportunity, with its water towers marked "Bourbon." Cuba is "Mural City USA," with historic murals gracing the buildings. Also in Cuba the

Wagon Wheel is the best-preserved, 1930s-era motel on Route 66. West of Cuba the world's largest rocking chair sits out front at the Fanning Outpost General Store.

The highway rolls into the Ozark Hills west of Rolla, and is lined with buildings constructed from distinctive native rock. This is a region of deep forests, sparkling streams, hidden caves, and spectacular bluffs. Route 66 wound its way down the steep grade at Arlington and into the resort community of Devils Elbow until the town was bypassed in 1942 to accommodate military traffic from nearby Fort Leonard Wood.

After passing through Lebanon the highway moves well away from the interstate, past Conway, Marshfield, and Strafford before arriving in Springfield, the "Queen City of the Ozarks." West of Springfield the communities of Halltown, Phelps, and Avilla were hit hard by the arrival of the

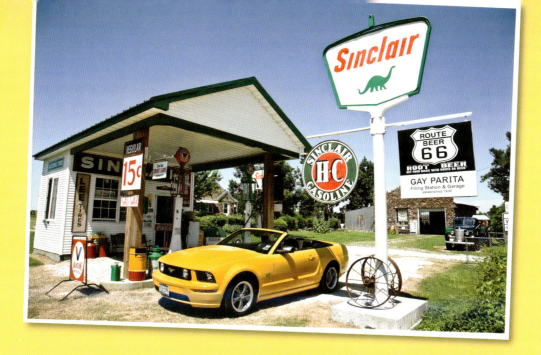

interstate. This segment is known as the "Ghost Highway," due to numerous roadside ruins. But there is life here, as Route 66 ambassador of goodwill Gary Turner greets travelers at his replica gas station in Paris Springs.

 Carthage is next along the route, with its magnificent courthouse and the Route 66 Drive-In Theatre. Webb City was once the heart of the Tri-State Mining District. In Joplin the highway has been detoured several times over the years due to collapsing mine shafts. Now marked as Missouri Route 66, the road heads west straight toward Kansas. A beautiful section of the old, two-lane highway awaits at a turnoff just before the state line.

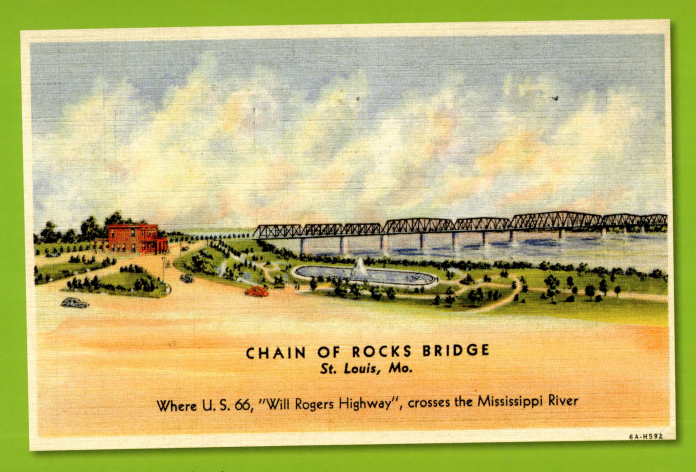

The Chain of Rocks Bridge carried Route 66 across the Mississippi River from 1936 to 1955.

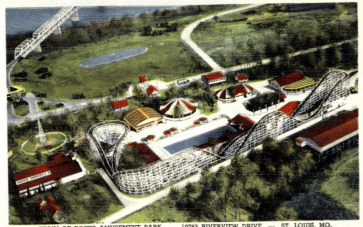

The Chain of Rocks Amusement Park stood on a bluff overlooking the bridge. It closed in 1977.

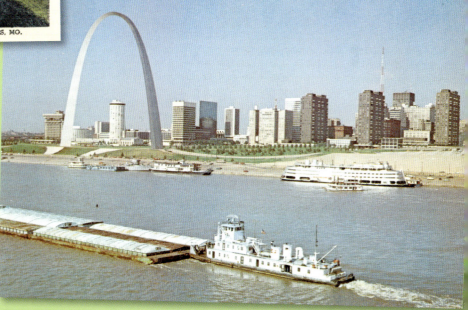

The Gateway Arch in St. Louis was constructed in 1965. At 630 feet it's America's tallest, man-made national monument.

Checkerboard Square was the headquarters of Ralston-Purina, makers of animal feed and cereal.

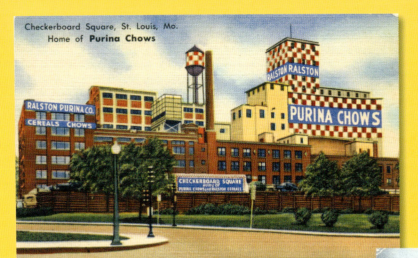

The St. Louis Cardinals and Browns played at Sportsman's Park on an early alignment of Route 66. The park was renamed Busch Stadium in 1953 and was demolished after the 1965 season.

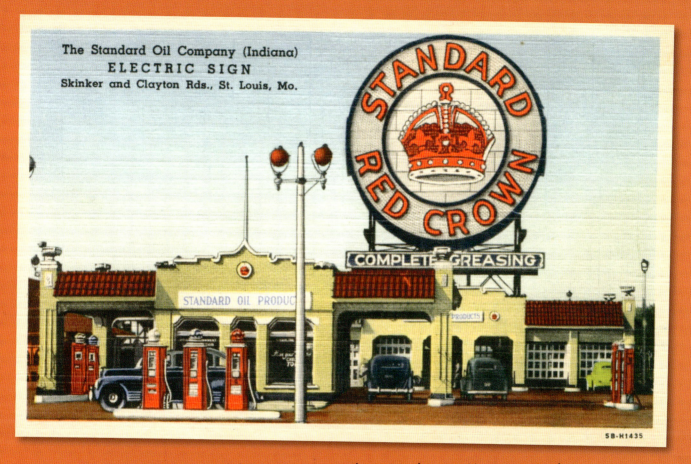

The massive sign at Hi-Pointe Standard Oil on original Route 66 used as much power as a city of 1,000 people.

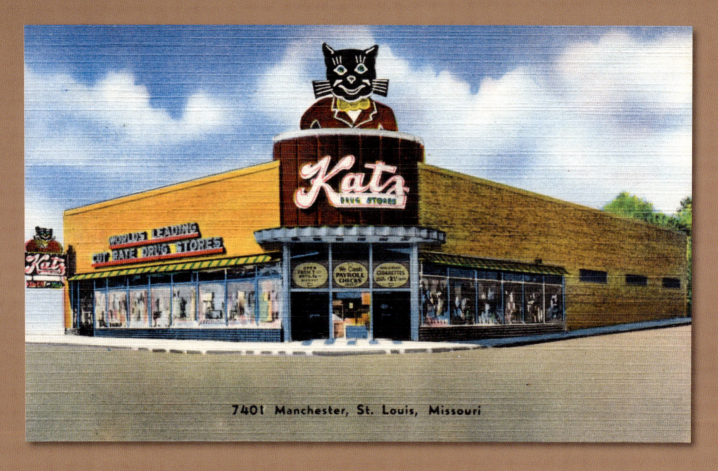

Original Route 66 (1926-33) followed Manchester Road through Maplewood, past the Katz Drug Store.

The original route continued through the then quiet village of Manchester. Manchester Road through the crowded suburb is clogged with traffic today.

From 1936 to 1965 Route 66 used Lindbergh Boulevard, traveling past the original Lambert Field Terminal. The terminal was named for aviation pioneer Albert Lambert.

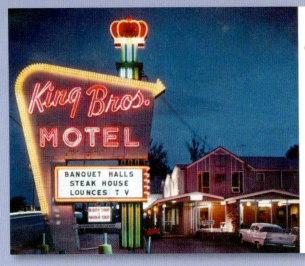

The King Brothers Motel was located on four major roadways: Routes 40, 61, 66, and 67. The Frontenac Hilton stands here today.

Watson Road is Route 66's best-known alignment through St. Louis, and was once populated with motels like the 66 Auto Court.

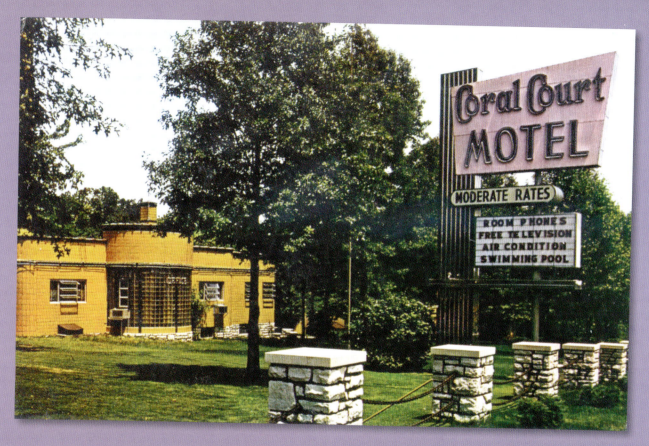

The Coral Court was one of the most beautiful motels on Route 66. It was demolished in 1995.

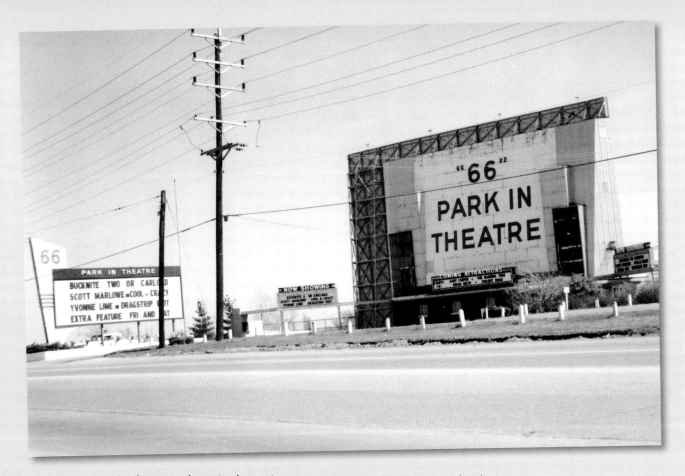

The landmark 66 Park-In Theatre opened in Crestwood in 1941; it was demolished in 1994.

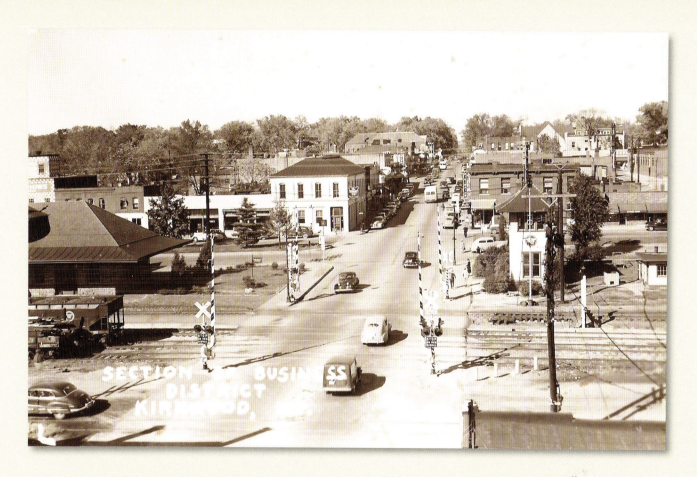

Kirkwood was the first planned suburb west of the Mississippi, and today it still retains a small town feel.

The route around St. Louis reunited with the city route south of Kirkwood, at the first cloverleaf interchange constructed west of the Mississippi.

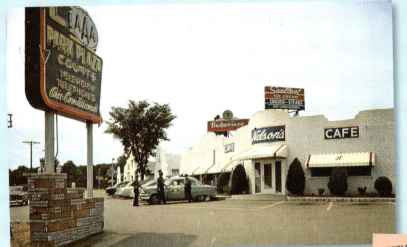

Nelson's Café was part of the Park Plaza Courts Complex, now the site of the Holiday Inn St. Louis SW-Route 66.

The Bridge Head Inn, later Steiny's, became EPA headquarters when the town of Times Beach was leveled due to dioxin contamination. It's now the Route 66 State Park Visitor Center.

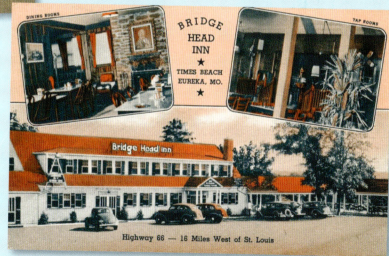

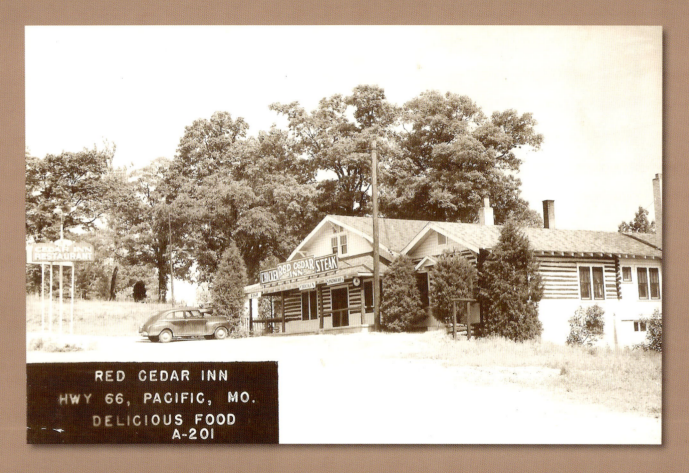

Former bootleggers James and William Smith used cedar logs to construct the Red Cedar Inn in 1934. It remained in the family until closing in 2005.

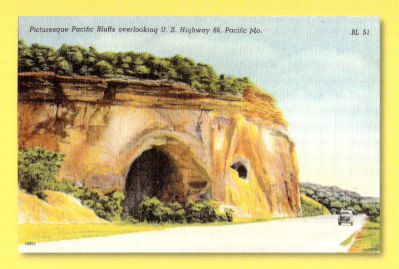

Caves created by silica mining in Pacific were exposed when the bluff was cut back for construction of new Route 66 in 1932-33.

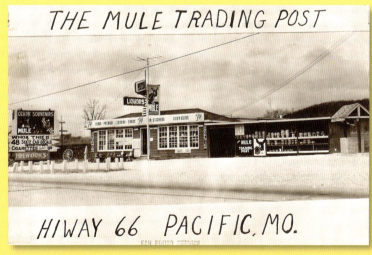

Frank Ebling founded the Mule Trading Post in Pacific in 1946. After Interstate 44 was constructed, Ebling moved to Rolla, where the mule still greets visitors today.

The Lovelace family built the Sunset Motel in 1946. Oliver Lee and Loleta Krueger ran it from 1971 to 2006. It's still in the family, and its iconic, neon sign has been restored.

The landmark Diamonds Restaurant in Villa Ridge, established 1927, was called the "World's Largest Roadside Restaurant."

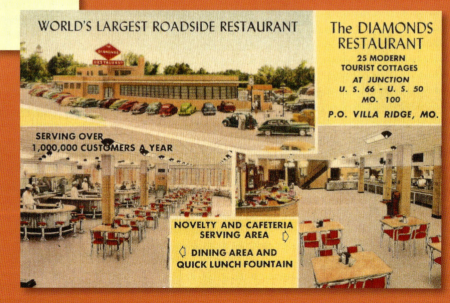

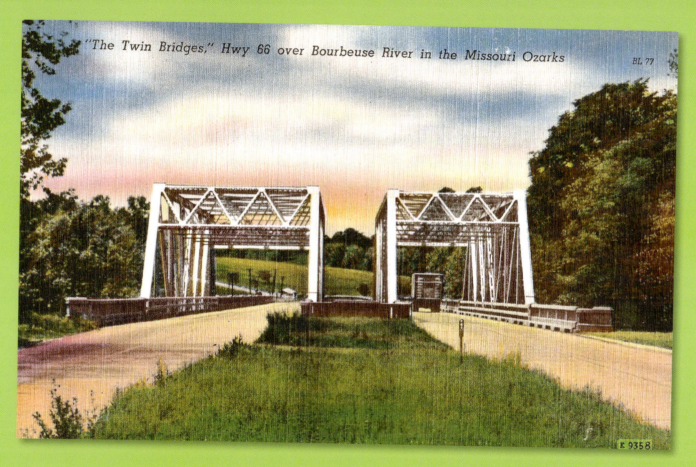

Just before reaching the Bourbeuse River, 66 split into dual lanes and then crossed the river on identical bridges.

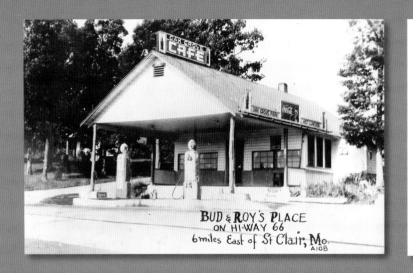

Only the pump island remains at the site of Bud and Roy's, also known as the Oak Grove Café.

Lewis' Café in St. Clair offered "ho-made" pie and coffee for a nickel, and is still serving travelers today.

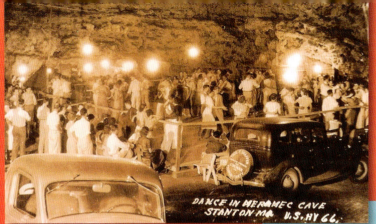

Meramec Caverns owner Lester Dill staged dances in a subterranean ballroom, invented the bumper sticker, and concocted a legend that the cave was a hideout for Jesse James.

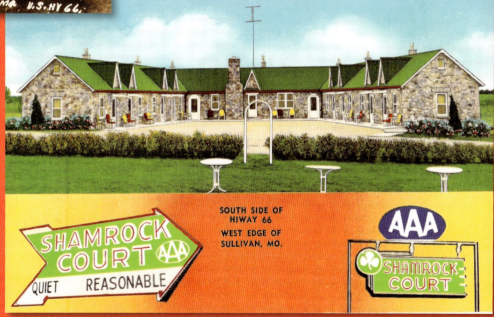

The Shamrock Motel was built in 1945, but today it's used as apartments. The building features the beautiful "Giraffe Rock" found on many Ozark structures.

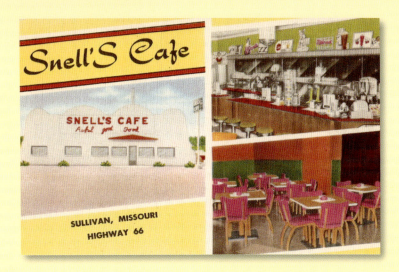

Mr. and Mrs. Fred Snell Sr. opened their café in Sullivan in 1949 with the slogan "Awful Good Food." It later became the Hitching Post Restaurant and then an antique mall.

The Wagon Wheel Motel in Cuba opened in 1934, and today has been beautifully renovated by Connie Echols.

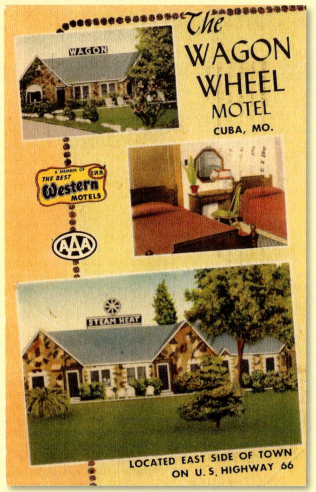

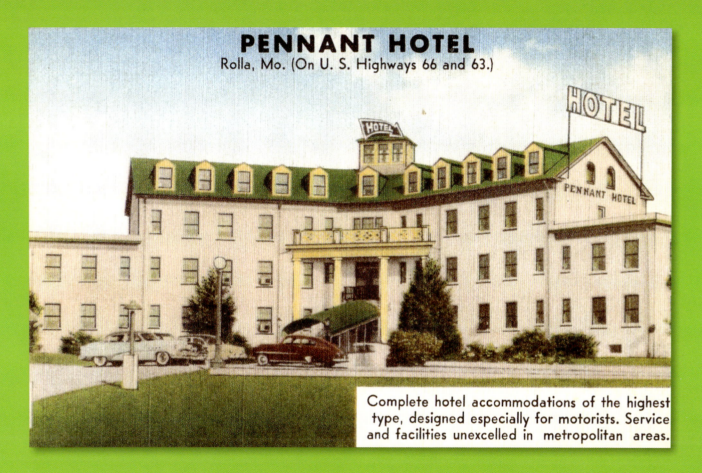

The Pennant Hotel in Rolla was one of the fine facilities developed by the Pierce Petroleum Company. It later became the Manor Motel and was torn down in 1970.

This 1946 view of Rolla looks east from the intersection with City 66, Pine Street.

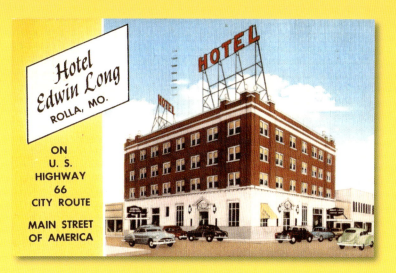

The Hotel Edwin Long hosted a celebration marking the paving of Route 66 across Missouri in March 1931.

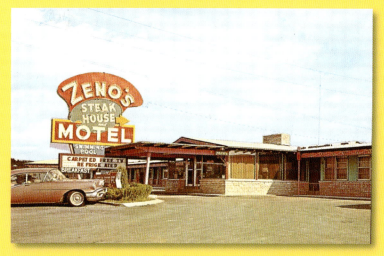

At the west end of Rolla, Zeno's was a landmark on Route 66 from 1957 to 2012.

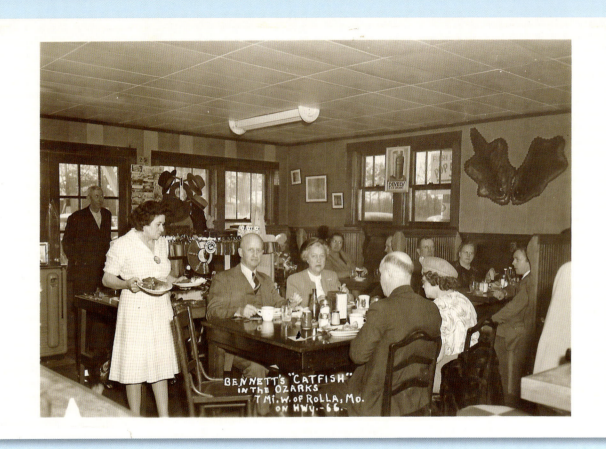

Paul Bramwell ran Bennett's Café with his wife, Gladys, and he was an evangelist known as "the fishing, coon-hunting preacher of the Ozarks."

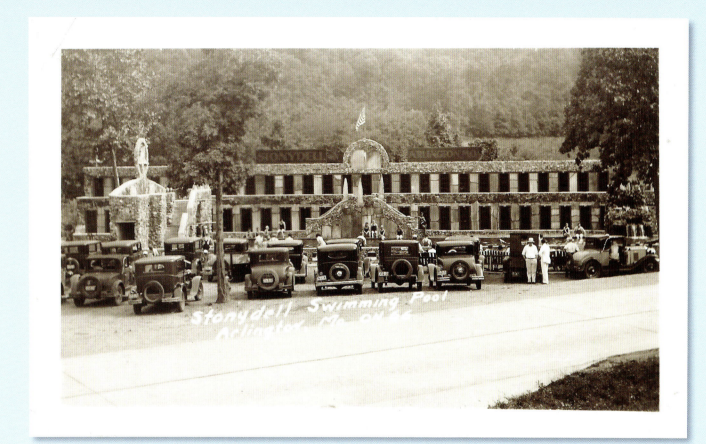

George Prewett constructed the amazing Stonydell Resort and its 100-foot-long swimming pool in Arlington in 1932. It was all torn down for I-44.

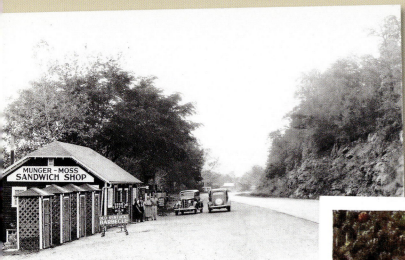

BIG PINEY RIVER, HI-WAY 66, DEVIL'S ELBOW

Howard and Nelle Munger ran a sandwich shop east of the Devil's Elbow Bridge. It became the Munger-Moss Sandwich Shop when Nelle married Emmett Moss, and it's now the Elbow Inn.

Spectacular bluffs make the winding, original route through Devils Elbow one of the most scenic on Route 66. Sadly the beautiful café burned in 1974.

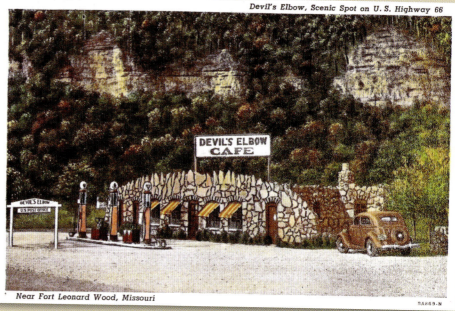

Devil's Elbow, Scenic Spot on U.S. Highway 66

Near Fort Leonard Wood, Missouri

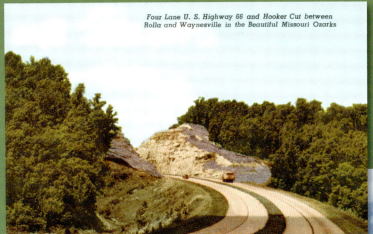

Four Lane U. S. Highway 66 and Hooker Cut between Rolla and Waynesville in the Beautiful Missouri Ozarks

Increased traffic serving Fort Leonard Wood required a four-lane highway, which opened in 1942. This 90-foot-deep rock cut at Hooker was the largest on a U.S. highway at the time.

In 1945 the Wells family relocated their station to the new highway. Sterling Wells and his wife, Betty, ran the Hillbilly Store until the interstate forced them to move again.

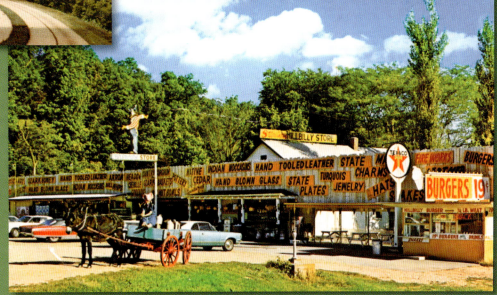

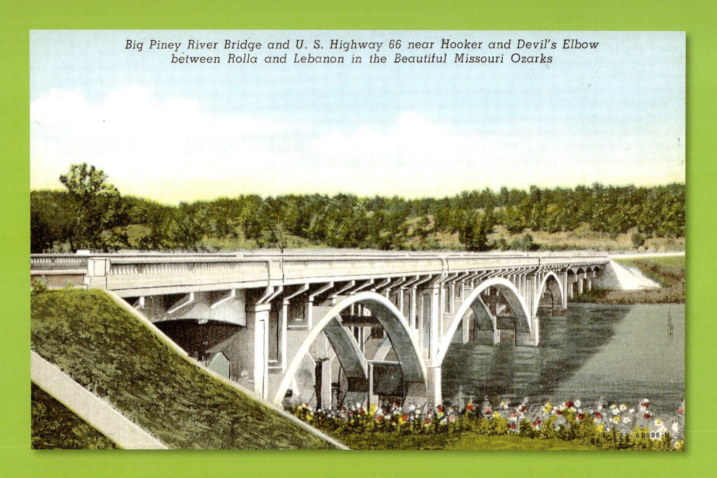

In 1981 the World War II—era route around Devils Elbow became the last section of Route 66 in Missouri to be bypassed.

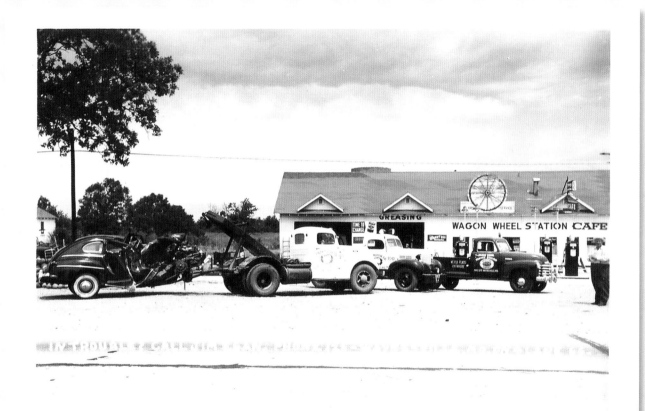

The towing business was brisk at James Eagan's Wagon Wheel because the stretch between Rolla and Waynesville was among the most dangerous on Route 66.

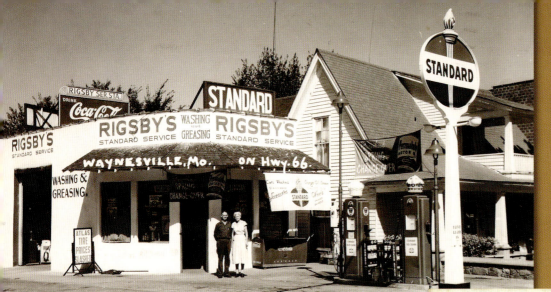

Claude and Eva Rigsby are shown posed at their station on the west side of the Waynesville Square. The home and the station structure still stand today.

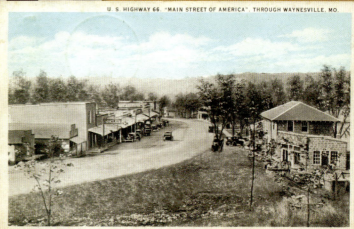

Waynesville was laid out in 1839 and named for General "Mad" Anthony Wayne. The sedate community was drastically transformed when Fort Leonard Wood was constructed.

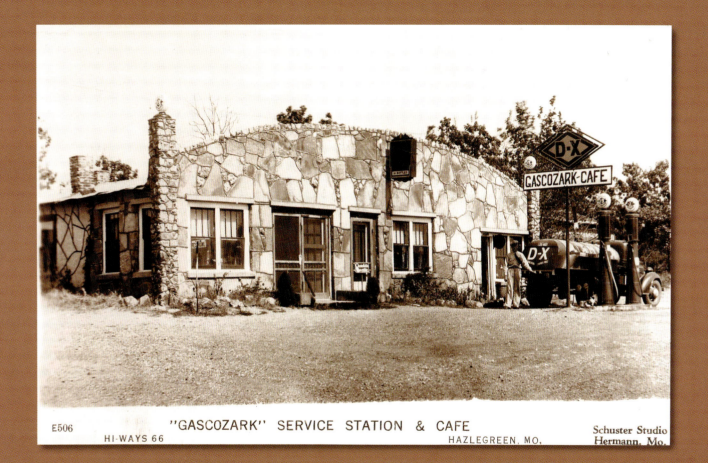

Frank A. Jones combined "Gasconade" and "Ozark" to come up with a unique name for his roadside business. The abandoned structure is now covered with vegetation.

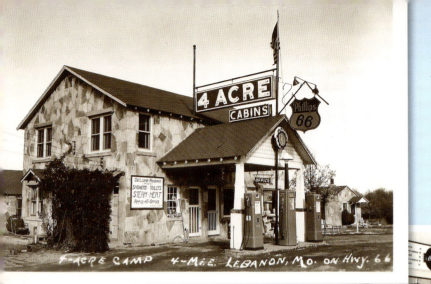

Ray Coleman and Blackie Waters opened the 4-Acre Court in Lebanon in 1939. The main building and most of the cottages are still there.

Dennis Scott built Scotty's Tourist City in the late 1940s on the east side of Lebanon.

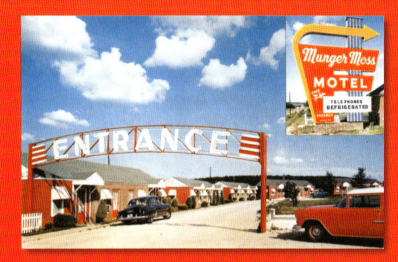

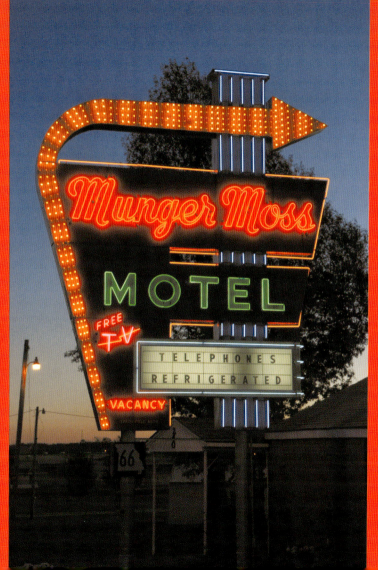

The Munger-Moss Motel in Lebanon opened in 1946. This 66 treasure has been operated by Ramona and Bob Lehmann since 1971. Jim Thole (right)

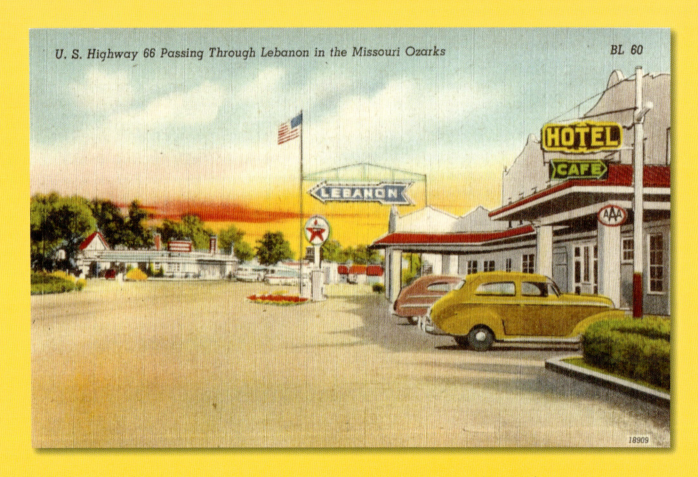

Nelson's Tavern is at right in this view of Lebanon. The roadside landmark with its beautiful gardens was demolished in 1957.

ELECTRICAL AND MUSICAL FOUNTAIN

NELSON DREAM VILLAGE — U.S. HIGHWAY No. 66 AND No. 5 — LEBANON, MO. 6A-H769

Colonel Arthur Nelson said the design for his tourist court came to him in a dream. Colored lights illuminated the fountain while music played.

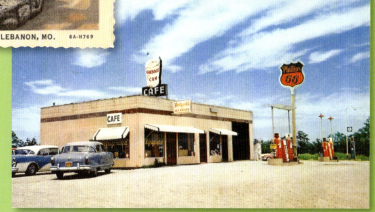

A friend suggested a name like "Garbage Can" would make Kermit and Letha Lowery's Café stand out along the busy road. The ruins remain along I-44 between Marshfield and Conway.

81

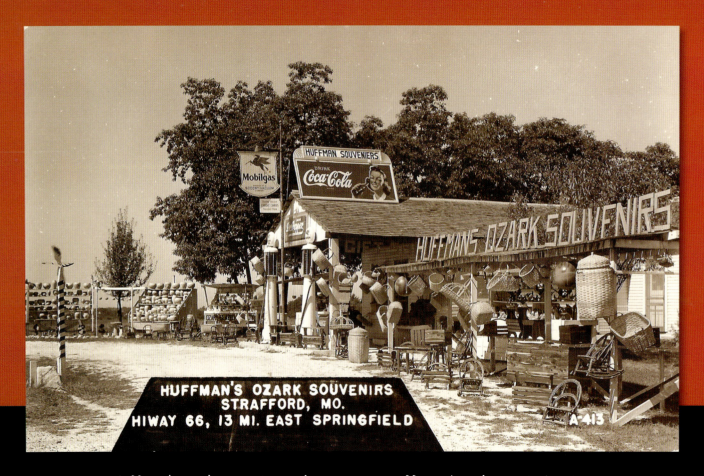

Huffman's Ozark Souvenirs was located at Strafford, the only town in America with two main streets and no back alleys, according to Ripley's Believe It or Not.

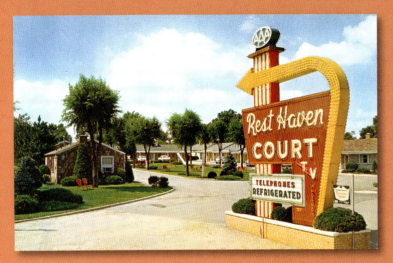

Hillary Brightwell and his wife, Mary, ran the Rest Haven Court from 1947 to 1977, and it's still in business. This marquee inspired the design of the Munger-Moss Motel sign.

The beautiful Rock Village Court was constructed in 1947 on the southwest corner of Glenstone Avenue and Kearney Street.

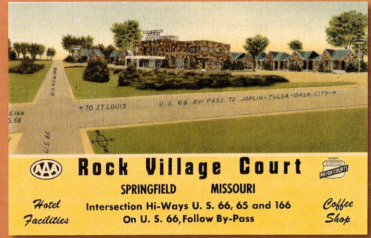

The Lily-Tulip plant, featuring an entrance resembling a giant paper cup, became Sweetheart Cup, and was later acquired by Solo. It closed in 2011.

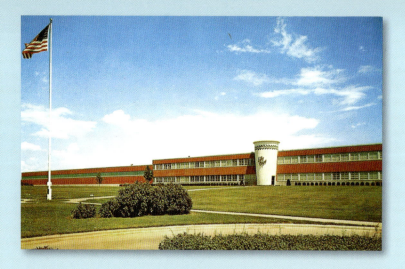

Lawrence and Elwyn Lippman's motor court grew into today's nostalgic, yet modern, Best Western Route 66 Rail Haven.

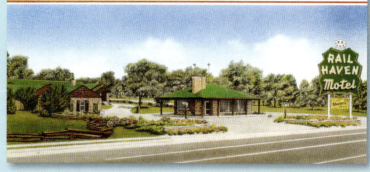

The Shrine Mosque was built by the Abou Ben Adhem Temple in 1923. Elvis Presley once played the auditorium.

On July 21, 1865, Wild Bill Hickok killed Dave Tutt in a duel on the Springfield Square, one of the first Wild West shoot-outs.

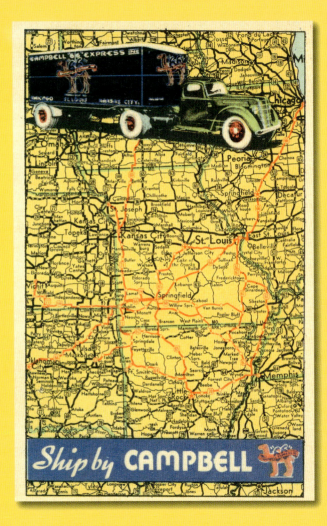

Springfield was the headquarters of Campbell's 66 Express. The trucking firm's camel mascot was named "Snortin' Norton" and their motto was "Humpin' to Please."

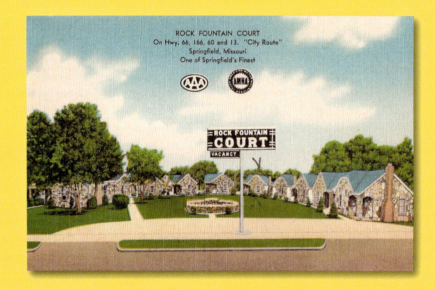

"Mac" MacCandless built the Rock Fountain Court in 1945. Sherman Nutt later changed the name to Melinda Court, after his daughter.

Old 66 (Missouri 96) between Springfield and Carthage is known as the "Ghost Stretch" for its abundant roadside ruins. Part of Log City, constructed in 1926, still stands there.

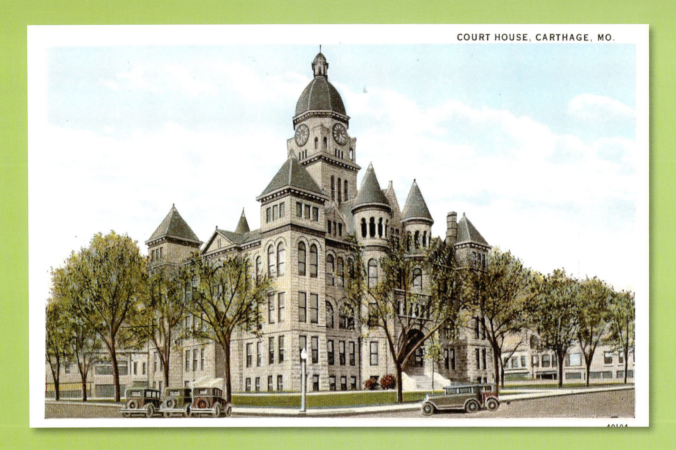

The Jasper County Courthouse in Carthage was dedicated in 1895. Carthage was the scene of two Civil War battles and was the home of outlaw Belle Starr, the "Bandit Queen."

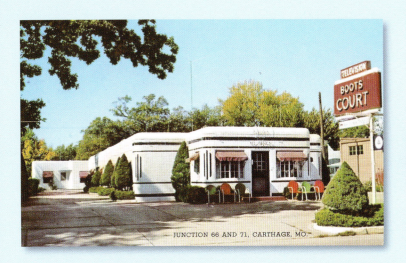

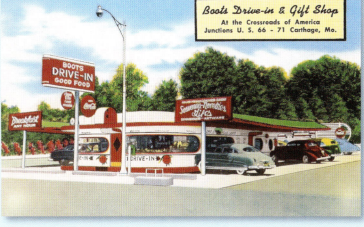

The Boots Motel, constructed in 1939 by Arthur and Ida Boots, was saved from demolition in 2003, and is being restored by Deborah Harvey and Priscilla Bledsaw.

Arthur Boots also designed his drive-in restaurant across the street from the motel. The altered building still stands.

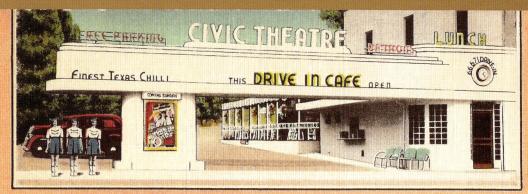

CIVIC DRIVE-IN CAFE Webb City, Mo.
On 66 Highway From Coast to Coast 71 from Canada to the Gulf

Approximately fifty mines were in operation around Webb City when its population peaked in the 1920s. The Civic Drive-In was later enclosed and eventually became an office building.

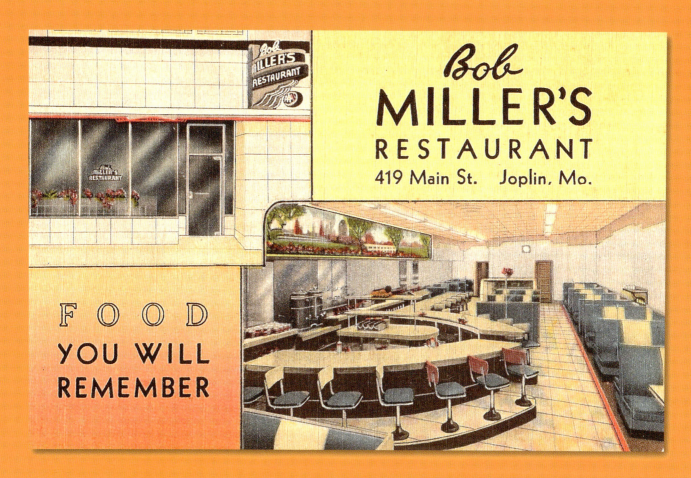

Bob Miller's restaurant in Joplin featured ultra-modern, pigmented structural glass on the exterior facade, the counters, and the floors. It closed in the 1990s.

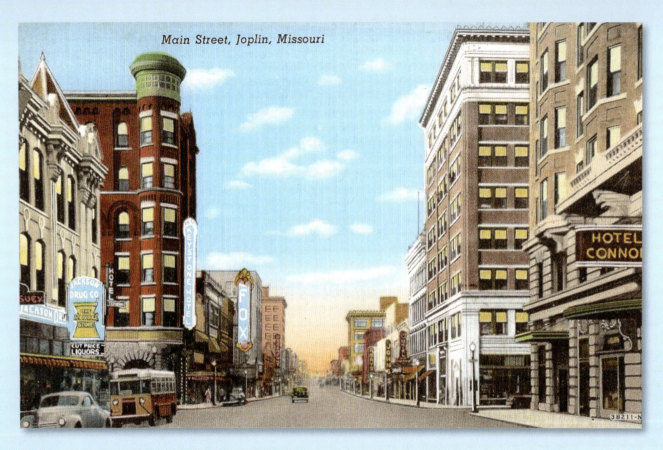

Joplin began as two lawless rival mining camps, and Main Street was once lined with saloons, dance halls, and gambling halls. The Keystone Hotel and Hotel Connor are gone.

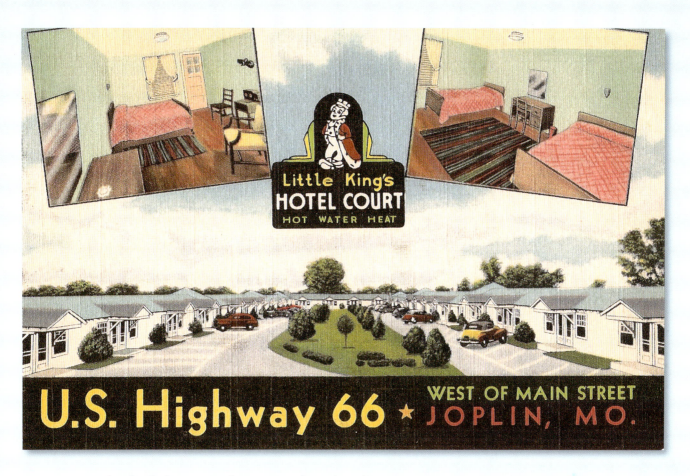

The final alignment of Route 66 through Joplin used Range Line to 7th Street past the Little King's Hotel Court.

CHAPTER 3

KANSAS

THERE ARE ONLY 13.2 MILES of Route 66 in Kansas, but every bit is historic. At first the road passes through a land scarred by lead and zinc mining. In Galena the "Four Women on the Route" (four businesswomen who are working to bring back this historic section of 66) offer a warm welcome at their restored gas station. Out front is the rusty antique tow truck that inspired the Tow Mater character in the Disney/Pixar movie Cars. Some buildings in the former mining town have been restored, including an old brothel. The bygone KATY railroad depot is now a museum dedicated to the mining industry.

Leaving Galena, Route 66 crosses the Spring River into Riverton, where the Eisler Brothers Country Store has been in business since 1925. Between Riverton and Baxter Springs, the old concrete truss "Rainbow Bridge" still stands. It was built in 1923 and it's the only one of its kind remaining on 66. Baxter Springs is known as the "First Cow Town in Kansas." After the Civil War the saloons eagerly welcomed the men driving massive herds of cattle up from Texas.

The tri-state area of Kansas, Missouri, and Oklahoma is haunted by the mysterious "Spook Light," which can often be seen bouncing along a dusty road. Skeptics say it is caused by car headlights on Route 66. This does not explain, however, why it has been sighted ever since the 1830s. There are many more colorful explanations offered, including the spirits of a murdered Osage Chief, or a Quapaw maiden, or the Cherokee forced from their homes onto the Trail of Tears.

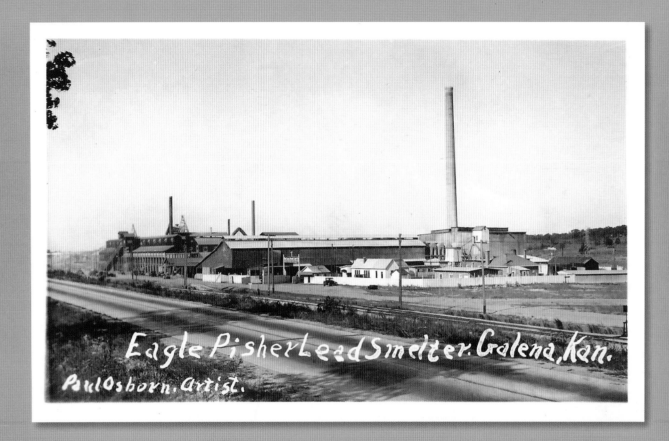

Entering Kansas Route 66 passes through "Hell's Half Acre," a landscape scarred by mining operations. The Eagle-Picher Smelter operated from 1878 to 2004. Steve Rider collection.

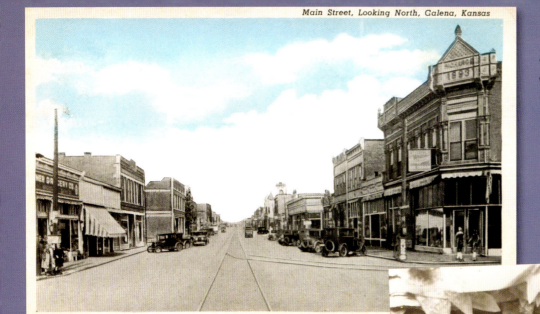

Galena was once a mining boomtown, where the main drag was known as Red Hot Street.

Just west of Galena Fred "Boodle" Lane offered spectacular rocks for sale to tourists. He also sold high-quality specimens around the world.

In 1952 June and Gates Harrold converted the former Joplin County Club into the Spring River Inn Restaurant. It closed in 1986 and was destroyed by fire in October 1998.

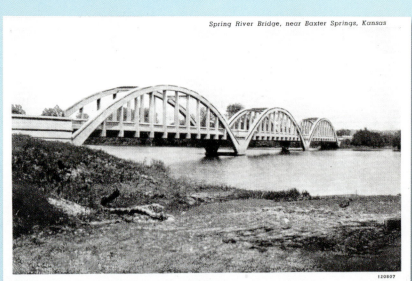

Route 66 crossed the Spring River on this Marsh Rainbow Arch Bridge, built in 1922 and torn down in 1986.

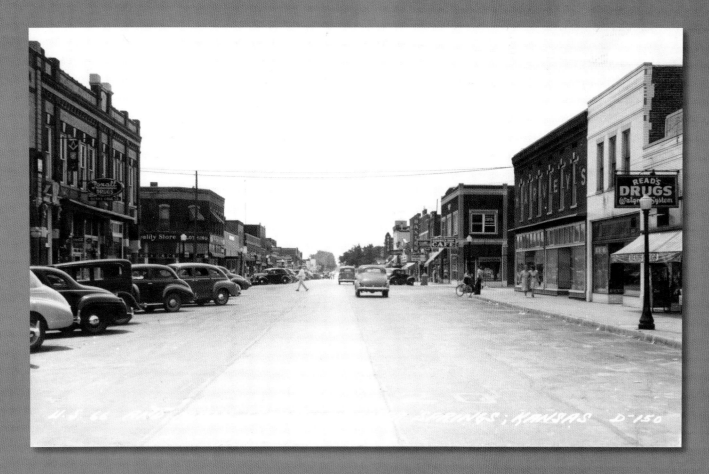

Baxter Springs bills itself as the "First Cow Town in Kansas." It was the scene of a massacre of Union troops by William Quantrill's guerillas during the Civil War.

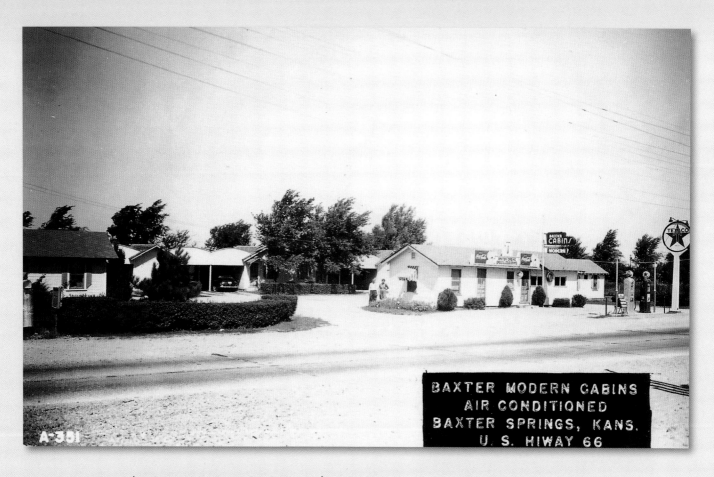

The Baxter Modern Cabins were located on an S curve just south of downtown Baxter Springs; it closed in 1965.

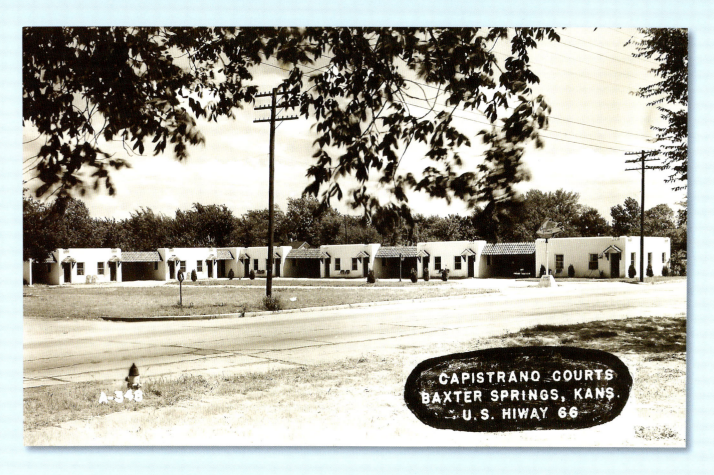

Nearly all the historic motor courts on Route 66 in Kansas have been demolished. The Capistrano Motel in Baxter Springs was torn down in 1988.

CHAPTER 4

OKLAHOMA

IT WAS IN THE STATE OF OKLAHOMA that Tulsa businessman Cyrus Avery conceived Route 66. There are still plenty of kicks on 66 here, the state with the most remaining miles of the original route. (Between Miami and Afton, a precious, original section of 9-feet-wide pavement can still be driven with care.) In eastern Oklahoma much of Route 66 was once the Ozark Trail Highway. In the western part of the state, the route mostly follows the old Texas Postal Highway. Over time, however, the route has changed. Initially 66 in the west came through Bridgeport, crossing the Canadian River on a rickety bridge that was owned by a politician who charged stiff tolls. Bridgeport became a ghost town when the El Reno Cutoff took traffic away in 1934. In the east the Turner Turnpike bypassed the towns between Tulsa and Oklahoma City in 1953, and the Will Rogers Turnpike connected Tulsa and the Missouri line in 1957. Today Route 66 is used by locals who want to avoid the tolls.

Starting on the eastern section of 66, Laurel Kane's restored gas station and collection of vintage Packards stand out in Afton. Claremore is the hometown and final resting place of Will Rogers. Phillips 66 gasoline coined its name near the oil capital of Tulsa when a car testing the new fuel hit 66 miles per hour on Route 66. At Stroud the Rock Café has been serving travelers since 1939. Arcadia's landmark Round Barn has stood since 1898.

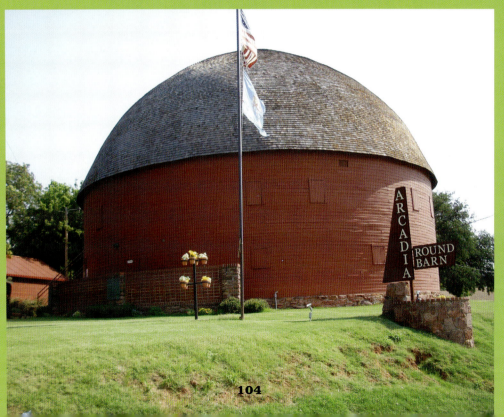

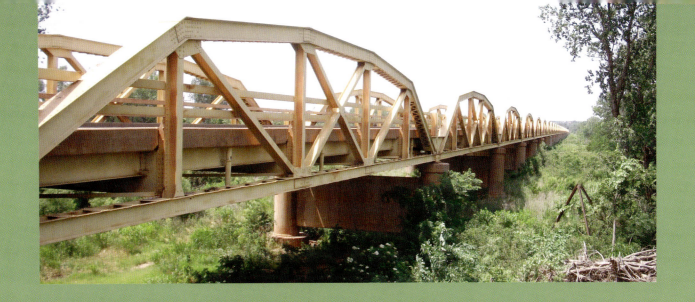

In the middle of the state, Oklahoma City is the site of the National Cowboy and Western Heritage Museum and the memorial to the victims of the 1995 Murrah Federal Building bombing. In Yukon, the hometown of country musician Garth Brooks, there's a giant flour mill with recently restored neon towers. West of El Reno is a wonderful stretch of old Route 66 that includes the 3,994-foot-long "Pony Bridge," with its thirty-eight, Warren pony trusses.

Farther west the Oklahoma Route 66 Museum is in Clinton, and Elk City has the National Route 66 Museum. Harley and Annabelle Russell, the "Mediocre Music Makers," are waiting to entertain you at the "World Class, World Famous Sandhills Curiosity Shop" in Erick. The ghost town of Texola is at the state line. A sign on a bar there sums it up nicely: THERE'S NO OTHER PLACE LIKE THIS PLACE ANYWHERE NEAR THIS PLACE SO THIS MUST BE THE PLACE.

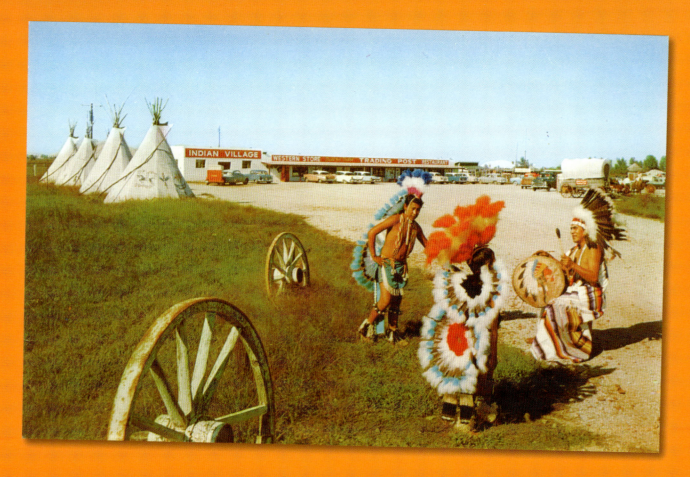

Indian Village at Quapaw lured Route 66 tourists with dances, a buffalo herd, Texas longhorns, and a rodeo arena.

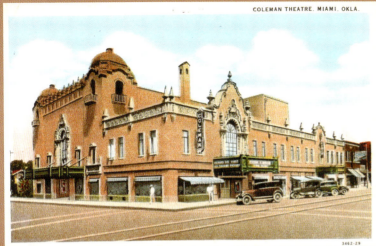

George L. Coleman made a fortune in mining and built the Coleman Theater as a gift to Miami. It opened in 1929 and was restored in 1989.

Miami, pronounced "My-AM-uh," was the first town chartered in the Indian Territory, and today is the headquarters of nine Native American tribes.

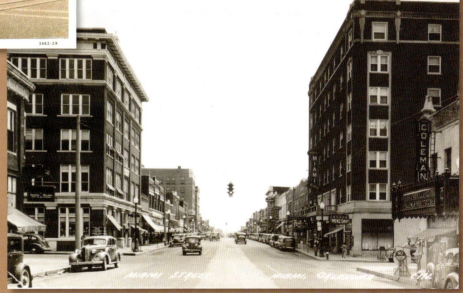

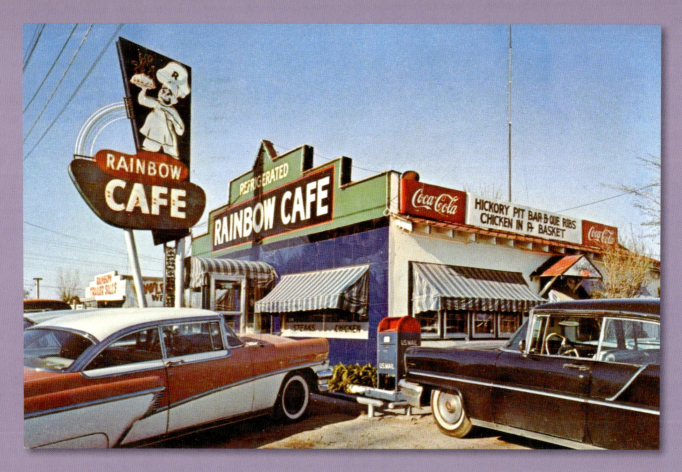

Art Tucker's Rainbow Café in Miami was painted with all the colors of the rainbow.

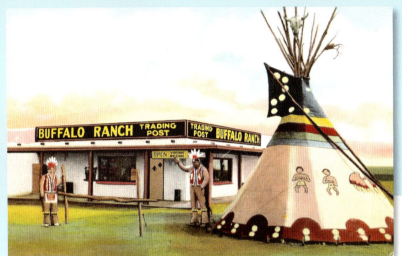

Russell and Allene Kay's Buffalo Ranch (1953–98) was a big roadside attraction at the junction of Route 66 and Route 59.

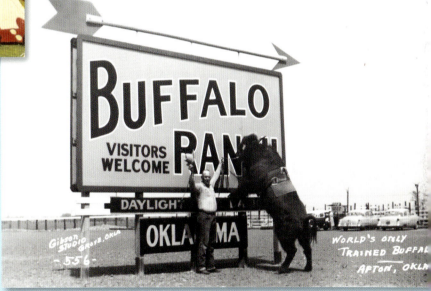

Larue Olson and his trained buffalo Pat performed at the Buffalo Ranch. The buffalo was trained but not tame, and he eventually killed Olson.

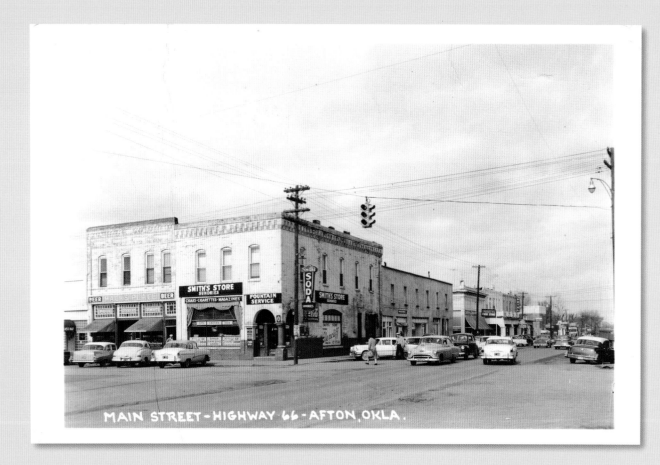

Afton is now the home of Laurel Kane's Afton Station, filled with memorabilia and a collection of vintage Packards.

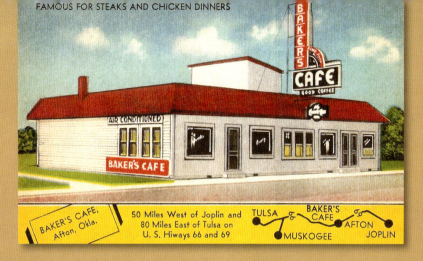

In 1932 Clint and Lillie Baker took over a small barbeque restaurant that grew into Baker's Café.

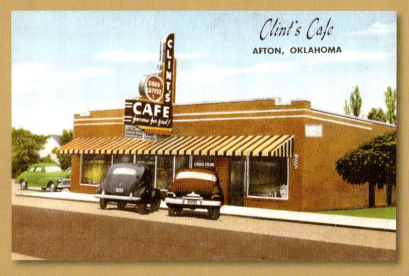

Clint Baker later operated Clint's Café. Clint's became the Davis Café; and the building burned in 2009.

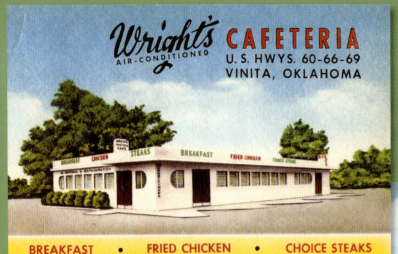

C. J. Wright's Cafeteria is now the site of an auto dealership.

Vinita is named for Vinnie Ream, who created the statue of Abraham Lincoln in the U.S. Capitol rotunda.

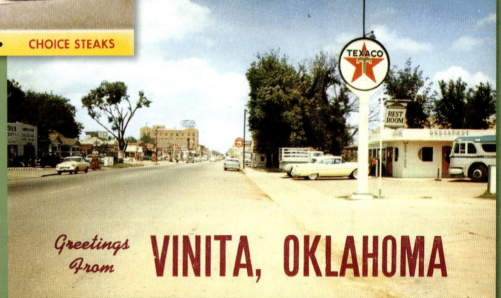

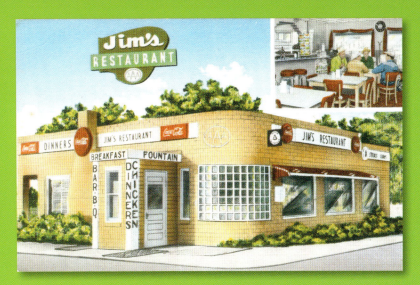

Jim's Restaurant opened in 1948 and was located where Route 66 curved to the west headed out of Vinita.

Ed Galloway retired to this farm near Foyil in 1937 and began building totem poles, including the largest in the world.

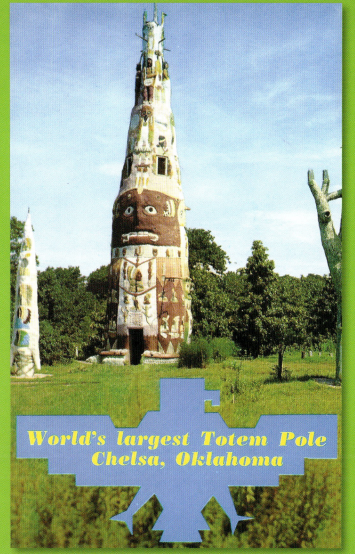

World's largest Totem Pole
Chelsa, Oklahoma

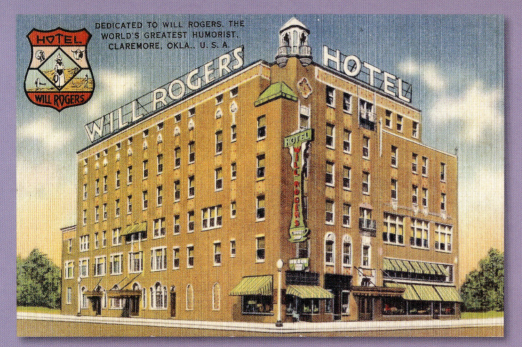

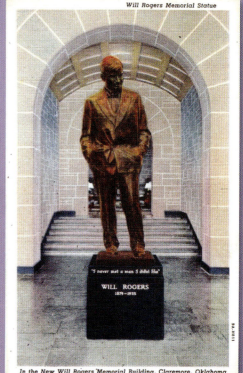

The Will Rogers Hotel opened in Claremore in 1930 and closed in 1991.

Will Rogers—comic, actor, and philosopher—was born near Claremore. After his death, the family donated the land and the state built a memorial museum.

Hugh Davis built an 80-foot-long blue whale for his wife Zelta at their Nature's Acres animal park and swimming hole. The beloved landmark was restored in 1997.

Zelta Davis posed with Betty, a gator that once latched on to her arm and tried to drag her underwater. Zelta punched Betty in the snout and got away.

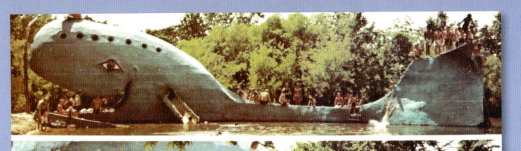

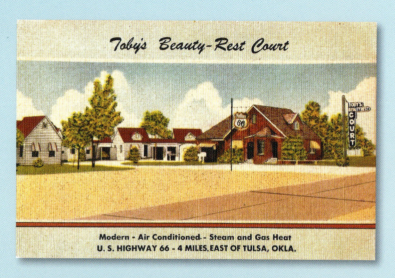

Toby's Beauty Rest Courts rented wood-framed cabins, which included air-conditioning and Beautyrest mattresses, to Route 66 travelers.

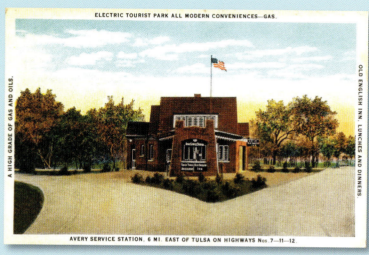

Cyrus Avery, "The Father of Route 66," ran this complex at Mingo and Admiral. It was torn down in 1943. Mike Ward collection.

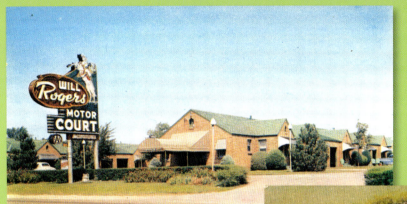

The Will Rogers Motor Court, with its classic sign, was in operation from 1941 until the 1990s.

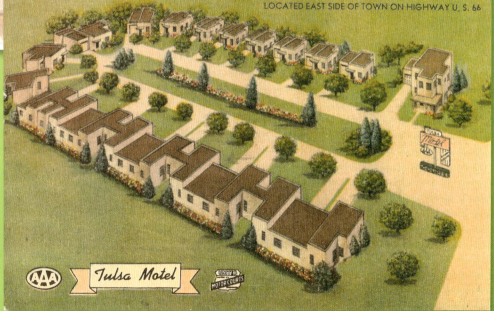

The Tulsa Motel had cottages that were entered from attached garages to ensure privacy.

The US 66 Café was on the northwest corner of 11th Street and Memorial Drive in Tulsa.

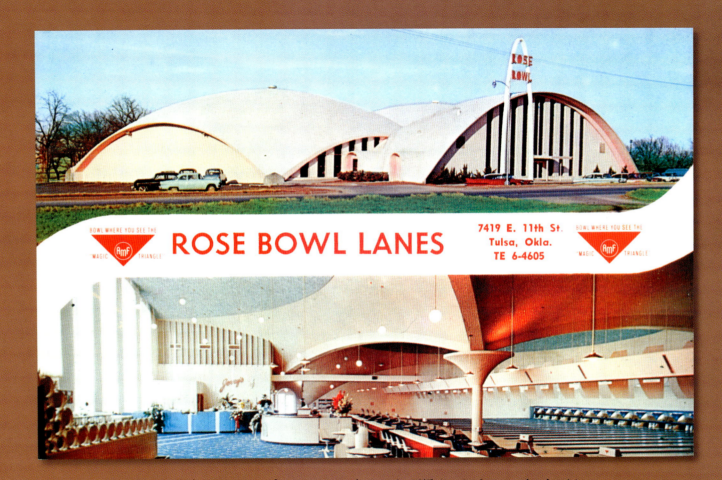

The Rose Bowl Lanes were featured in the movie UHF. Its design was inspired by the domed, concrete bomb shelters used in Germany during World War II.

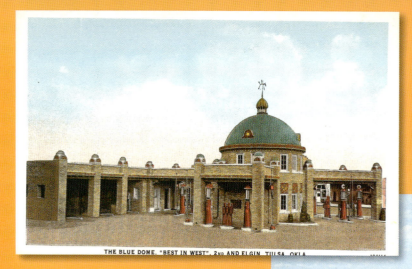

THE BLUE DOME, "BEST IN WEST", 2ND AND ELGIN, TULSA, OKLA.

The Blue Dome Station was modeled after the Hagia Sophia in Istanbul. Now restored, it is the heart of the Blue Dome District, a center of nightlife. Steve Rider collection.

Tulsa Oklahoma
Teepees to Towers

Creek Indians, driven from their Alabama homes by the U.S. government, established a settlement they called Tulasi, or "Old Town," between 1828 and 1836.

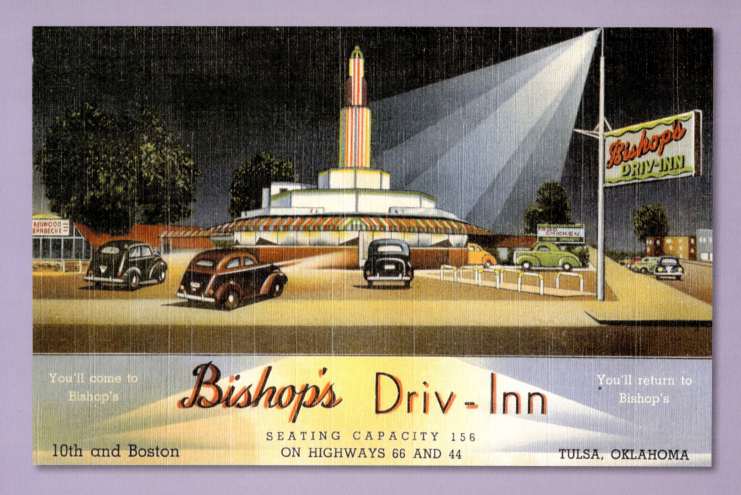

William Wallace Bishop's Driv-Inn was briefly in business from 1938 until 1942.

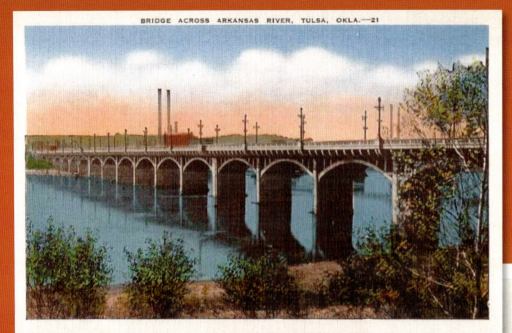

The 11th Street Bridge, completed in 1917, carried 66 traffic across the Arkansas River. In 2004 it was renamed for Cyrus Avery.

Offering box chicken to go, 66 Chicken and Steaks tried to take advantage of its location on the highway.

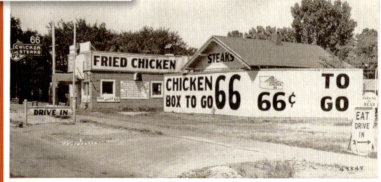

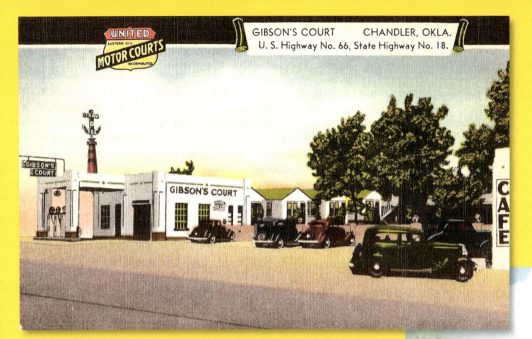

Route 66 passes through Sapulpa, Bristow, and Stroud before entering Chandler where Joe Gibson operated Gibson's Court.

Joe Gibson also operated the Lincoln Motel, which opened in 1939 and is still in business today.

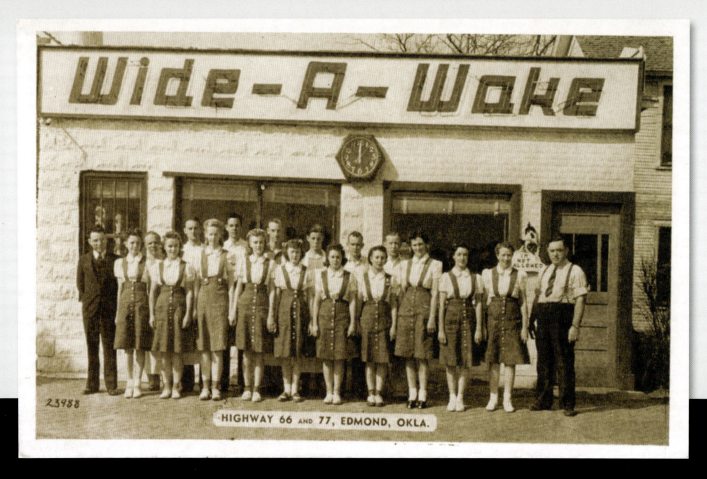

The Wide-A-Wake Café in Edmond served travelers and locals from 1931 until 1979.

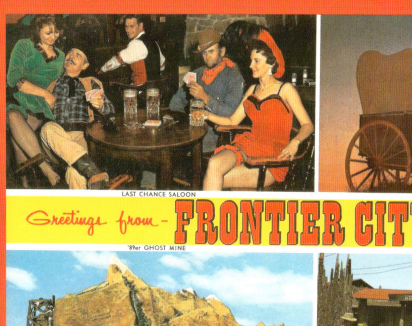

LAST CHANCE SALOON

COVERED WAGON

Greetings from — FRONTIER CITY, U.S.A.

'89er GHOST MINE

GUNFIGHT CORRAL

The Frontier City Amusement Park opened in 1958, offering gunfights, train rides, and Native American dances. It's still open today.

The Palomino Motel's pony greeted guests, and was said to be "one of the most photogenic horses in Oklahoma."

Colorful motels, such as the Flamingo, once lined Lincoln Boulevard.

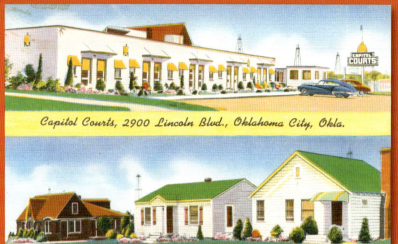

From 1926 to 1954, Route 66 entered Oklahoma City using Kelley Avenue, Grand Boulevard, and Lincoln Boulevard past the Capitol Courts.

Garland's offered curb service from 1939 until 1950. Carhops, dressed in sailor outfits with short skirts and white boots, served customers.

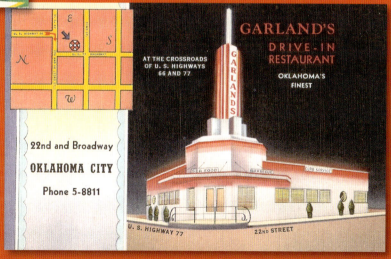

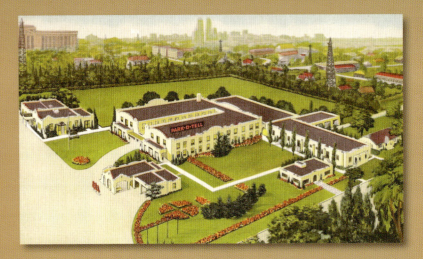

The Park-O-Tell was billed as "Traveler's Paradise" when it opened in 1930. It was demolished when Lincoln Boulevard was routed around the State Capitol building.

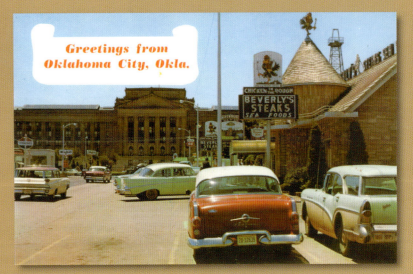

The oil well on the State Capitol grounds could be seen from points around Oklahoma City, including from Beverly's Steaks.

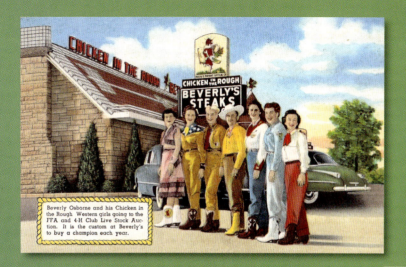

Beverly and Rubye Osborne were among the first to franchise fast food in the United States. Their "Chicken in the Rough" was served without silverware, a radical idea at the time.

The Classen Cafeteria was one of twenty-three cafeterias in Oklahoma City. It closed in 1967.

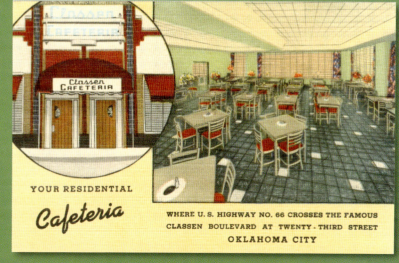

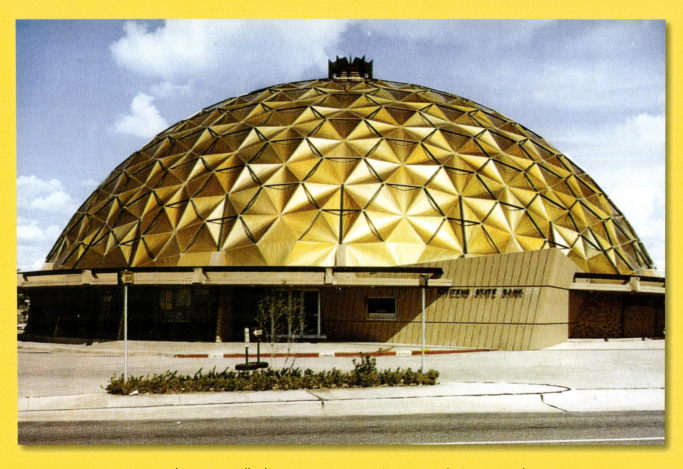

Based on Buckminster Fuller's geodesic design, the dome of the Citizen's State Bank was the world's first made from gold-anodized aluminum.

Lakeview Courts offered boat rides on the 1919, man-made Lake Overholser.

The De Luxe Courts were another offering for travelers on Route 66.

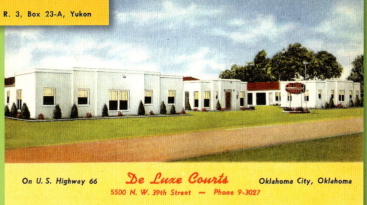

It was altered to read "Amarillo's Finest" when it was featured in the 1988 film Rainman.

The Beacon Motel and Café became the Big 8 Motel, now demolished.

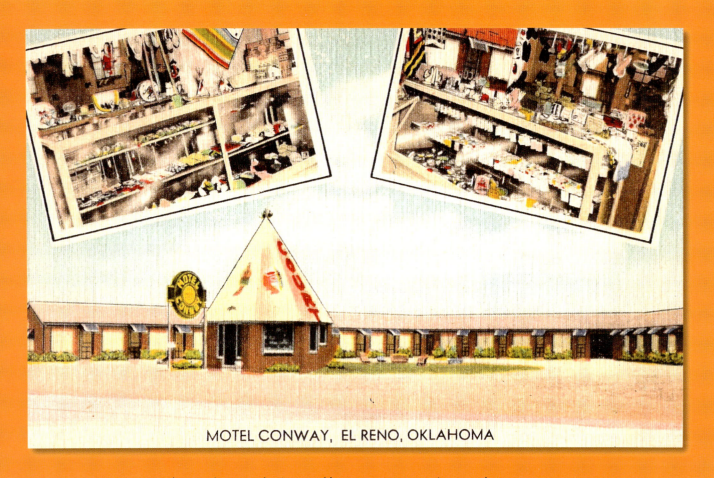

Route 66 is known for motels shaped like wigwams, but the Motel Conway in El Reno was shaped like a teepee.

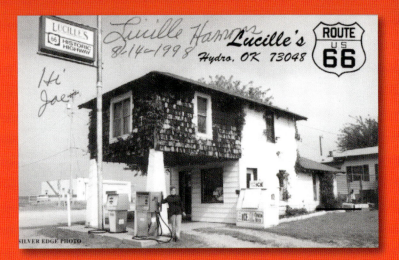

Lucille Hamons became beloved as the "Mother of the Mother Road," and she welcomed travelers near Hydro from 1941 until the day she died in 2000.

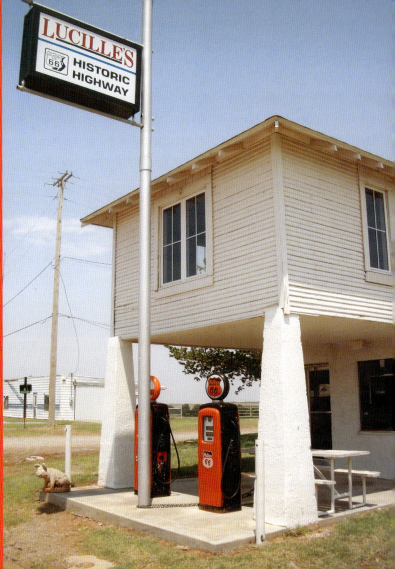

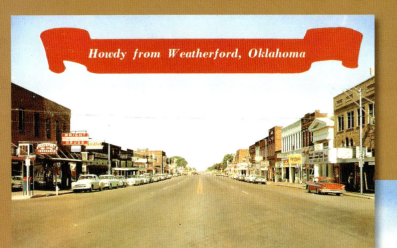

Weatherford is the hometown of Thomas P. Stafford. He was a former astronaut and air force general, who is honored with a museum in town.

Glenn Wright's station in Weatherford opened in 1926, but this structure was replaced in 1960.

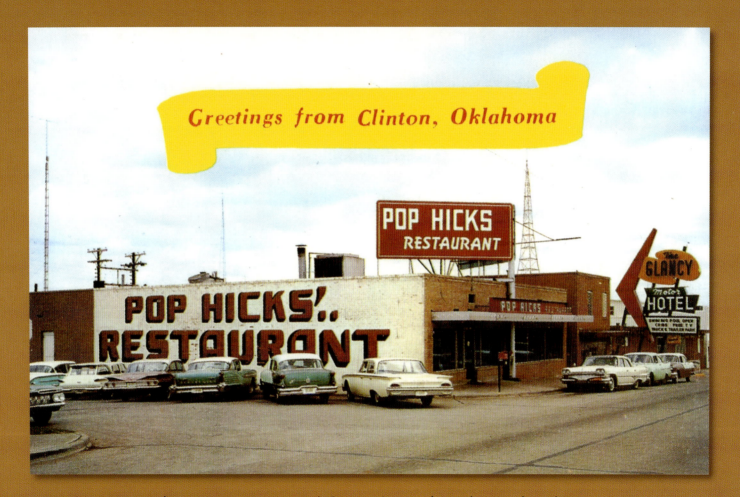

Pop Hicks Restaurant, opened in 1936, was the best-known landmark in Clinton.

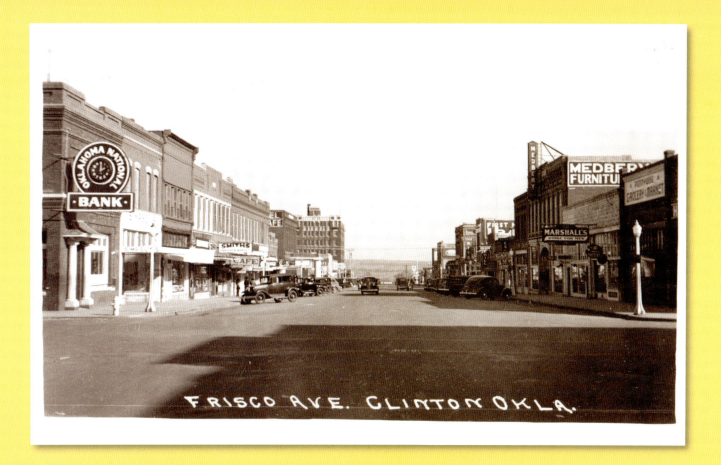

Route 66 originally used Frisco Avenue in Clinton. The final alignment used Gary Boulevard, named after the governor who worked to upgrade Route 66.

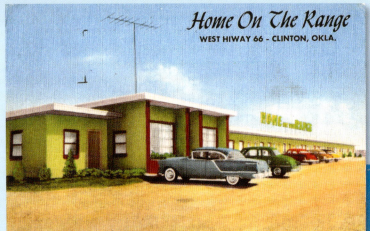

The Home on the Range Motel in Clinton still stands and is now the Relax Inn.

Elvis Presley stayed at "Doc" Mason's Trade Winds Motel in Clinton four times, each visit in Room 215, which remains much as it was then.

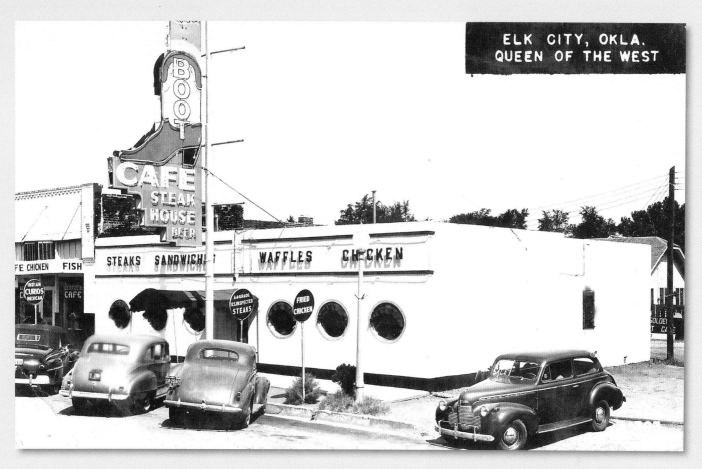

Crowe, Oklahoma, was once renamed "Busch," in hopes of landing a brewery. When that fell through, residents chose Elk City, after Elk Creek.

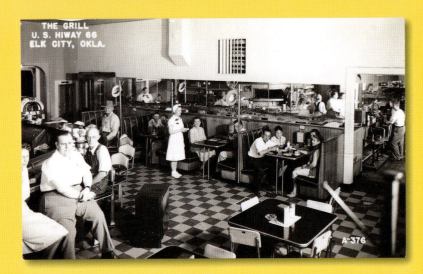

The Grill was a classic Route 66 café, complete with a jukebox, in Elk City.

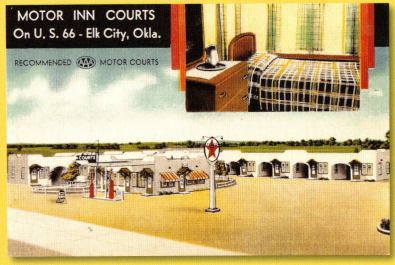

The Motor Inn Courts in Elk City advertised "Where tired tourists meet Good Eats and Good Beds."

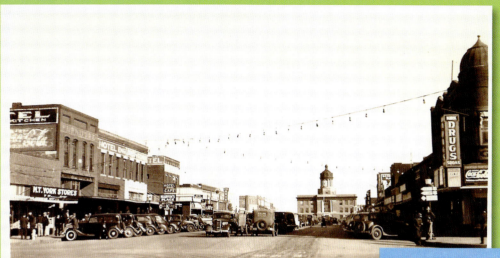

The Beckham County Courthouse in Sayre, visible in the background, was featured in the movie The Grapes of Wrath.

Paul and Ruby Mackey built the Sunset Motel on the east side of Sayre in 1950.

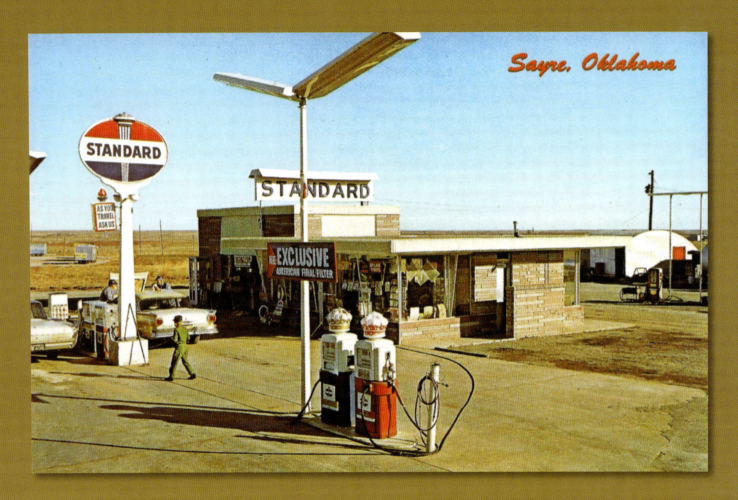

Bill Spence and Garth Russell's Standard Station opened in 1949.

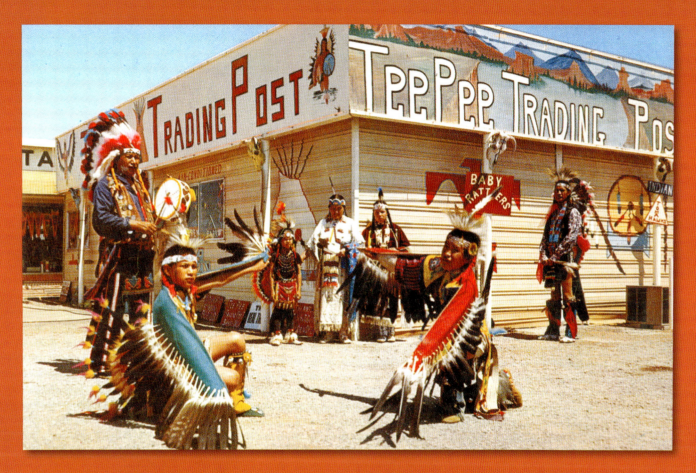

Gideon "Great Lighting" Wade and his family performed ceremonial dances at the Teepee Trading Post, next to the Spence and Russell Standard Station.

CHAPTER 5

TEXAS

ROUTE 66 CROSSES 178 MILES of the Texas Panhandle. The early settlers here found a featureless terrain so vast that they drove stakes in the ground to mark their routes. Early Route 66 travelers once faced the dreaded Jericho Gap, an 18-mile dirt section between McLean and Groom. Locals raked in cash using teams of horses to pull vehicles from the thick, black mud until the gap was finally paved in 1937.

Shamrock was once a busy stop at the intersection with U.S. Route 83—and the lights are still shining at the art-deco U-Drop Inn. At McLean a vintage Phillips 66 station has been restored. Also here is the Devil's Rope Museum, which is housed in a former brassiere factory and includes exhibits on barbed wire and a section devoted to Route 66.

Amarillo is the Spanish word for "yellow," which is also the color of the soil along Amarillo Creek and the abundant wildflowers found here. Route 66 entered Amarillo on 8th Street, today's Amarillo Boulevard. The original route then turned south on Fillmore Street through downtown, then headed west on 6th and 9th Streets.

The Big Texan Steak Ranch, now located on the interstate, offers a hearty dose of Texas kitsch and a famous 72-ounce steak dinner. It's free for customers who can down it in one hour. West of town ten vintage tail-finned beauties are buried in the earth at the Cadillac Ranch. Created by a group of artists for an eccentric millionaire, they now stand as a reminder of the glory days of the road.

Adrian is said to be exactly midway between Chicago and Los Angeles on Route 66. Glenrio straddles the state line, a classic Route 66 ghost town caused by the arrival of the interstate.

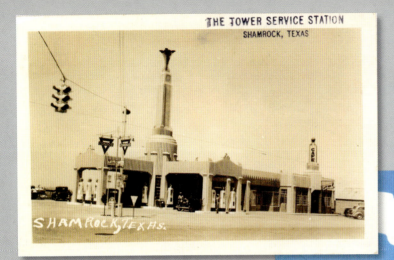

Shamrock's most famous landmark is the Tower Service Station and U-Drop Inn Café, constructed in 1936. Today it serves as a welcome center. Steve Rider collection.

This was the view looking west on Route 66 from the junction with U.S. Route 83. Most of these businesses closed or moved after Interstate 40 opened in 1973.

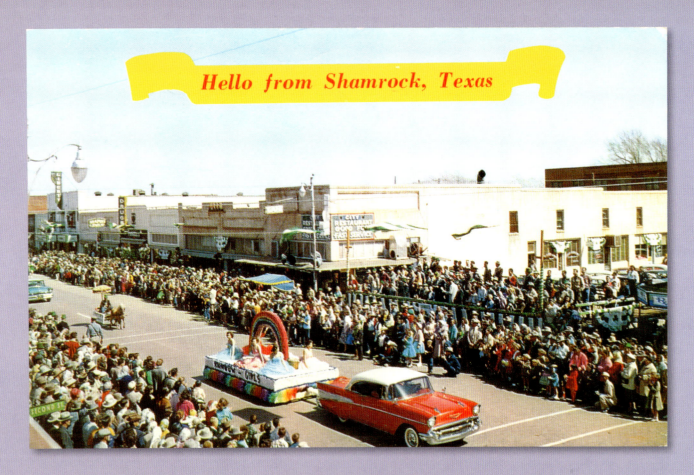

Shamrock is extremely proud of its Irish heritage, and in 1938 the town started the tradition of a big parade to celebrate St. Patrick's Day.

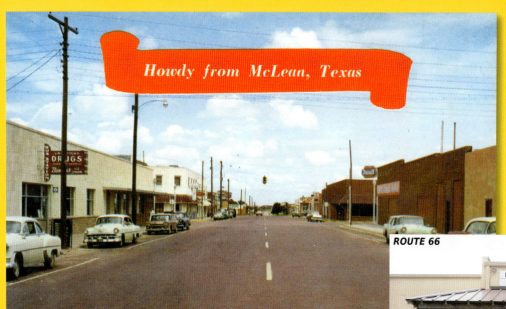

The owner of the massive R. O. Ranch, Alfred Rowe, donated the land for the town of McLean. He died aboard the Titanic while returning from a visit to his native England.

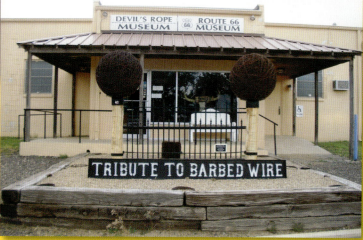

Two huge balls of barbed wire stand in front of the Devil's Rope and Route 66 Museum in McLean.

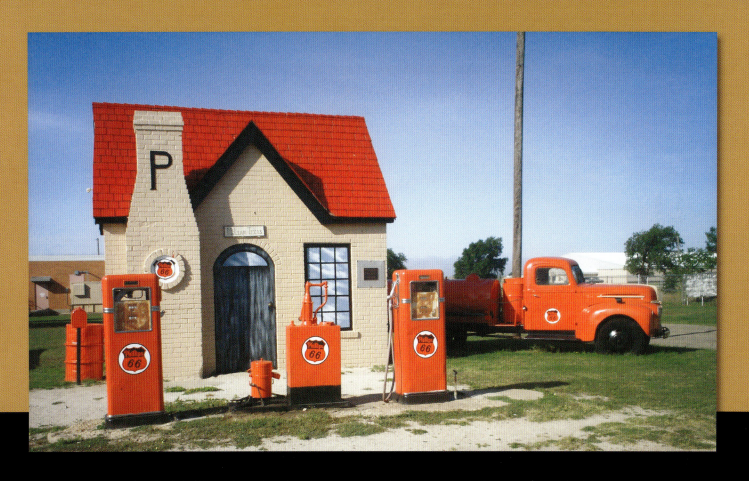

The first Phillips 66 station in Texas opened in McLean in 1929 and closed in 1977. The Old Route 66 Association of Texas restored the exterior in 1992.

The leaning water tower at Groom was built to promote Ralph Britten's Truck Stop, long ago closed.

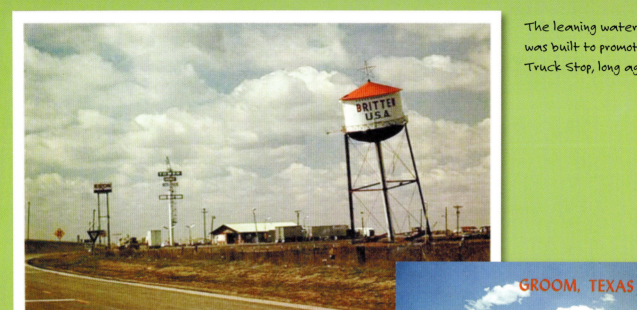

This motel was named the Golden Spread, a name sometimes used to describe the sunny climate and vast ranches of the Panhandle.

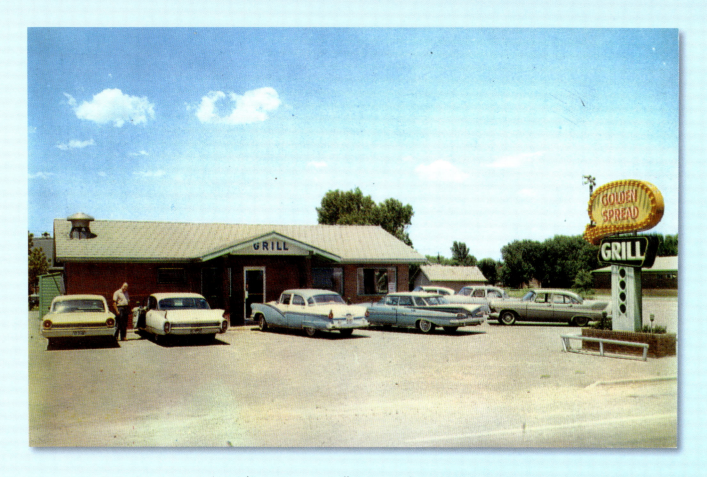

Ruby Denton ran the Golden Spread Grill in Groom from 1957 to 2002. The building became the Route 66 Steakhouse.

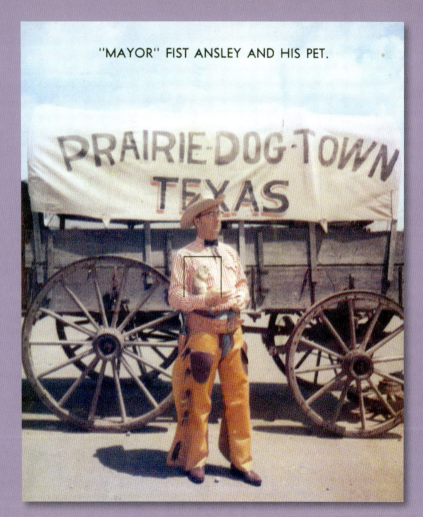

Forrest "Fist" Ansley's Prairie Dog Town, made up of tiny buildings and prairie dog burrows, was designed to draw tourists to his Amarillo curio shop.

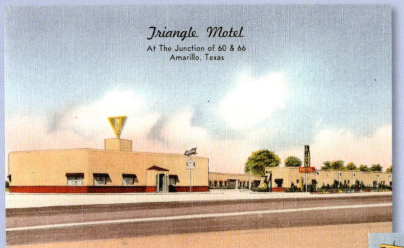

The intersection of U.S. Routes 66 and 60 formed a triangle, where former Borger, Texas, mayor S. M. Clayton built the Triangle Motel in 1946. It closed in 1977.

Modern accommodations were complimented with Pueblo architecture at the Pueblo Court.

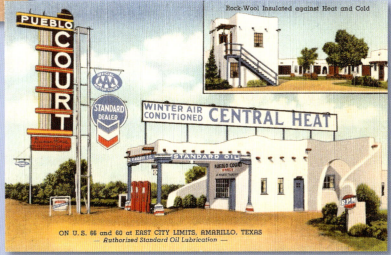

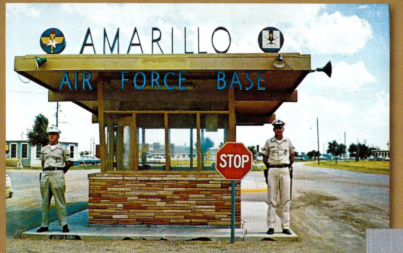

The Amarillo Army Airfield was established in 1942; it became the Amarillo Air Base in 1950 and closed in 1968.

James Bailey's Motel opened in 1952. It later became the Cactus Motel and developed into the Royal Inn.

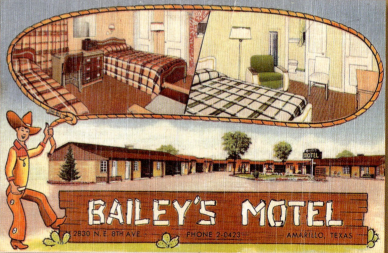

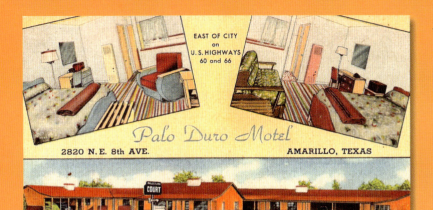

The Palo Duro Motel was one of several in Amarillo that opened in 1952. It was still in business in 2014.

The Silver Spur was one of several motels in Amarillo that made use of western imagery to draw customers. Its vintage sign still makes a nice photo op.

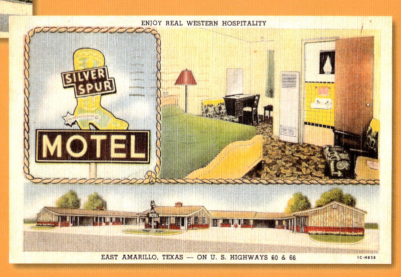

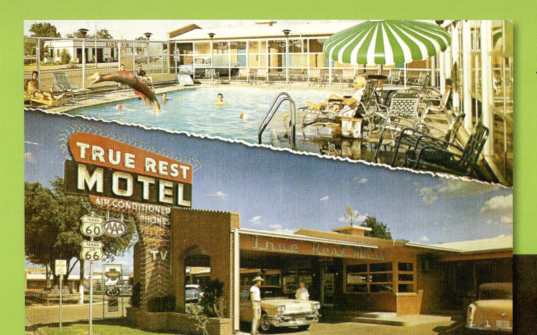

In 1954 the True Rest Motel was expanded and remodeled with a beautiful Spanish-ranch design.

A blaze of neon greeted weary travelers on Northeast 8th Avenue's "Motel Row." Eighth Avenue became Amarillo Boulevard in 1964.

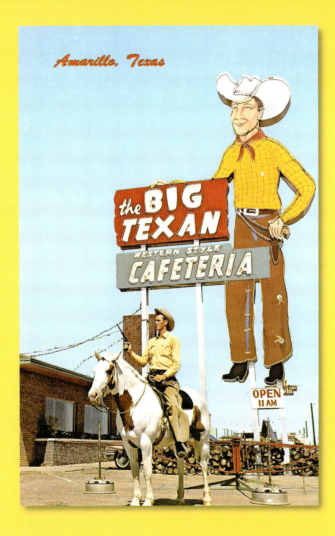

R. J. "Bob" Lee thought tourists needed a restaurant that epitomized the popular image of the West, so he opened the Big Texan in 1960.

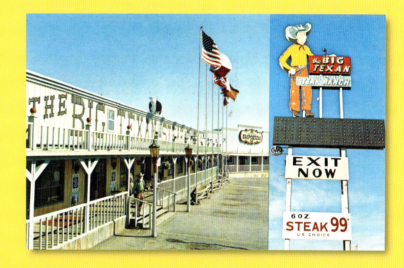

In 1962 Bob Lee began offering a 72-ounce steak dinner free to customers who could eat the whole thing, including sides, in one hour. The Big Texan moved to Interstate 40 in 1970 and remains a major Route 66 attraction.

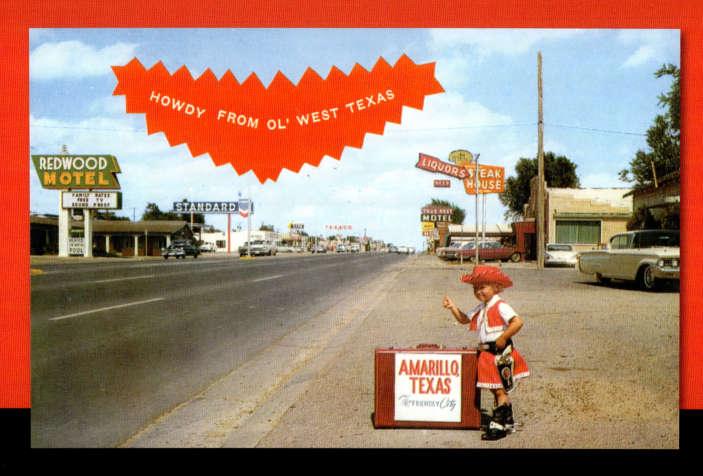

This little cowgirl posed at the intersection of 8th Avenue/Amarillo Boulevard and Fillmore Avenue, the busy junction of U. S. Highways 60, 66, 87, and 287.

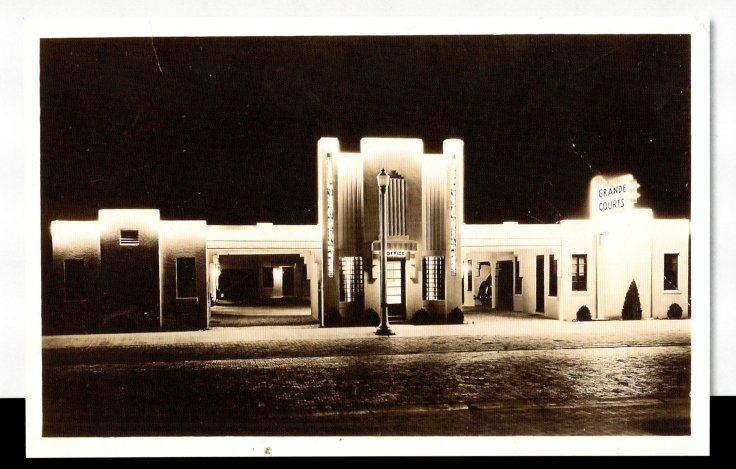

Don D. Parker opened the Grande Tourist Courts at 600 Northeast 8th Avenue in 1937.

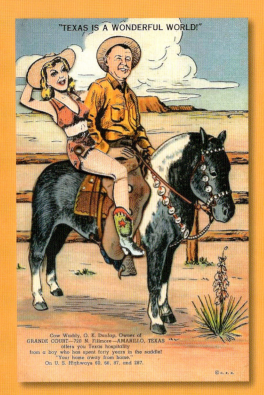

A real photo of Coe Dunlap on a horse was the basis for this rare, mechanical postcard in which the cowgirl swings her legs back and forth.

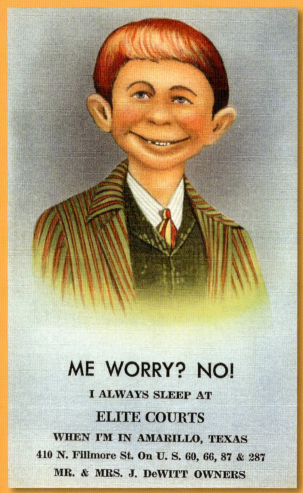

The Grande Tourist Courts issued several novelty postcards, including this one using a decades-old image that later became Mad magazine's fictitious mascot, Alfred E. Neuman.

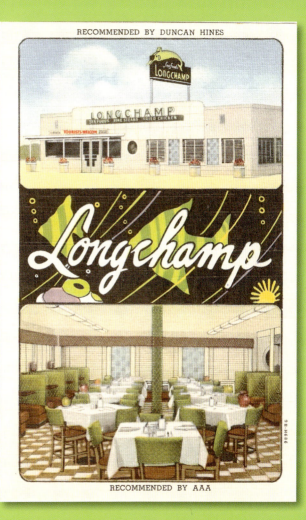

Harry Kindig converted an old gas station into the Long Champ Dining Salon in 1945. Kindig specialized in seafood but soon found out the locals preferred steak.

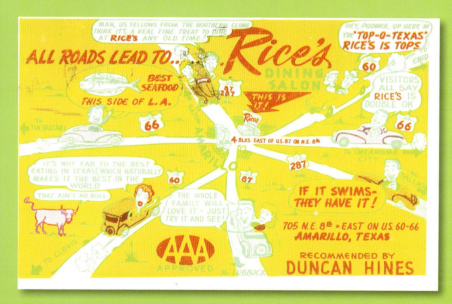

Homer and Auline Rice took over the Long Champ in 1947; it became Rice's Dining Salon in 1953.

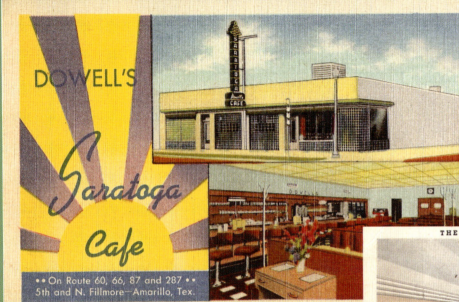

Bob Dowell was an avid booster of Route 66 and a pioneer in tourism research. He opened Saratoga Café Number 2 in Amarillo in 1948 with his brother Elmer.

Owners Tillman and Mickey McCafferty are at left in this view of the Aristocrat Cafe. It was in operation from 1945 to 1957.

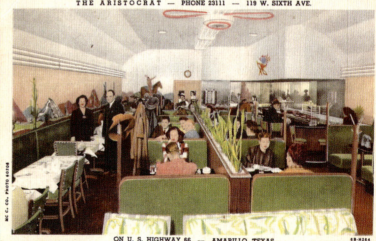

Santa Fe Building and Polk Street, Amarillo, Texas

The Santa Fe Railway's General Office Building opened in 1930, and it is now home to Potter County government offices.

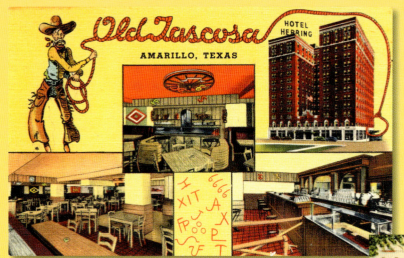

Cattle and oil barons made multimillion dollar deals in the Old Tascosa nightclub in the basement of the Hotel Herring.

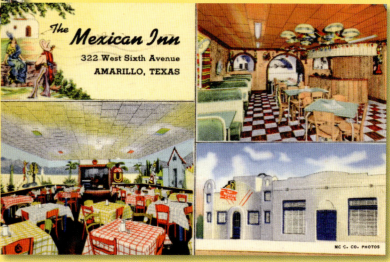

Original Route 66 turned south at Fillmore to West 6th, Bushland, and West 9th. West 6th Avenue, once home to the Mexican Inn, is now lined with historic buildings.

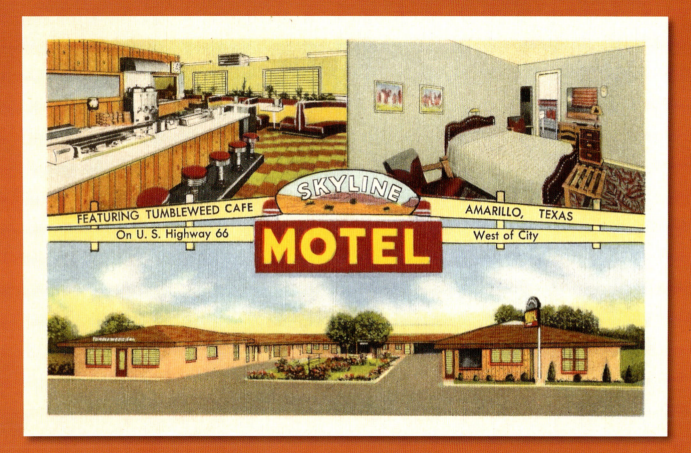

The Skyline Motel opened after Route 66 was moved to a westward extension of 8th Avenue in 1953.

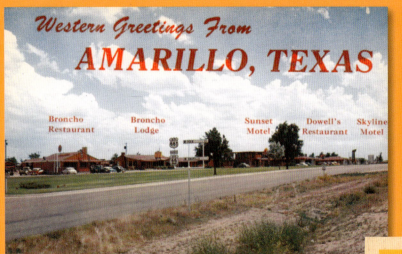

A string of motels and restaurants surrounded the traffic circle where original Business 66 met the 1953 route west over 8th Avenue.

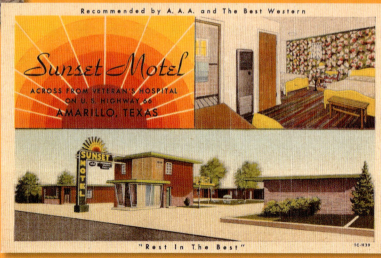

The Sunset Motel was also located on the circle and later became the Astro Motel.

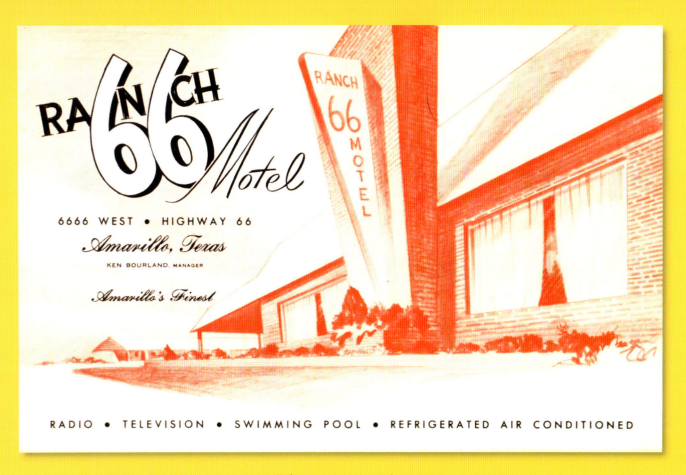

Ken Bourland operated Amarillo's Ranch 66 Motel, which had the appropriate address of 6666 West 66. Steve Rider collection

The Cadillac Ranch was created by a trio of artists for an eccentric millionaire in 1974.

Vega, meaning "grassy meadow" in Spanish, was settled in 1899 and became the Oldham County Seat in 1915.

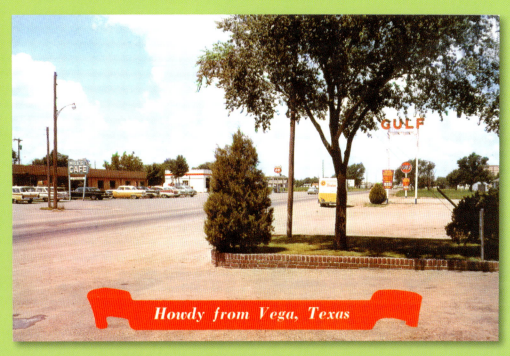

Looking west on Route 66 in Vega, Hill's Café is at left. Orville Henry Groneman operated the Gulf Station at right.

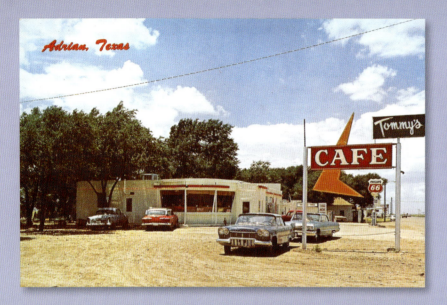

Bob Harris used surplus from a control tower for his new café in Adrian in 1947. It later became Tommy's, but is better known as the Bent Door.

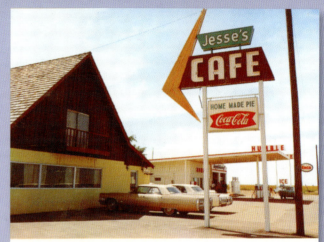

JESSE'S CAFE ADRIAN, TEXAS DUB'S ENCO SERVICE

Adrian is proud of its status as the "Geo-mathematical Center of Route 66." Jesse's eventually became the Midpoint Cafe.

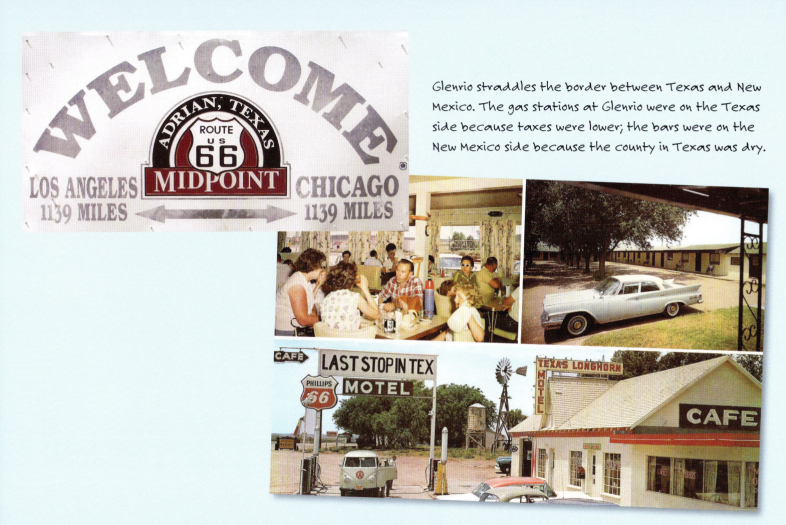

Glenrio straddles the border between Texas and New Mexico. The gas stations at Glenrio were on the Texas side because taxes were lower; the bars were on the New Mexico side because the county in Texas was dry.

CHAPTER 6

NEW MEXICO

ROUTE 66 ACROSS THE "LAND OF ENCHANTMENT," presents an amazing variety of culture, history, and scenery. Parts of the route follow the Old Santa Fe Trail and the El Camino Real, "the Royal Road," the oldest road in America.

The route originally turned north past Santa Rosa to Romeroville. It then meandered into Santa Fe and dropped south, entering Albuquerque on 4th Street and finally turning west at Los Lunas. La Bajada Mesa was the most feared part of the old route between Santa Fe and Albuquerque, dropping 800 feet in 1.6 miles with twenty-three hairpin switchback curves. The highway was rerouted around La Bajada (Spanish for "the descent") in 1932.

Arthur T. Hannett lost his bid for reelection as governor in 1925. Hannett, partly for revenge, ordered construction of a highway between Santa Rosa and Albuquerque, bypassing the state capital. It opened just hours before the new governor was sworn in. The new highway, known as "Hannett's Joke," became Route 66 in 1937. It cut the distance across New Mexico from 509 to 399 miles and entered Albuquerque on Central Avenue. Route 66 through the Nob Hill neighborhood is now a trendy mix of the old and new, and Albuquerque's Old Town has old-world charm with ten blocks of historic adobe buildings.

After climbing Nine Mile Hill, the highway heads for the picturesque Laguna Pueblo. The "Sky City," Acoma Pueblo, is just to the south. It is the oldest, continuously inhabited community in the United States, dating back to about 1075 A.D. Farther on Route 66 curves around the black lava fields called El Malpais, or "badlands," near Grants.

There were numerous trading posts, animal attractions, snake pits, and tourist traps between Albuquerque and Gallup, some of which fleeced tourists with fake ruins and rigged games of chance. Some of the most rowdy spots were atop the Continental Divide.

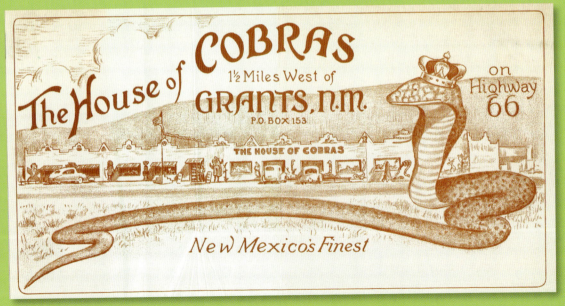

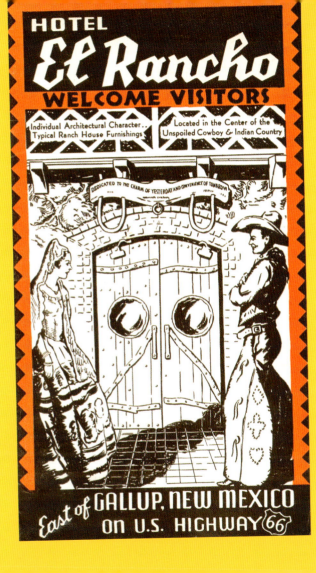

Gallup is the "Indian Capital." El Rancho Hotel, "The World's Largest Ranch House," served as the headquarters for many movie stars who filmed Westerns in the area in the 1930s and 1940s. The hotel still offers the "charm of yesterday with the convenience of tomorrow."

Route 66 clings to the side of Devil's Cliff near Manuelito, offering spectacular views of the area. At the Arizona line a huge metal arch once spanned the highway and invited travelers to come again. It's just a memory now, as it was obliterated by the interstate.

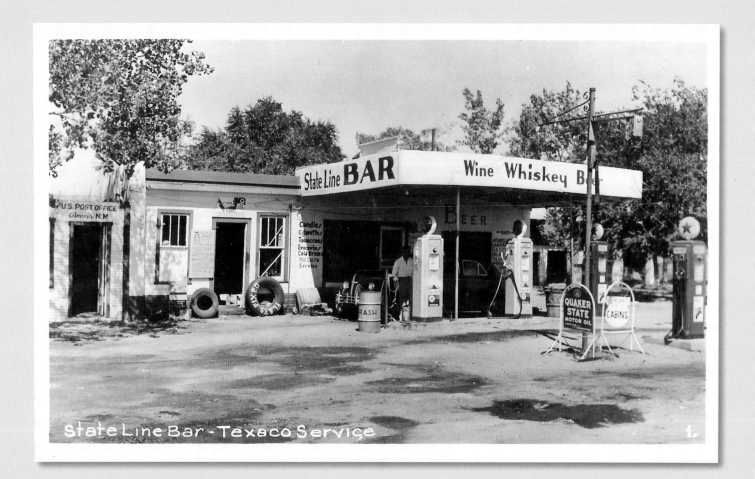

Homer and Margaret Ehresman operated the State Line Bar at Glenrio.

W. A. Huggins constructed the Blue Swallow Court in 1939, but Mr. and Mrs. Ted Jones owned it when this view was made.

Lillian Redman was gifted the Blue Swallow in 1958, and she made it a Route 66 icon.

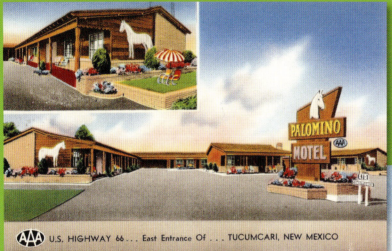

Red billboards announced TUCUMCARI TONITE!, promoting the town with "2,000 motel rooms," including those at the Palomino Motel.

The Tocom-Kari Court promoted the concocted legend of the origin of the name "Tucumcari" as the sad tale of doomed Native American lovers named Tokom and Kari.

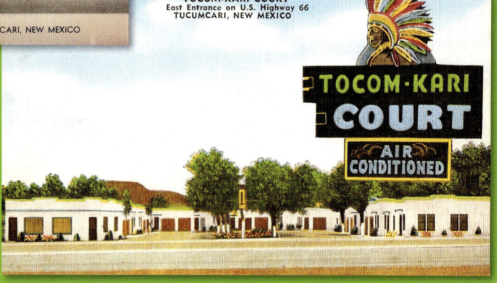

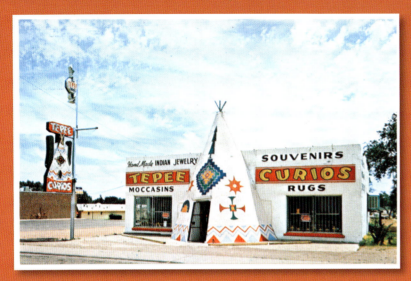

Tepee Curios, opened in 1944, was originally a gas station and curio shop.

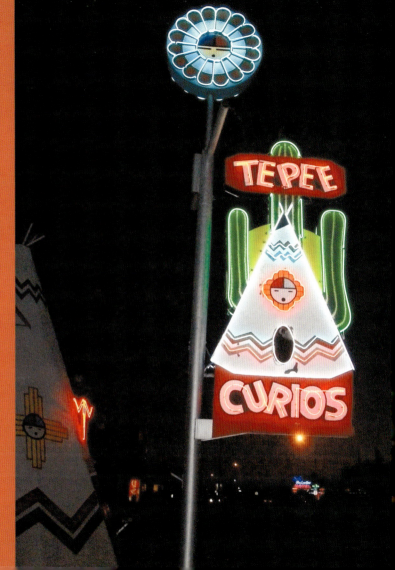

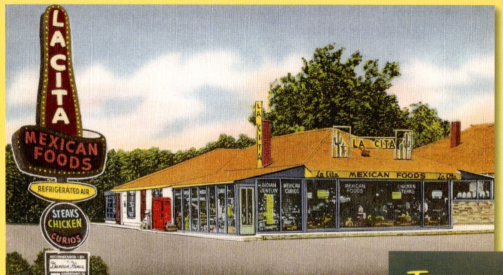

La Cita opened on Route 66 in 1940, but it relocated across the highway in 1961.

Brightly lit motels, service stations, and restaurants lined Route 66 through Tucumcari in the early 1960s.

Tucumcari Mountain probably took its name from the Comanche tukamukaru, meaning "to lie in wait." The Comanche used it as a lookout.

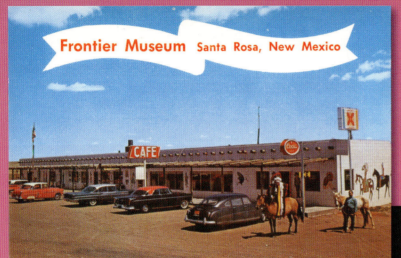

Only ruins remain at the site of the Frontier Museum, between Tucumcari and Santa Rosa.

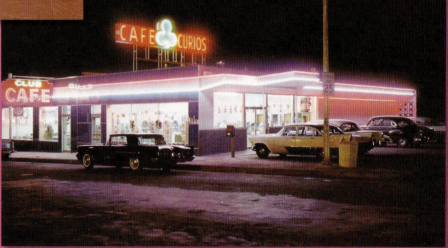

The Club Café in Santa Rosa was known for its billboards featuring a smiling fat man. It closed in 1992.

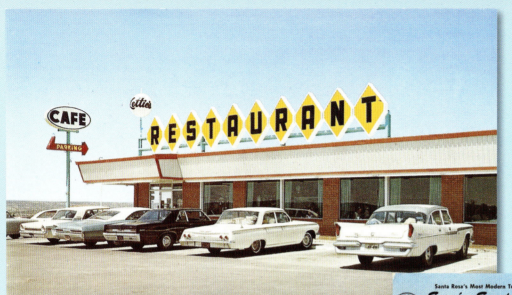

There were once more than sixty gas stations, twenty motels, and fifteen restaurants in Santa Rosa, including Lettie's, which still offers breathtaking views of the valley.

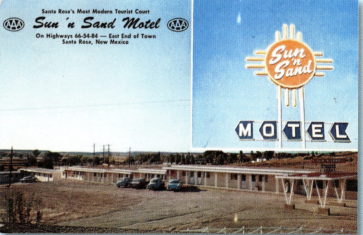

The sign at the Sun 'n Sand Motel features the symbol of the Zia Pueblo Indians: a circle with four points radiating from it, signifying life.

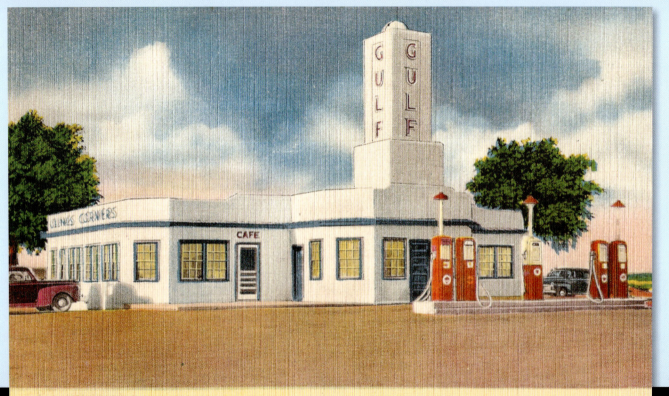

Clines Corners on Highway 66, New Mexico

In 1934 Roy Cline moved his gas station to the new alignment of Route 66 at U.S. Route 285. Cline convinced Rand McNally to put Clines Corners on their maps.

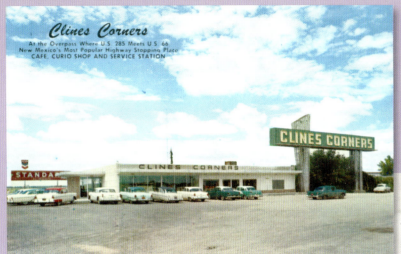

Roy Cline sold the business in 1939, but the name has stayed the same and it remains a popular stop on Interstate 40.

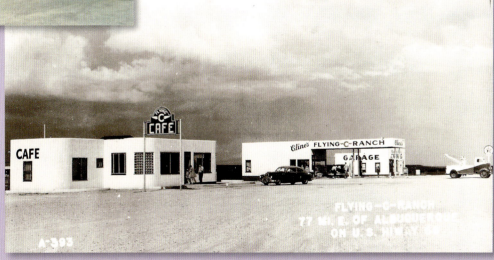

After selling Clines Corners, Roy Cline opened the Flying-C-Ranch.

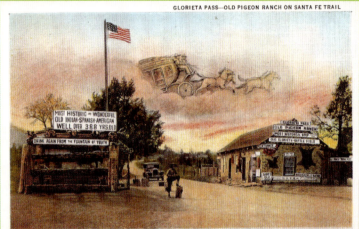

The Pigeon Ranch, once a stage stop on the Santa Fe Trail and a hospital during the Civil War, was made a tourist attraction by Thomas Greer. The building and well remain.

Route 66 passed through Santa Fe until Governor Arthur Hannett lost his bid for reelection. He ordered a new highway bypassing the capital, which became Route 66 in 1937.

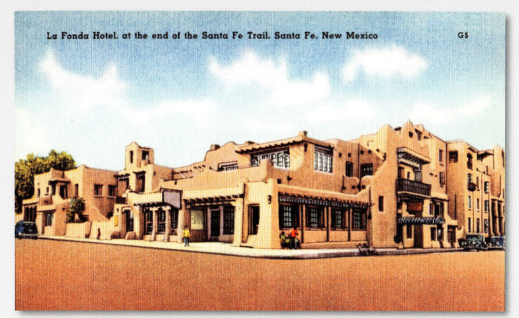

An inn, or fonda, has occupied the southeast corner of the plaza in Santa Fe since 1610. The current La Fonda was built in 1922 and was one of the famous Harvey Houses.

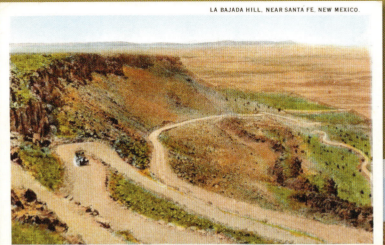

The route over La Bajada Mesa (Spanish for "the descent") drops 800 feet in 1.6 miles with twenty-three switchbacks. La Bajada was bypassed in 1932.

Original Route 66 passed through the "The Big Cut," between Santa Fe and Albuquerque. It was considered an engineering marvel when it was dug out in 1909.

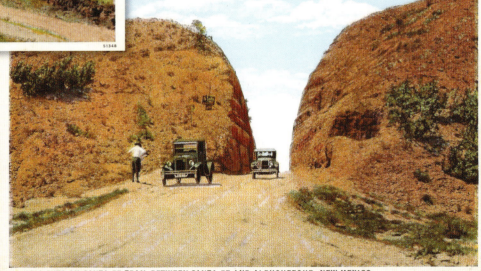

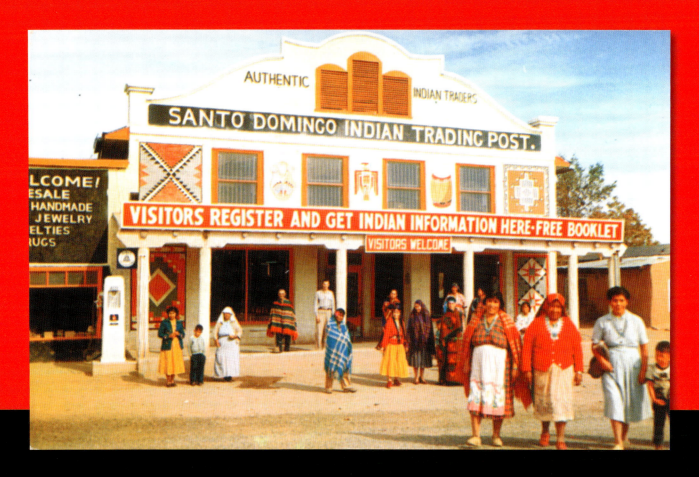

The Santo Domingo Trading Post opened in 1881; it burned in February 2001, but restoration began in 2012.

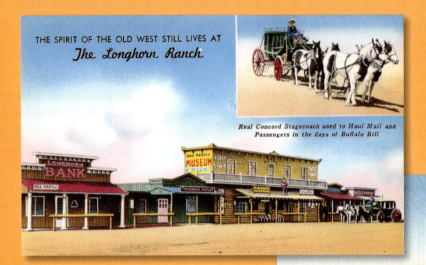

The Longhorn Ranch gave tourists the Hollywood version of the old west, complete with a saloon, Native American dances, and rides in a vintage stagecoach. It closed in 1977.

Hubert "Blackie" Ingram's personality made his place in Moriarty a landmark.

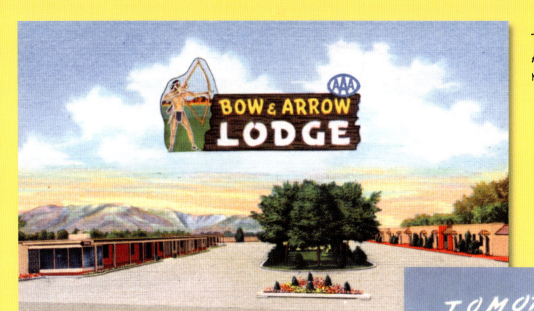

The Bow and Arrow Lodge in Albuquerque, originally the Urban Motor Lodge, opened in 1941.

David Betten opened El Jardin Lodge in 1946 and advertised it as "Tomorrow's Hotel Today."

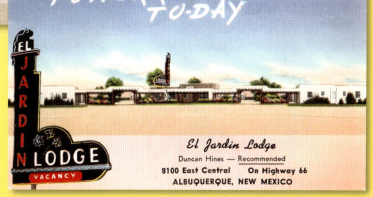

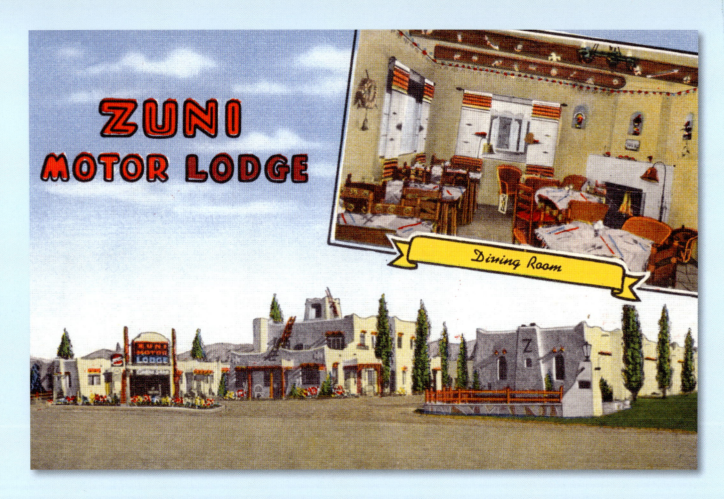

The Zuni Motor Lodge made good use of a regional theme to attract tourists.

The Pueblo-style Tewa Lodge opened in 1949 and is still in business today.

TEWA LODGE — ALBUQUERQUE, N. MEX.

The Iceberg Café and station enticed customers to stop with its unique design. It was originally a frozen custard stand at 3015 Central, but it moved to this location in 1936.

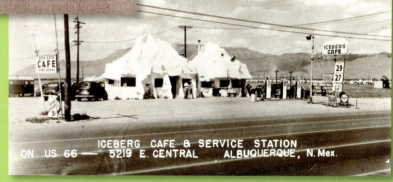

ICEBERG CAFE & SERVICE STATION
ON US 66 — 5219 E. CENTRAL ALBUQUERQUE, N. Mex.

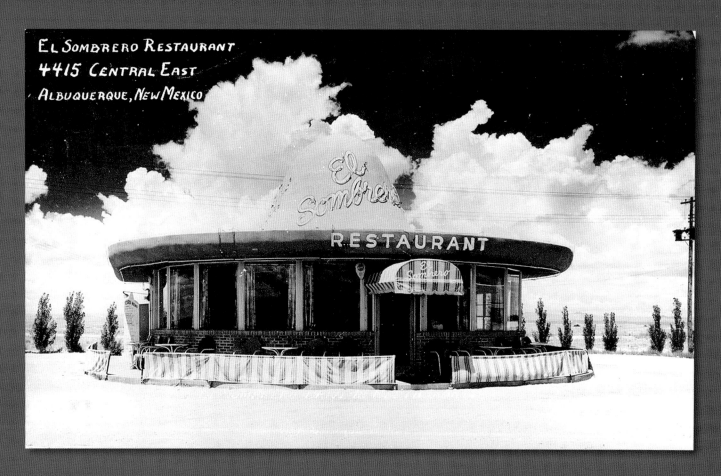

Another example of roadside architecture reflecting the business's offerings, El Sombrero was in operation from 1949 to 1958.

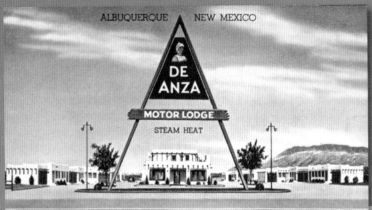

The De Anza Motor Lodge was built by Zuni trader Charles Garrett Wallace and S. D. Hambaugh in 1939. It features unique murals by a Zuni artist and is awaiting restoration.

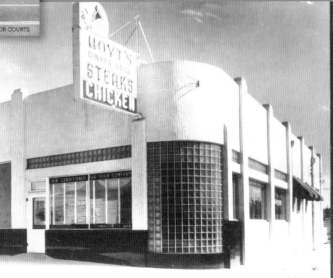

Gwynn and Claudine Hoyt opened the Dinner Bell in 1943.

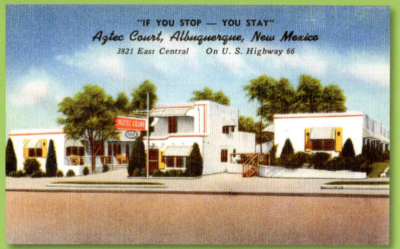

The Aztec opened in 1931, and it was the oldest, continuously operated motor court on Route 66 in New Mexico.

Charley's Pig Stand moved to this building in 1935. Several businesses have occupied it since Charley's closed in 1954, but the calf and pig images are still visible on the façade.

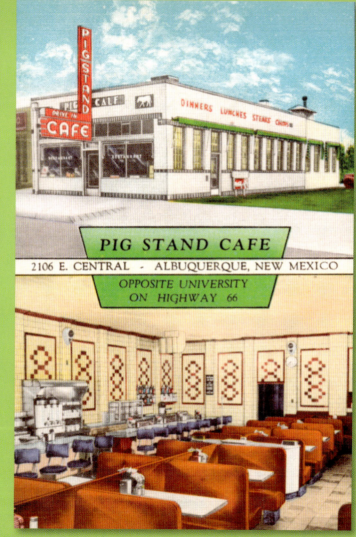

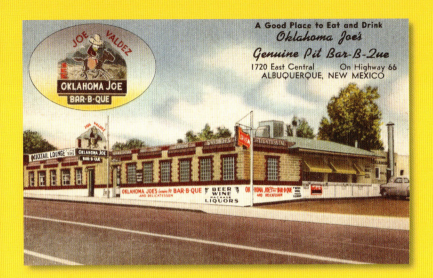

Joe Feinsilver ran Oklahoma Joe's from 1941 until 1956, and it eventually became a University of New Mexico student hangout known as Okie's.

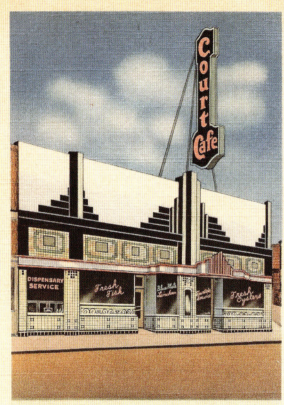

Bob Katson opened the Court Café in 1925, and the black carrera glass façade was added in 1935. The building has housed a series of bars but still stands.

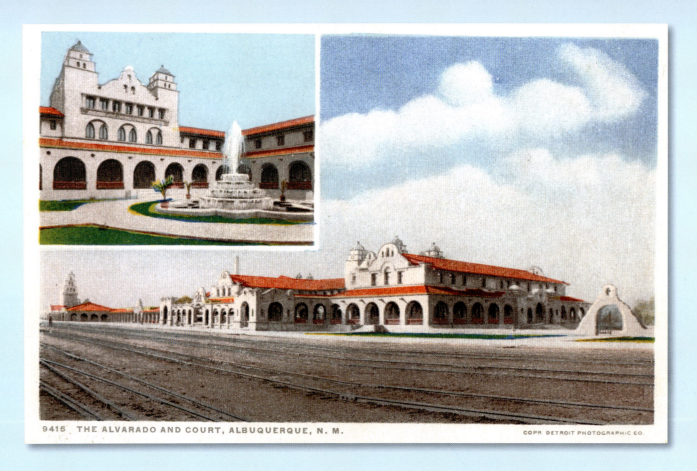

9415 THE ALVARADO AND COURT, ALBUQUERQUE, N. M. COPR. DETROIT PHOTOGRAPHIC CO.

The Fred Harvey Alvarado Hotel, noted for its California mission-style architecture, opened in 1902 and was a jewel in the Harvey line of hotels.

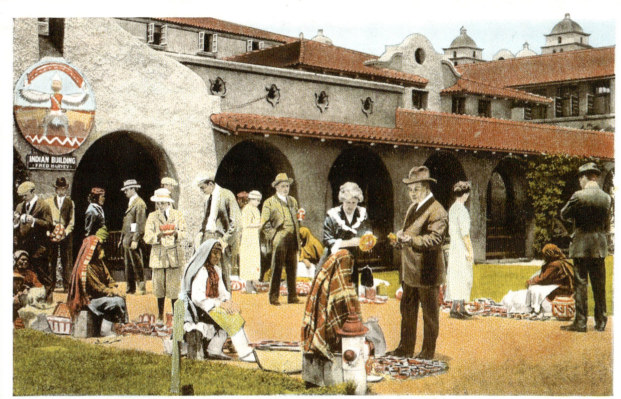

Amazing Native American art was sold to tourists at the Fred Harvey Indian Building that adjoined the Alvarado Hotel.

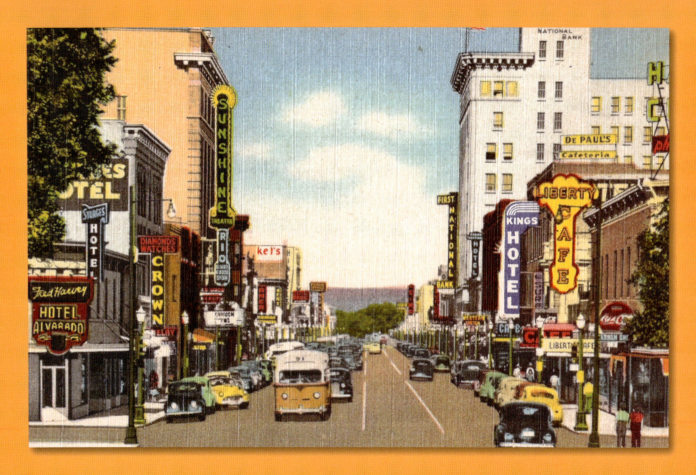

Looking west on Central Avenue from the Santa Fe railroad overpass, notable stops in Albuquerque included the Liberty Café and Sunshine Theatre.

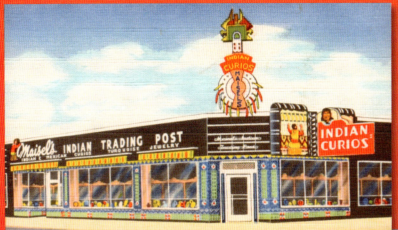

Morris Maisel's Indian Trading Post opened in 1923 across from the Alvarado Hotel.

The Kimo Theatre opened in 1927 and closed in 1968. The name is Tewa and is loosely translated as "king of its kind."

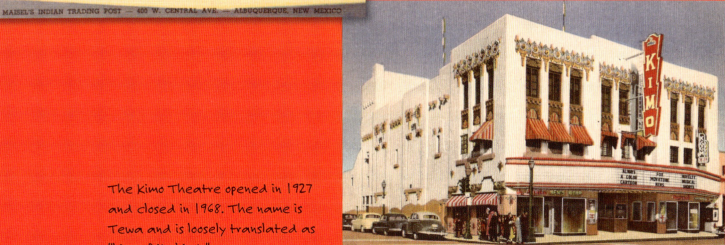

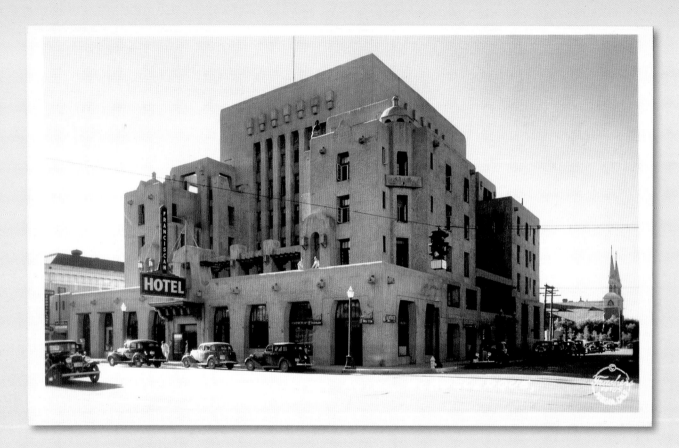

The Franciscan Hotel, a Pueblo "expressionist" building at Central Avenue and 6th Street, opened in 1923 and closed in 1970. It was financed and built by the people of Albuquerque.

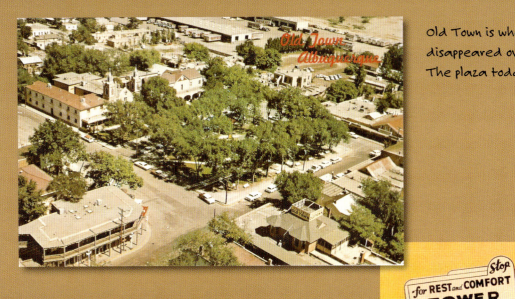

Old Town is where Villa de Alburquerque (the extra "r" disappeared over the years) was established in 1706. The plaza today houses shops and restaurants.

Ben F. Shear constructed the modern Tower Court in 1939. A 30-foot, stepped tower served as the office for the motel.

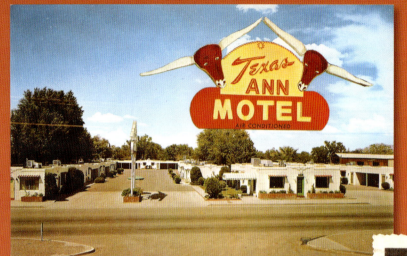

The Texas Ann Motel was featured in a 1955 episode of I Love Lucy, which co-starred Vivian Vance of Albuquerque.

Bob Katson, owner of the Court Café (page 197), opened Katson's Drive-In in May 1940. It closed in September 1942 due to wartime shortages.

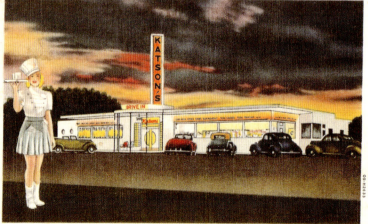

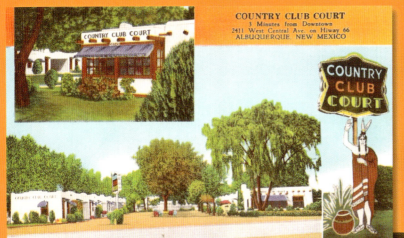

The Country Club Court, built in 1937, later became the Prince Motel, the Relax Motel, and the 21 Motel.

Dan Murphy built El Vado Court in 1936, and today the property awaits redevelopment.

Leaving Albuquerque headed west Route 66 climbs Nine Mile Hill. Night travelers headed east can top the hill and see the spectacular lights of the city spread below.

There were several classic trading posts west of Albuquerque, including the Hill Top, Tomahawk, and Rio Puerco.

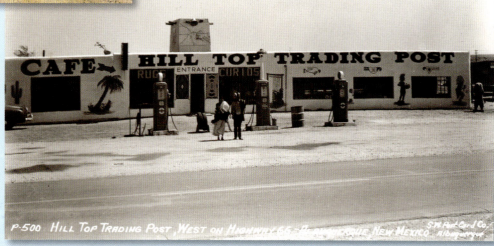

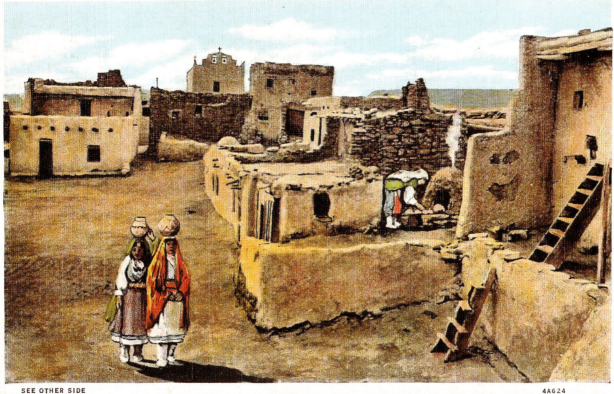

Route 66 cuts through the Laguna Pueblo lands. The mission at the Old Pueblo of Laguna dates to 1699.

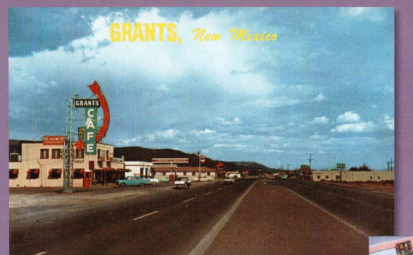

Grants was originally a railroad camp, established by brothers Angus, Lewis, and John Grant. The discovery of uranium nearby in 1950 launched a twenty-year boom.

The Franciscan Lodge in Grants opened in 1950 and is still there.

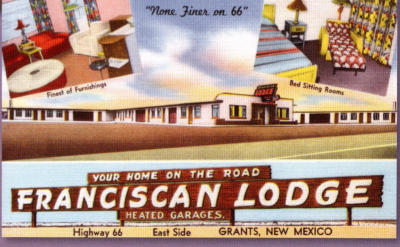

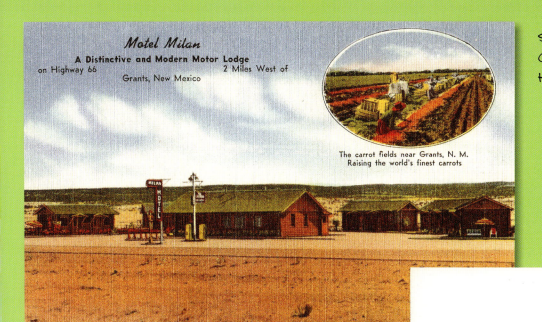

Salvador Milan opened his motel in Grants in 1946. Note the inset showing the famous carrot fields of the area.

Herman Atkinson's Lost Canyon Trading Post, one of several between Grants and Gallup, lured tourists in with the snake-filled "Den of Death."

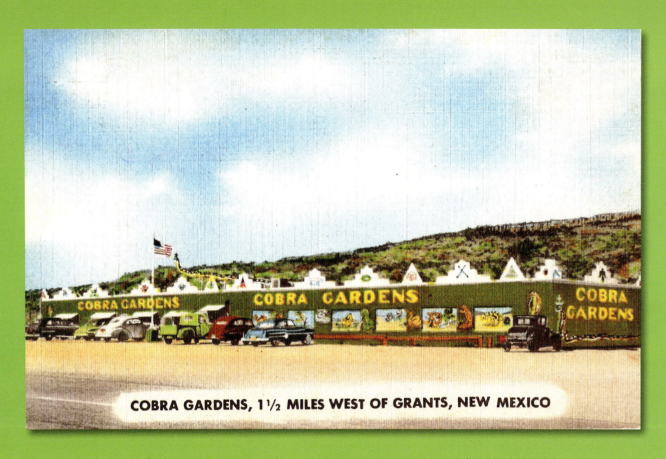

COBRA GARDENS, 1½ MILES WEST OF GRANTS, NEW MEXICO

The snakes proved to be such an attraction that Herman Atkinson turned his trading post into Cobra Gardens, with the largest collection of cobras in the United States.

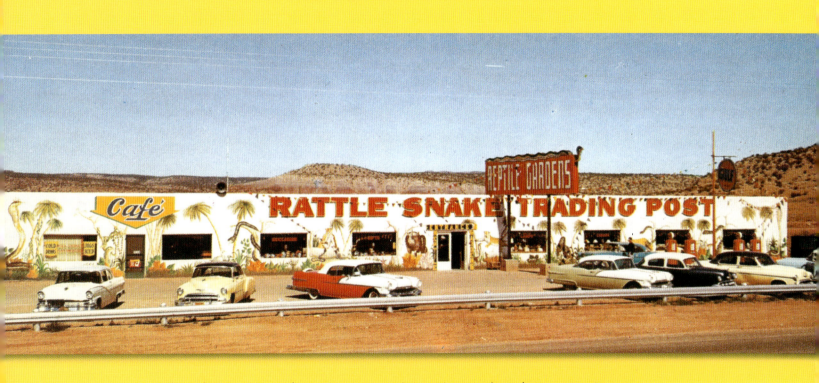

Jake Atkinson, Herman's brother (opposite), ran the Rattlesnake Trading Post. It beckoned tourists with a fake, "giant prehistoric reptile" made of cow vertebrae and plaster.

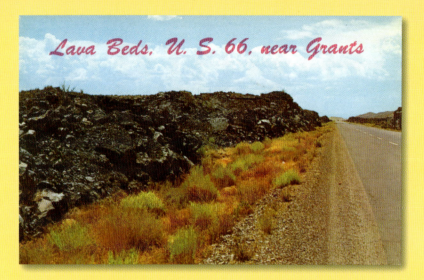

West of Grants Route 66 twists and turns through the lava beds known as "El Malpais."

Johnnie Maich opened his café at Thoreau (pronounced "threw") in 1927. It became part of Johnnie's Inn and the Red Mountain Market and Deli.

JOHNNIES CAFE, THOREAU, N. MEX.

GOOD EATS

Reasonable Prices Tourist Headquarters

U. S. HIGHWAY 66

Mileage from Johnnies Cafe

WEST TO		EAST TO	
Continental Divide	5	Grants	31
Gallup, N. Mexico	32	Laguna	65
Painted Desert	106	Los Lunas	116
Petrified Forest	118	Albuquerque	139
Holbrook, Ariz.	134	Domingo	176
Winslow	167	Santa Fe	203
Flagstaff	230	Las Vegas	277
Maine	250	Trinidad, Colo.	418
Grand Canyon	315	**NORTH TO**	
Williams	266	Crown Point	28
Needles, Cal.	470	Chaco Canyon	60
Los Angeles	770	**SOUTH TO**	
		Albuquerque	139
		El Paso	444

212

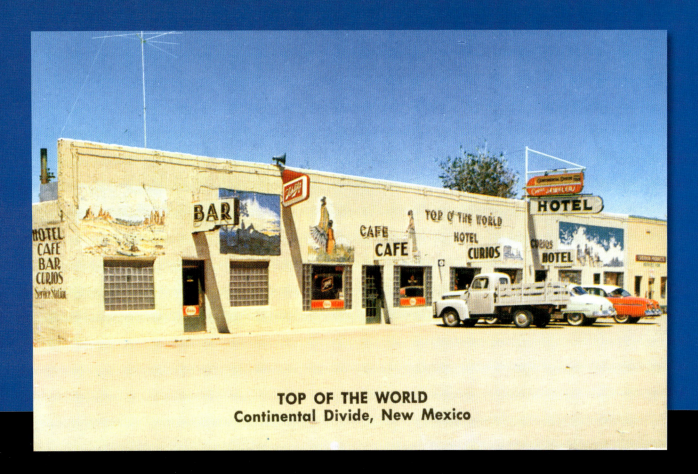

Some businesses at the Continental Divide fleeced tourists with rigged games of chance. The area was known for transients, bar brawls, and prostitution.

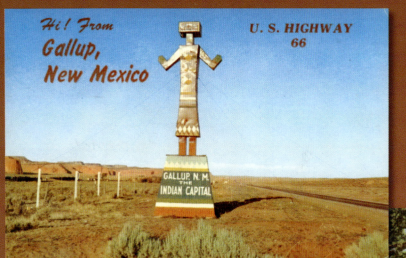

This oversize kachina on Route 66 marked the eastern entrance to Gallup, "The Indian Capital of the World."

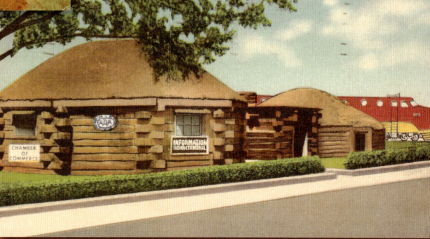

The local Chamber of Commerce at Gallup was housed in replica Navajo hogans.

Casa Linda Court opened in 1937 and was operated by Evelyn and John Simm for more than twenty years.

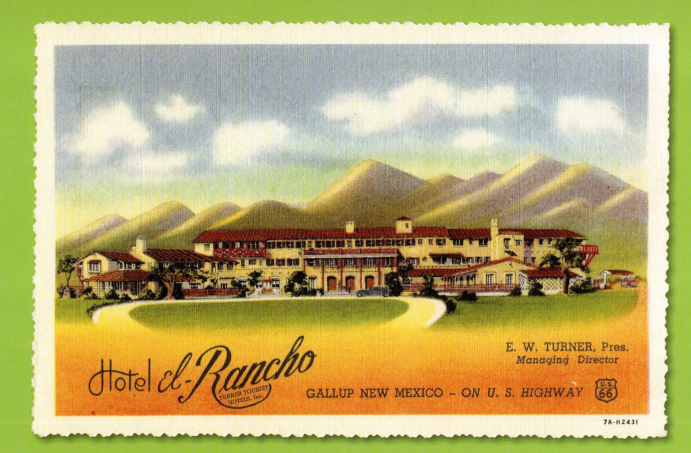

El Rancho, "The World's Largest Ranch House," was the headquarters for eighteen movies. It still retains its old west charm.

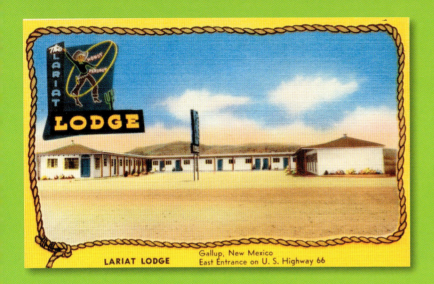

The original Lariat Lodge sign, with the cowboy and his lasso, was replaced in the 1950s. The second neon sign is still one of the coolest in Gallup.

The Avalon Café in Gallup opened in 1945 and it eventually became the Avalon Restaurant.

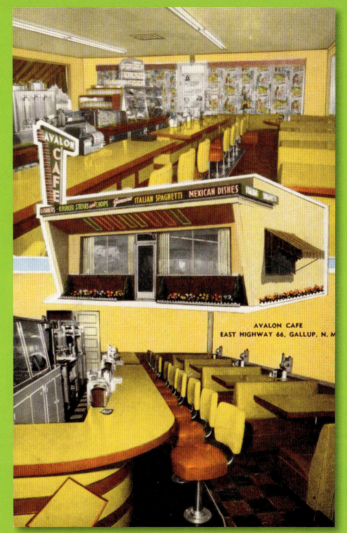

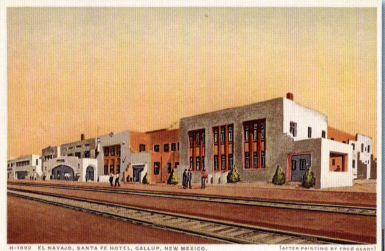

H-1892 EL NAVAJO, SANTA FE HOTEL, GALLUP, NEW MEXICO. (AFTER PAINTING BY FRED GEARY)

A spectacular blend of modern architecture and Native American culture, the Fred Harvey El Navajo Hotel was open from 1923 to 1957.

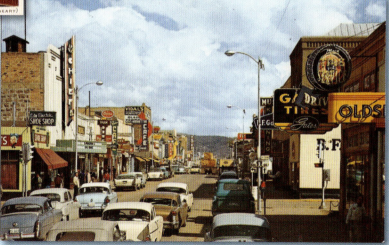

Gallup was named for railroad paymaster David Gallup. Workers would "go to Gallup" for their pay. This view looks east at the junction with U.S. Route 666 (now U.S. Route 491).

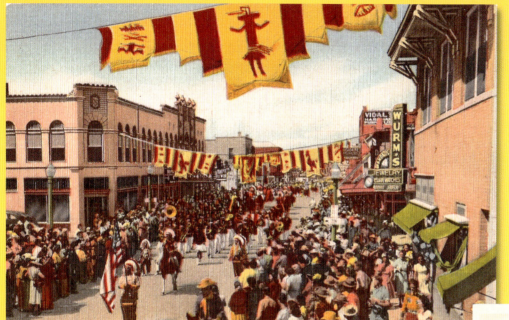

The annual Inter-Tribal Indian Ceremonial has been a major attraction in Gallup since 1922.

Jimmy Blatsios constructed the Heller Building for his White Café in 1929. The landmark now houses a Native American jewelry store and art gallery.

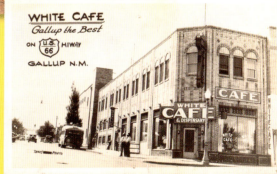

The Shalimar Hotel opened in April 1960 and was originally owned by Spencer Moss. It closed in 2001 and was torn down in 2006.

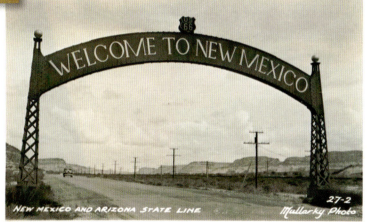

This arch stood at the Arizona/New Mexico state line but was demolished for the construction of I-40.

CHAPTER 7

ARIZONA

ROUTE 66 IN ARIZONA links well-known natural attractions such as the Grand Canyon, the Petrified Forest, the Painted Desert, and Meteor Crater. In 1857 Lieutenant Edward F. Beale surveyed a wagon road with the help of twenty-three camels. The Santa Fe Railroad followed Beale's road, and the Fred Harvey Company constructed lavish Harvey Houses along the line.

Colorful trading posts offering Native American jewelry, petrified wood, and curios could be found along Route 66, and they are still available here today. The route was also lined with billboards featuring shapely cowgirls, jackrabbits, and promises of killer snakes.

Travelers can still sleep in a concrete teepee at the Wigwam Motel in Holbrook, see the world's largest petrified log at the Geronimo Trading post, or sit atop a giant jackrabbit at the Jack Rabbit Trading Post in Joseph City. Standin' on the Corner Park in Winslow commemorates the classic Eagles song "Take It Easy."

Only ghostly ruins remain where Two Guns once offered a roadside zoo and the infamous Apache Death Cave. Beneath the San Francisco Peaks, Flagstaff has many cafes and interesting shops.

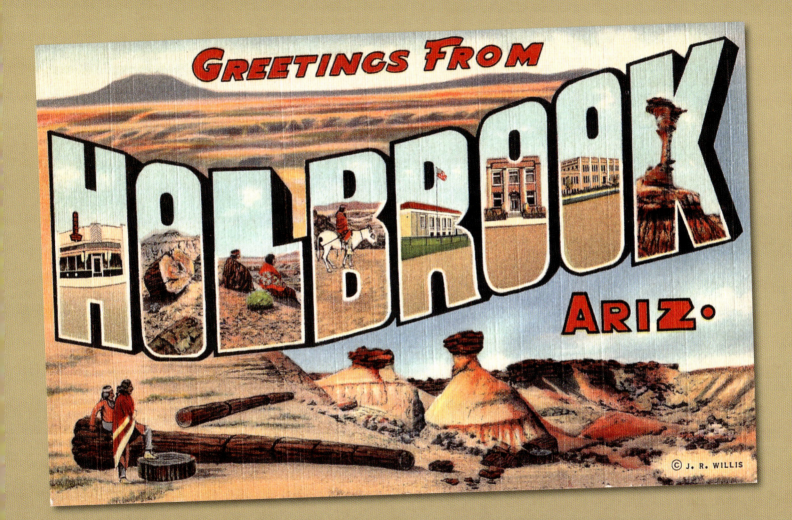

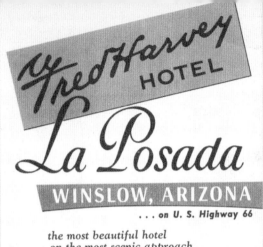

Williams was the last community on Route 66 to be bypassed, the occasion marked with a bittersweet ceremony on October 13, 1984. Williams still offers plenty of Route 66 nostalgia, as well as train trips to the Grand Canyon.

The Delgadillo's Snow Cap Drive-In, Angel and Vilma Delgadillo's Route 66 Gift Shop and Visitor Center, and Historic Seligman Sundries are quirky stops in Seligman, the town that inspired the fictional Radiator Springs in the movie *Cars*. Seligman is part of a 159-mile-long stretch of original Route 66, past Grand Canyon Caverns and into Kingman. The old powerhouse in Kingman houses a Route 66 museum and the town is the gateway to Hoover Dam.

Exit 44 on Interstate 40 marks the start of a breathtaking run with hairpin curves and steep grades over the Black Mountains, where the classic Cool Springs Camp has been restored. The road then plunges sharply past the ghost town of Goldroads and into Oatman, an old mining town where burros roam the street seeking handouts and leaving their calling cards on the sidewalks. Shops, cafes, and staged Wild West gunfights cater to tourists.

Route 66 continues through the harsh desert to the Colorado River. For Dust Bowl refugees, such as the fictional Joad family in *The Grapes of Wrath*, it was their first look at the promised land of California. But a long drive through the lonesome desert was still ahead. In the novel Tom Joad declared, "Never seen such tough mountains. This here's a murder country. This here's the bones of a country."

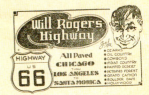
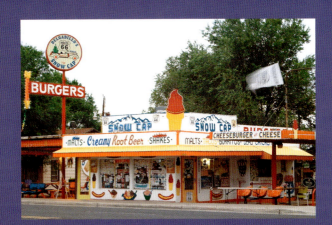
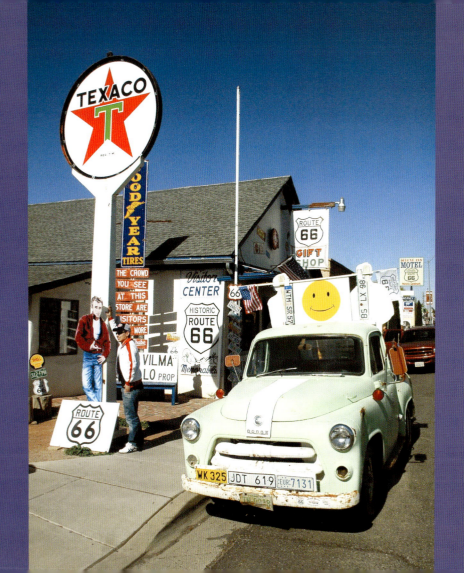

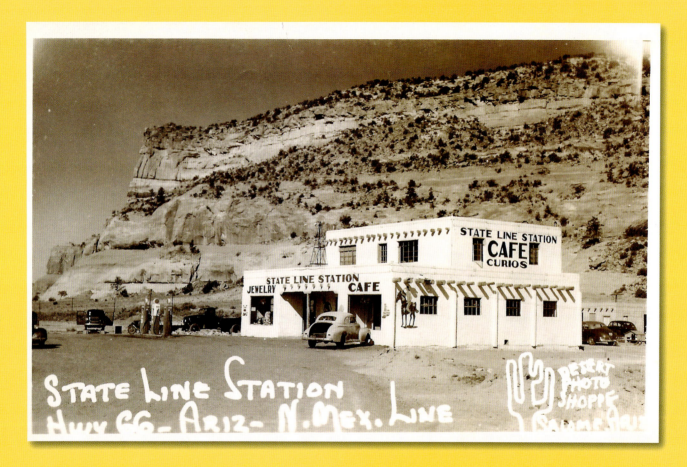

The State Line Station trading post was opened by Jake and Leroy Atkinson in 1940 and was right on the Arizona/New Mexico state line.

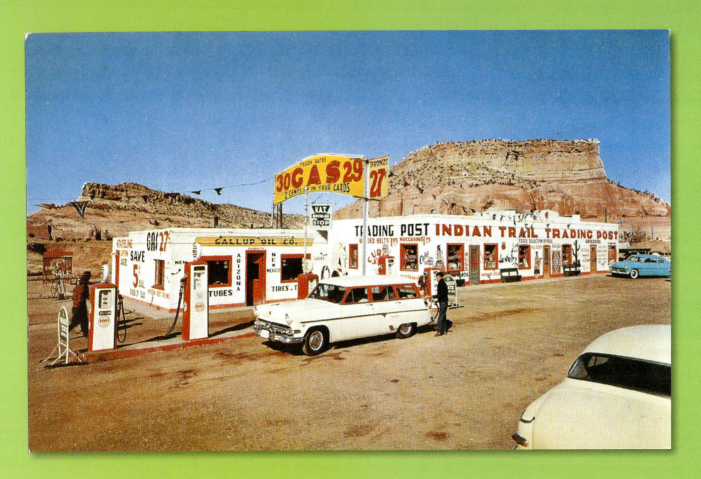

Max and Amelia Ortega opened the Indian Trail Trading Post at Lupton in 1946. Only the abandoned station remains today.

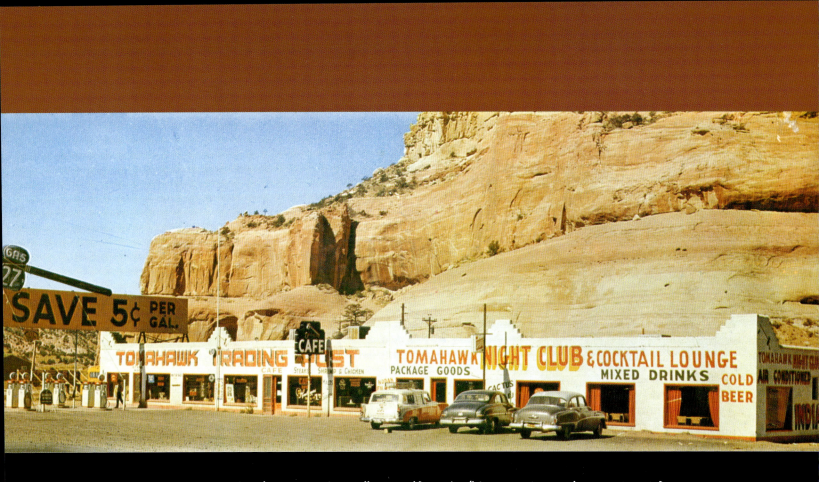

The Tomahawk Trading Post billed itself as the "First stop in and last stop out of Arizona," and the "most complete comfort stop on Highway 66."

The Navapache Café was mentioned in Jack Rittenhouse's Guidebook to Route 66 as a "town" consisting of a tourist court, gas station, garage, and store.

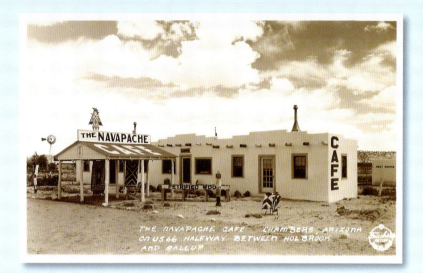

This is the rarest and most desirable Route 66 postcard, from the Painted Desert Trading Post. It closed in 1956, and only lonely ruins remain today. Steve Rider collection

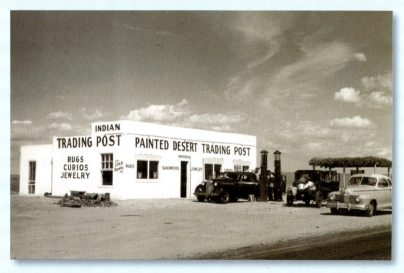

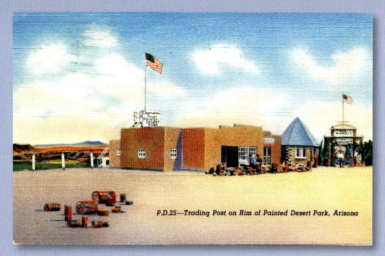

P.D.25—Trading Post on Rim of Painted Desert Park, Arizona

Julia Grant Miller's Painted Desert Park was considered an eyesore by government officials. It offered a spectacular view.

Hopi Indians (Orlin and Zellah) on the Edge of Painted Desert

Bands of colored sediments and clay in the Chinle Formation were exposed by erosion, creating the remarkable vistas at the Painted Desert.

The Painted Desert Inn was originally a home built with petrified wood in 1924. Expanded and remodeled by the Civilian Conservation Corps, it is now a museum and visitor's center.

Millions of years ago volcanic ash and sand covered a forest of stately pine trees. Silica slowly replaced the wood, and then erosion exposed the logs of the Petrified Forest.

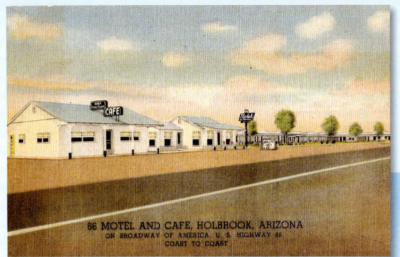

Holbrook, home of the 66 Motel, is named for Henry Holbrook. He was the chief engineer for the Atlantic and Pacific Railroad.

Bob Lyall's 66 Steak House was located next to the 66 Motel. It later became the Hilltop Café.

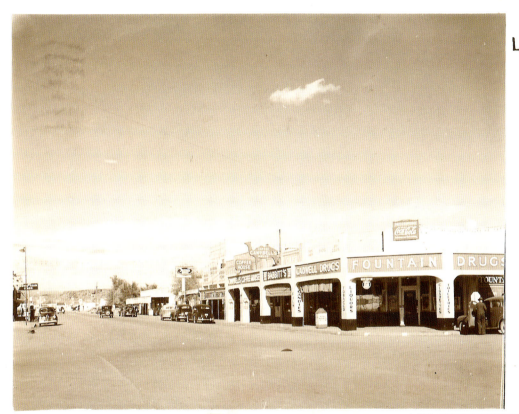

Looking North

on U. S. Highway 66

HOLBROOK ARIZONA

X841

Chester B. Campbell's Coffeehouse was known for "Son-of-a-Bitch Stew," a cowboy dish made with the heart, liver, brains, and other calf organs.

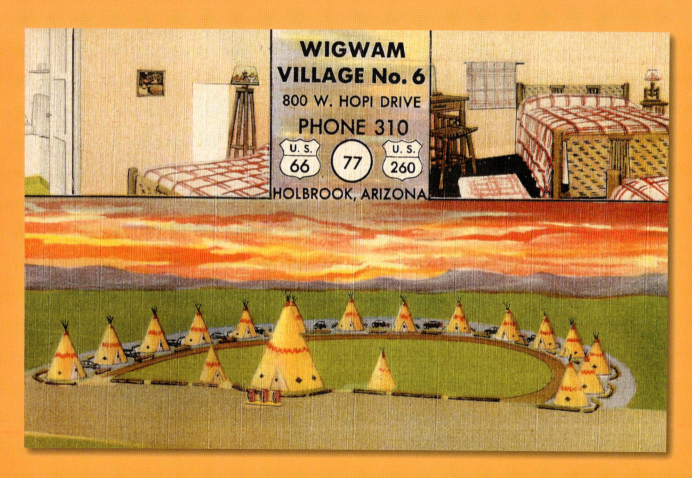

Chester Lewis opened the Wigwam Motel on June 1, 1950. It is composed of fifteen steel-framed and stucco-covered wigwams, where travelers can still stay today.

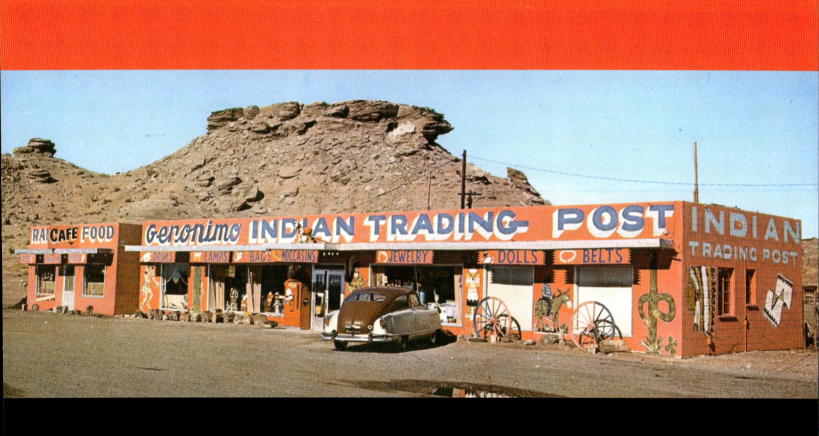

Geronimo Trading Post, established about 1950, has been greatly expanded and is home to the world's largest petrified log, weighing 89,000 pounds.

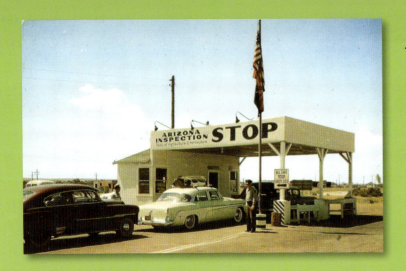

This Arizona Department of Agriculture and Horticulture Inspection Station was on Route 66 just west of Holbrook.

Frederick "San Diego" Rawson established the Old Frontier trading post in Joseph in 1927. The eccentric Ella Blackwell took over in 1947 and the post was abandoned after she died in 1984.

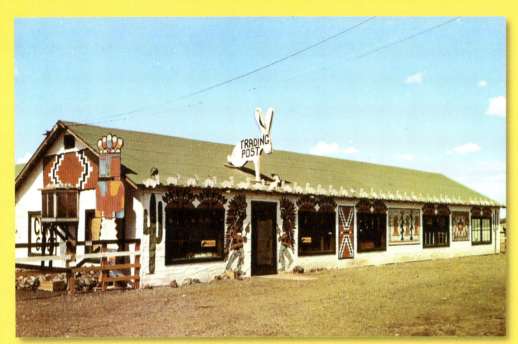

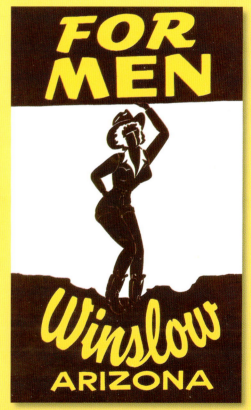

The Jack Rabbit Trading Post, famous for its billboards with a black bunny, has been operated by the Blansett family since 1961.

Billboards for the Jack Rabbit and Wayne Troutner's Store for Men could be found as far away as New York. Troutner's featured a silhouette of a curvaceous cowgirl.

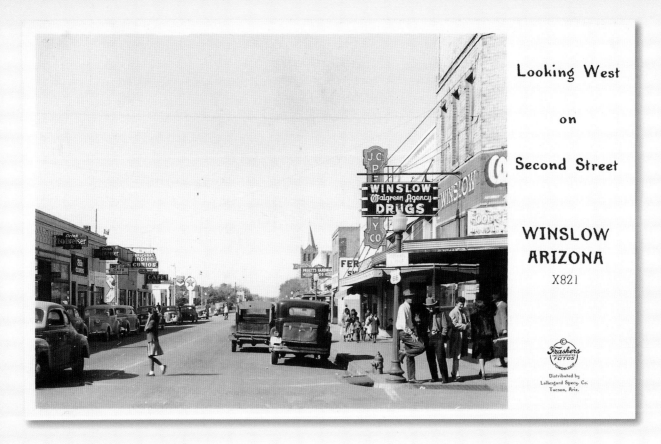

This man was "standin' on the corner" in Winslow long before the Eagles recorded "Take It Easy." This site now includes a sculpture of a musician and a mural illustrating the song.

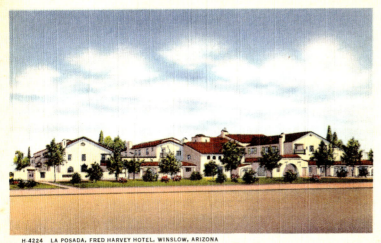

La Posada was the last of the great Fred Harvey hotels to be constructed, opening in 1930 and closing in 1959. It has been beautifully restored.

H-4224 LA POSADA, FRED HARVEY HOTEL, WINSLOW, ARIZONA

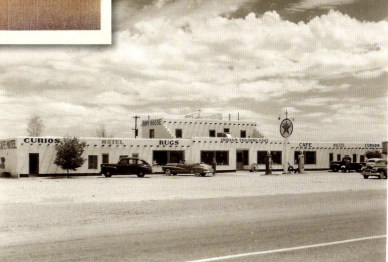

HOPI HOUSE
INDIAN
TRADING POST

10 miles west of Winslow, Arizona
MOTEL
TRAILER PARK
CAFE
BASKETS
NAVAJO RUGS
POTTERY
Genuine INDIAN JEWELRY
Wholesale and Retail
E 4658

Former Hawaiian bandleader Ray Meany and his wife, Ella Blackwell, owned the Hopi House at Leupp Corner and the Old Frontier in Joseph City. I-40 killed the Hopi House.

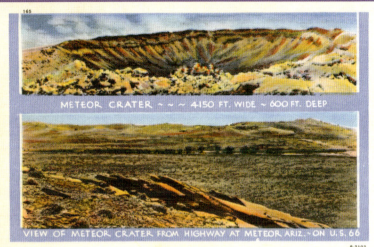

Meteor Crater is 4,150 feet across, 3 miles in circumference, and 570 feet deep. The Hopi believed the crater was caused by a god cast down from heaven.

Dr. Harvey Nininger's American Meteorite Museum closed in 1953, a few years after Route 66 was moved away.

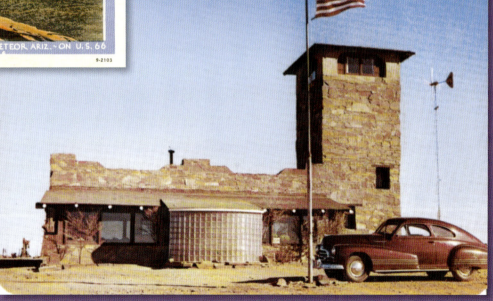

At Canyon Diablo Harry "Indian" Miller built a roadside zoo and store he called Fort Two Guns. He erected fake ruins around a cave where the Navajo had trapped and killed forty-two murderous Apache in 1878 and called it the "Apache Death Cave." Phil Gordon collection

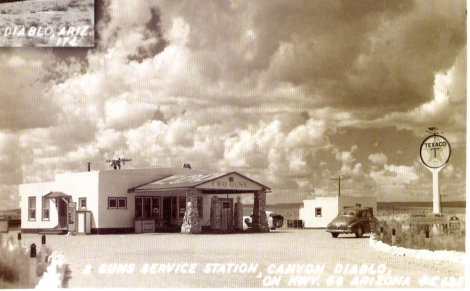

Harry Miller was acquitted after shooting his landlord, Earl Cundiff, at Two Guns in 1926. Cundiff's widow and her new husband relocated the business when Route 66 was realigned in 1938. Only ruins remain today.

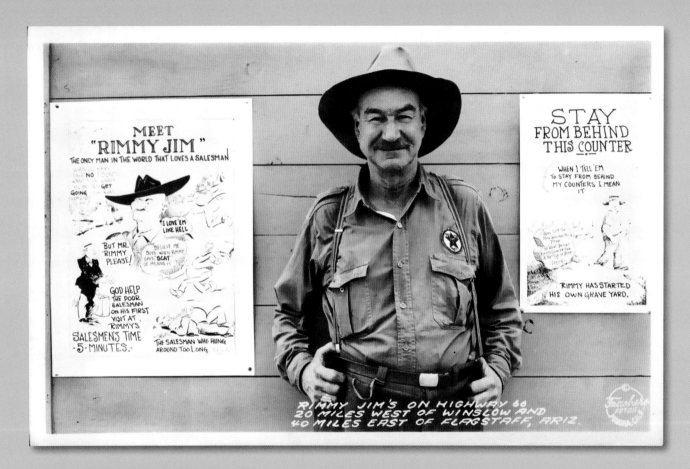

"Rimmy Jim" Giddings claimed he kept a graveyard for salesmen at his trading post, and he placed an intercom beneath the outhouse seats to startle visitors.

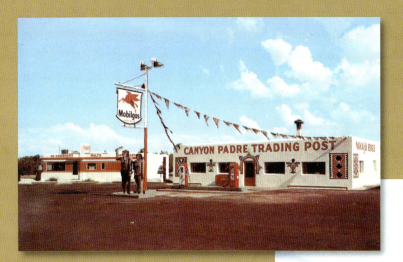

Jean and William Troxell's Canyon Padre Trading Post became the Twin Arrows Trading Post in 1960, known for two giant arrows made from utility poles.

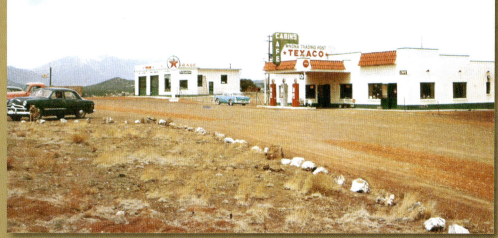

The town of Winona was little more than a trading post east of Flagstaff but gained fame when it was included as a lyric in the song "(Get Your Kicks on) Route 66" because it rhymes with Arizona.

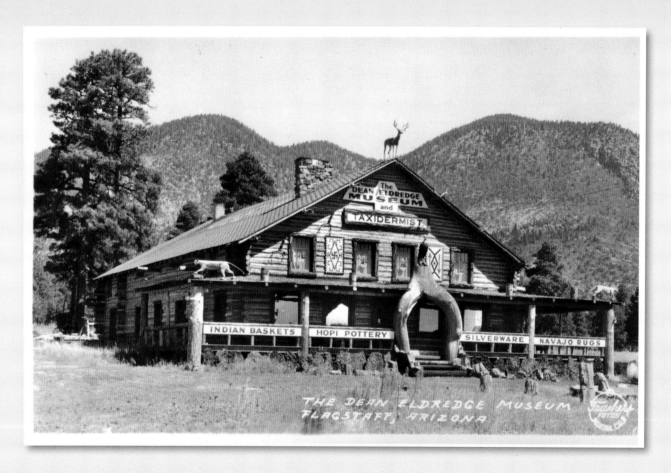

Dean Eldredge gathered thousands of taxidermy mounts and oddities for his popular museum, which is now the Museum Club.

Longtime 66 Motel owner Myron Wells served as president of the Route 66 Association; he led a group who tried to ban new businesses along I-40.

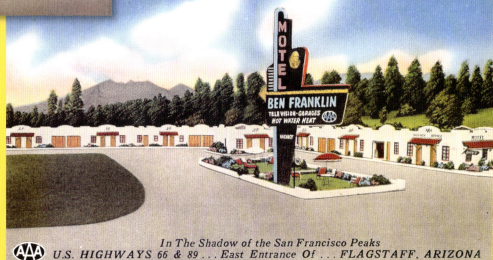

Earl Tinnin, who had constructed the Toonerville Trading Post between Winslow and Winona, owned the Ben Franklin Motel in Flagstaff.

A series of restaurants has occupied the building, but the impressive sign at the Western Hills in Flagstaff still stands.

In 1876 a group of immigrants turned a pine tree into a flagstaff to celebrate July 4th. A railroad camp established in 1880 was named "Flag Staff," which was shortened to one word in 1881.

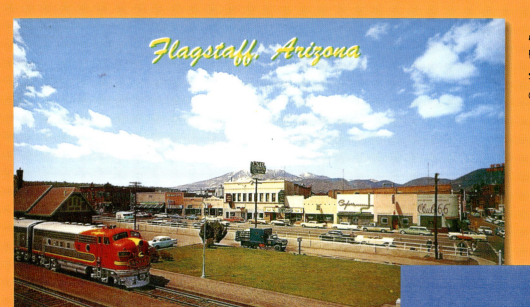

An old boxcar served as the original Flagstaff depot. The present structure, now the Flagstaff Visitor Center, opened in 1926.

Frank Sofea was a photographer who opened the Black Cat Café when his eyesight failed.

The Monte Vista opened in 1927 and is the oldest continually operating hotel in Flagstaff. A twelve-year-old girl won a contest by coming up with the name, which means "mountain view."

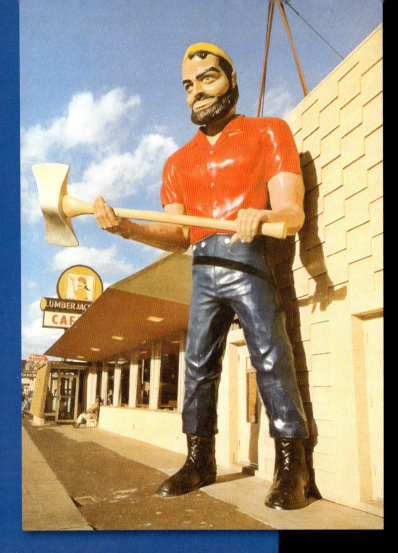

The two giant lumberjacks from the Lumberjack Café now guard the J. Lawrence Walkup Skydome at Northern Arizona University.

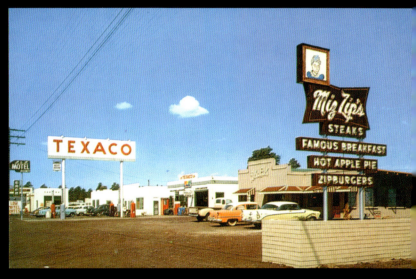

The Lockhard Family originally named their café "Let's Eat," then decided on a zippier name. LET'S EAT, in neon, still adorns the façade at Miz Zip's.

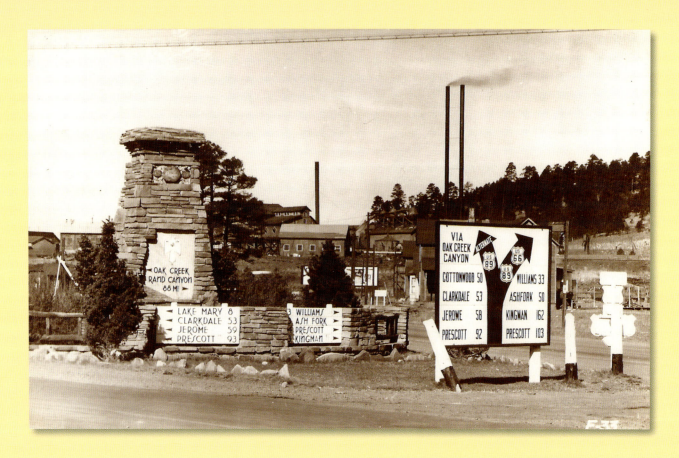

This marker stood where U.S. Route 89A split off from Routes 66 and 89 at the west end of Flagstaff. The Saginaw and Manistee Lumber Company mill is in the background.

Tourists headed to the Grand Canyon, turned off Route 66 between Flagstaff and Williams. The canyon is 57 miles from this junction.

Williams is named for trapper and scout William Sherley Williams. The Bill Williams Mountain Men organization, shown here on parade, honors pioneer trappers and traders.

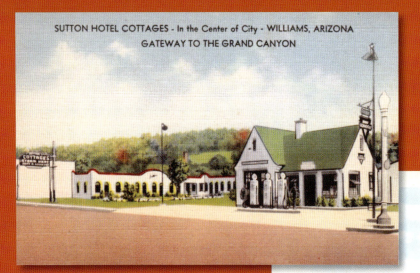

The Sutton Hotel Cottages became Cruiser's Route 66 Bar and Grill. Williams was the last community on Route 66 to be bypassed. Mike Ward collection

The Santa Fe Railroad began service to the Grand Canyon in 1901, and the Fray Marcos Hotel, one of the famous Harvey Houses, opened in 1908.

Domino the cow is emblazoned on the sign, souvenir menus, and other items at Rod's Steakhouse, which opened in 1946.

Ash Fork was a busy place before the Santa Fe Railroad moved away in 1950 and I-40 opened in 1979. Two fires have virtually wiped out the business district.

U. S. Highway 66, West Through Ash Fork, Arizona

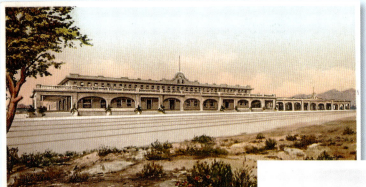

The Harvey House in Ash Fork was named for explorer Silvestre Escalante.

Ezell and Zelma Nelson operated the Copper State Court from 1928 to 1989. The garages had railings for tying up horses.

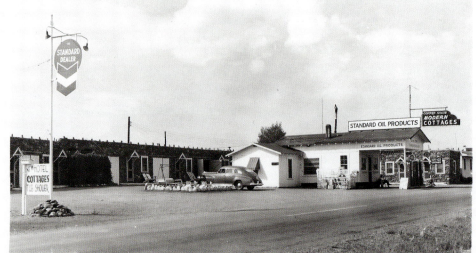

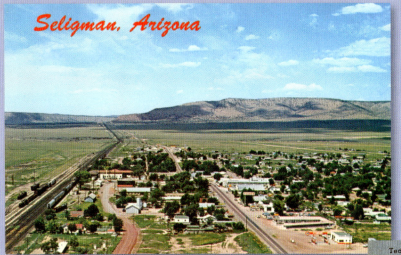

The longest unbroken stretch of Route 66 begins between Ash Fork and Seligman, and runs 162 miles to Topock. Seligman's preserved Route 66 heritage makes it a popular tourist stop.

Ted's Fountain and Trading Post is now Route 66 Historic Seligman Sundries. Seligman was the inspiration for the fictional town of Radiator Springs in the movie Cars.

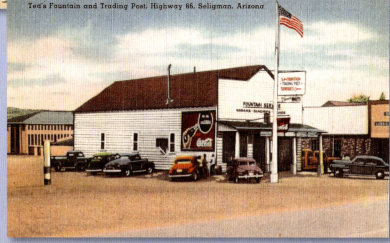

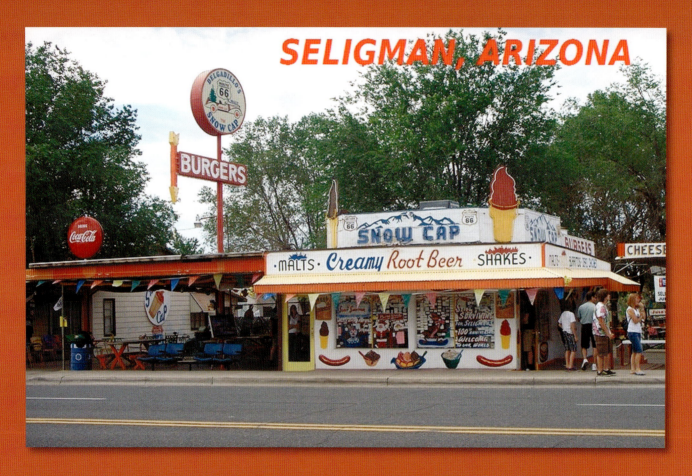

Juan Delgadillo's sense of humor entertained tourists at the Snow Cap Drive-In. His brother Angel is credited with sparking the Route 66 revival in the 1980s.

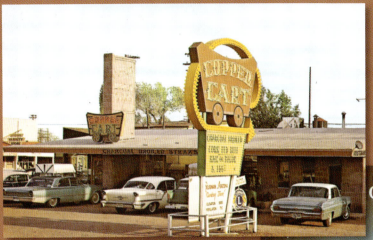

The Copper Cart Restaurant opened in 1950, and its classic neon sign still welcomes visitors today.

Walter Peck was on his way to a poker game when he stumbled upon a cave entrance in 1927. The cave became Dinosaur Caverns in 1957 and Grand Canyon Caverns in 1962.

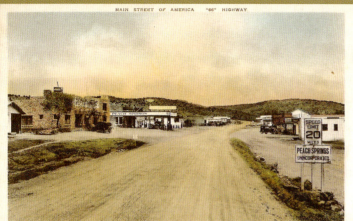

STREET SCENE, HIGHWAY 66 PEACH SPRINGS, ARIZONA

Peach Springs is the headquarters of the nearly one-million-acre Hualapai Reservation. Hualapai means "People of the Tall Pine."

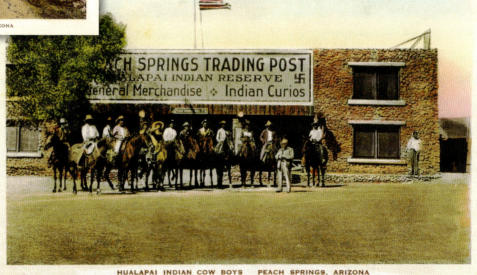

HUALAPAI INDIAN COW BOYS PEACH SPRINGS, ARIZONA

Ancel Taylor built a new Peach Springs Trading Post in 1928. It is now the headquarters for the Hualapai Game and Fish and Tribal Forestry.

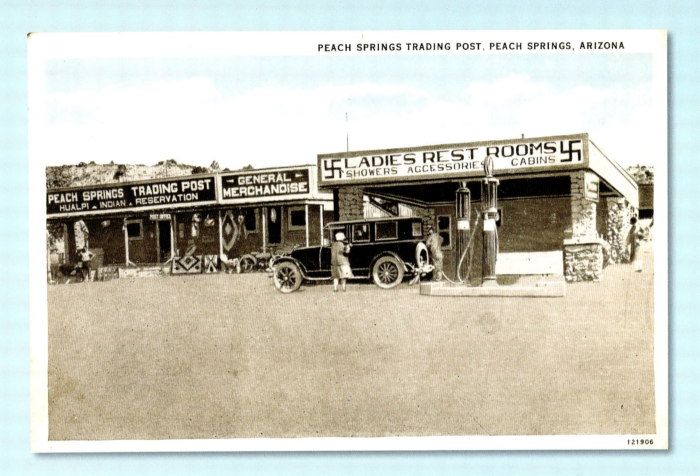

The Peach Springs Trading Post was established by E. H. Carpenter in 1917. Note the swastikas. To the Navajo, the ancient "whirling log" was a sacred symbol.

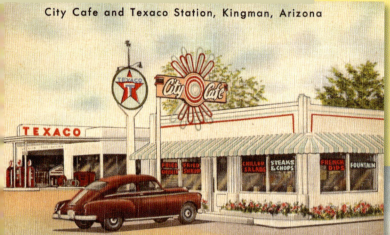

City Cafe and Texaco Station, Kingman, Arizona

Roy Walker opened the City Café in 1943, and it was operated by William McCasland for many years. The City Café became the Hot Rod Café, but was torn down in 2009.

CASA LINDA CAFE — KINGMAN, ARIZONA

Former Harvey Girl Clara Boyd and her husband, Jimmy, opened Casa Linda Café in 1933; the building still stands today.

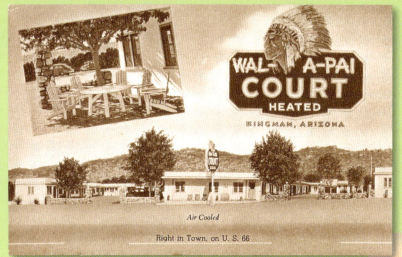

The Wal-a-Pai Court took its name from the phonetic pronunciation of "Hualapai," and it made much use of Native American imagery to attract tourists.

Conrad Minka drilled passages into the solid rock of the mountain to bring air to an evaporative cooler into the rooms at his White Rock Court.

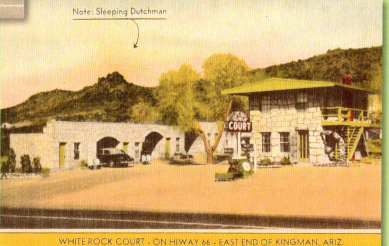

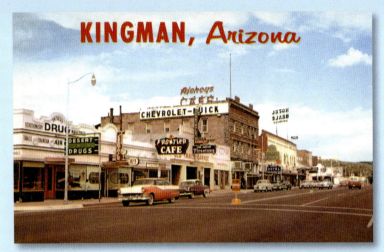

Route 66 through town is named Andy Devine Avenue after the Kingman native who starred as Guy Madison's sidekick in the <u>Adventures of Wild Bill Hickok</u> television series.

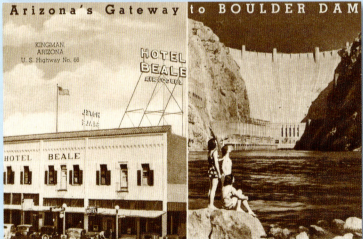

Andy Devine's parents ran the Hotel Beale in Kingman from 1906 to 1926. The former landmark has been vacant since 2000 and has fallen into disrepair.

COOLEST SPOT ON THE DESERT
21 miles west of Kingman, 9 miles east of Oatman
ARIZONA
on U. S. Hwy. 66
E3910

When prospector Lowell "Ed" Edgarton established Ed's Camp on the National Old Trails Road in 1919, he planted a large saguaro cactus in the driveway.

Cool Springs thrived from 1926 until it was bypassed in 1952. The burned ruins were blown up for the movie <u>Universal Soldier</u>, but Ned Leuchtner resurrected the landmark.

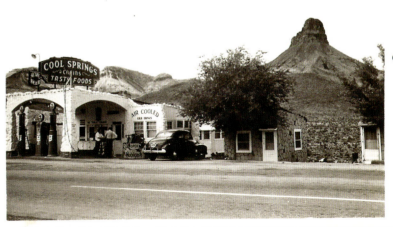

COOL SPRINGS
THE ONLY TOURIST MART
On U. S. Hwy. 66
20 miles west of Kingman
ARIZONA
E3911

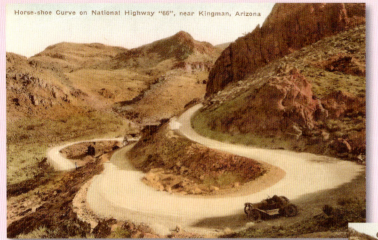

Horse-shoe Curve on National Highway "66", near Kingman, Arizona

Route 66 twists and climbs to Sitgreaves Pass at 3,550 feet, and then drops 700 feet in 2 miles. In the days of gravity-fed carburetors, locals drove up the grade backward!

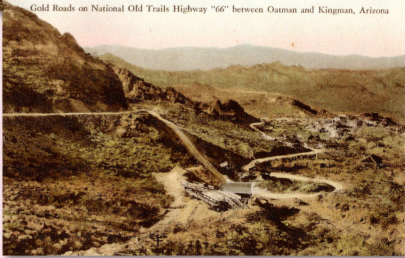

Gold Roads on National Old Trails Highway "66" between Oatman and Kingman, Arizona

The route continues its plunge to the remnants of Gold Road, a former mining boomtown that was mostly destroyed in 1949 to avoid new taxes.

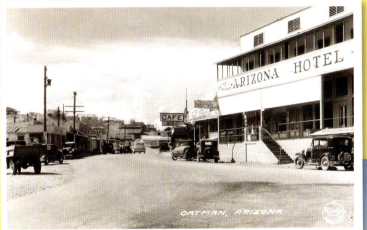

Oatman had 20,000 residents during the mining boom. Many businesses closed within twenty-four hours after the bypass opened on September 17, 1952, and the population fell to about 60.

Oatman now attracts 500,000 tourists annually. The descendants of burros, turned loose by miners in the 1940s, roam the streets freely. Colorful shops and cafes line the main street.

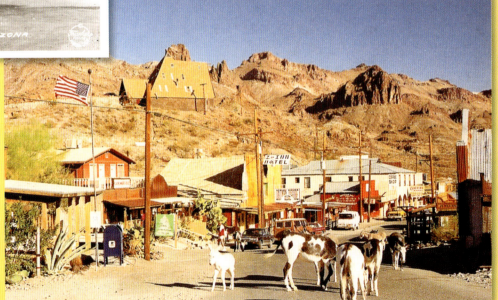

Les Crinklaw's station at Topock was the last westbound stop on Route 66 before the Colorado River.

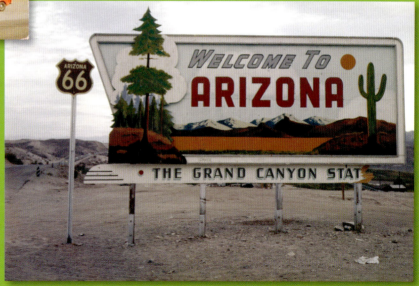

This billboard greeted motorists crossing into Arizona from California.

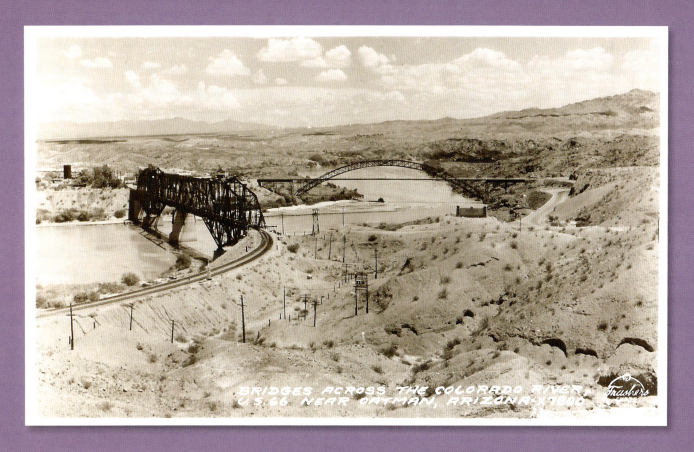

BRIDGES ACROSS THE COLORADO RIVER, U.S. 66 NEAR OATMAN, ARIZONA-X7800

The graceful National Old Trails Arch Bridge, at right, now carries a pipeline. The rails were removed from the train bridge, at left, and it carried Route 66 from 1947 to 1966.

CHAPTER 8

CALIFORNIA

CALIFORNIA WAS THE PROMISED LAND for the Dust Bowl refugees. It was also the destination for those dreaming of Hollywood stardom or new jobs, and vacationing families. Some of those travelers on Route 66 probably were disappointed with their first glance at California across the Colorado River. They found that a 150-mile stretch of brutal desert, with few services for travelers, was still ahead.

Needles is an important railroad town where the former El Garces Harvey House and Train Depot still stands. West of Needles the post-1931 route is covered by Interstate 40, but the National Old Trails Road and early Route 66 is an easy drive along the railroad through Goffs. The road then runs straight as an arrow where "towns" such as Essex, Chambless, and Bagdad consisted of little more than a lonely service station. Roy's Café and Motel at Amboy is a notable survivor.

Barstow is another important transportation hub, where Interstates 40 and 15 meet, and the Casa del Desierto Harvey Hotel is home to the Route 66 Mother Road Museum and the Western Railroad Museum.

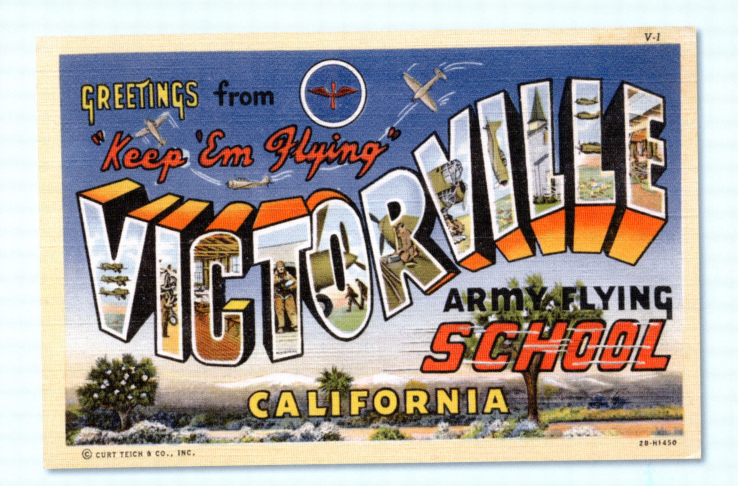

The California Route 66 Museum is located in Victorville. Traveling from Victorville, the Summit Inn still serves travelers at the summit of Cajon Pass before Route 66 plunges down the other side of the mountain. Much of Old 66 is covered by I-15 in the narrow pass, but a wonderful stretch of old highway begins at the Cleghorn exit.

The road follows Mount Vernon Avenue through San Bernardino, where the first McDonald's opened in 1948. Just east of Rialto, the classic Wigwam Motel has been restored. Continuing on Bono's Historic Orange in Fontana is one of the last of the orange-shape stands once common in California, and there are still some Route 66–era remnants through Rancho Cucamonga, Upland, Glendora, Azusa, Monrovia, and Arcadia.

Route 66 enters Pasadena along the route of the annual Tournament of Roses Parade, and one stretch crosses the iconic, 1913 Colorado Street Bridge over the Arroyo Seco. There are a couple of routes into Los Angeles, but the Arroyo Seco Parkway (Pasadena Freeway) is scenic and historic. From 1953 to 1964 Route 66 used the Hollywood Freeway with its four-level interchange.

The Mother Road originally ended at 7th Street and Broadway in

downtown Los Angeles. The historic highway now follows Sunset Boulevard onto Santa Monica Boulevard where the famous Hollywood sign is visible on the hill above.

From 1936 to 1965 the official western end of Route 66 was at Lincoln and Olympic Boulevards. But the sentimental end point is just to the south of the Santa Monica Pier. Travelers can dip their toes into the Pacific Ocean, celebrating a journey of "more than 2,000 miles all the way," as the song says.

Needles, named for the jagged peaks of the Black Mountains, was founded in 1883.

Route 66 originally followed Front Street, K Street, and Spruce Street to the Needles Highway. The later route followed Broadway.

The Palms was originally located on the west end of Needles, but the cabins were moved to the split at Front Street and Broadway in the late 1930s.

The El Garces Harvey House and Train Depot at Needles was named for Father Francisco Garces, a missionary. It closed in 1949 and restoration began in 2007.

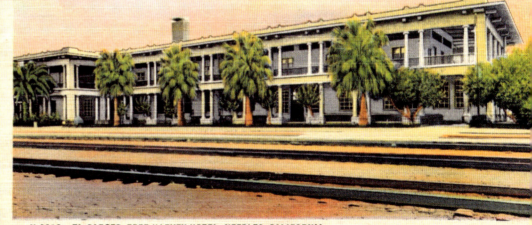

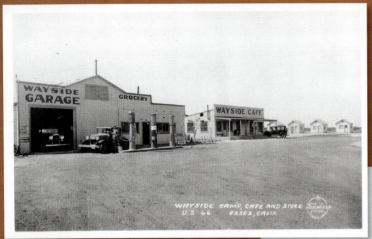

Essex offered the most traveler services between Needles and Amboy. The Wayside was popular because it offered free water from a well out front.

The Amboy Crater is a volcanic cinder cone, active as recently as 500 years ago. It is 250 feet high, 1,500 feet in diameter, and surrounded by 24 miles of lava flow.

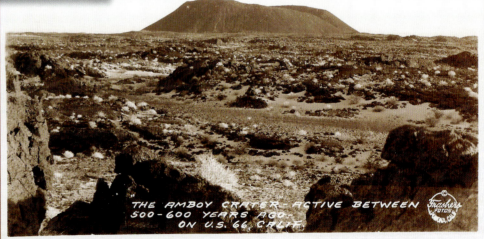

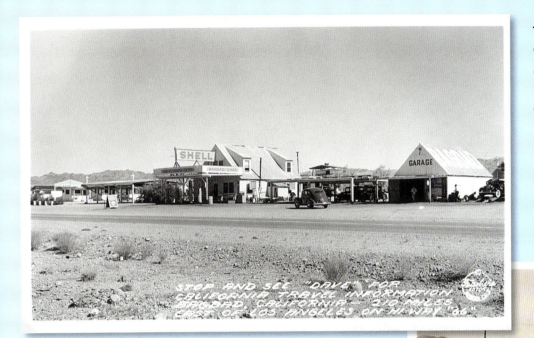

The Bagdad Café inspired a 1988 movie of the same name that was actually shot about 50 miles away in Newberry Springs. No trace of Bagdad remains today.

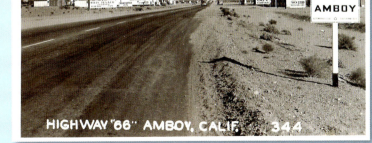

The railroad stops from Amboy to the Arizona line were named alphabetically and included Bristol, Cadiz, Danby, Edson, Fenner, Goffs, and so on.

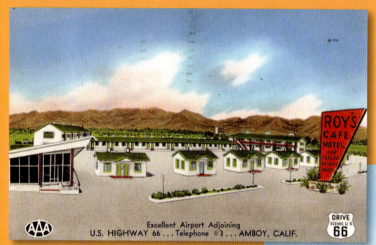

Roy Crowl opened Roy's in 1938 and his brother-in-law, Buster Burris, ran it for many years. Albert Okura, owner of the Juan Pollo restaurant chain, bought the entire town in 2005.

There were several roadside businesses in Amboy, including the Road Runner's Retreat, until Interstate 40 opened in 1972.

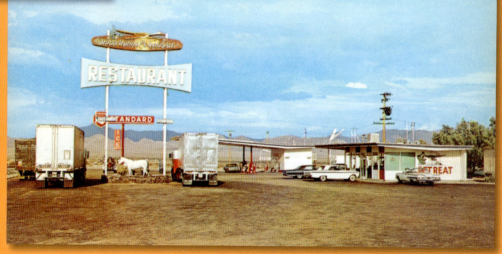

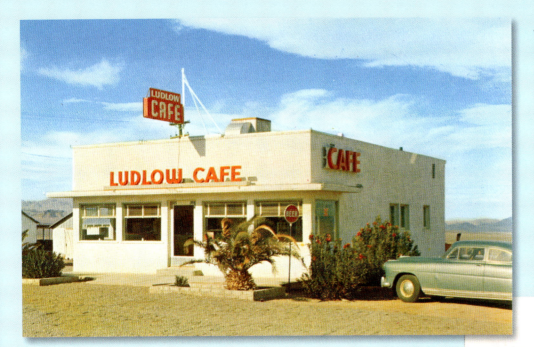

Water was brought in by tanker car to the isolated community of Ludlow, named after the man who repaired Santa Fe railcars. Only the shell of the café remains.

An important subsidiary line met the Santa Fe at Waterman Junction. In 1886 the community was named for William Barstow Strong, the president of the railroad.

Main Street Barstow, California

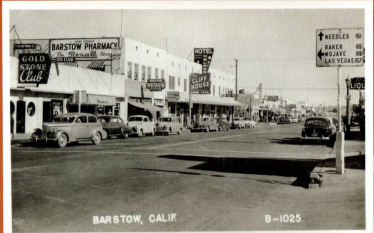

Barstow continued to be a major junction point as U.S. Routes 66, 91, and 466 converged there. Today busy Interstates 40 and 15 meet in Barstow.

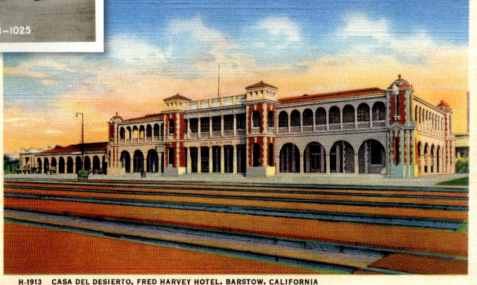

Barstow's Casa del Desierto Harvey Hotel was completed in 1911. Barstow saved it from demolition in 1989.

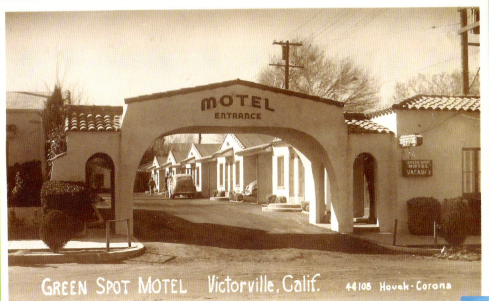

The first drafts of the <u>Citizen Kane</u> script were written at the Green Spot Motel in Victorville.

When John Roy built the Green Spot Motel in 1937, he also opened the Green Spot Café just across the street.

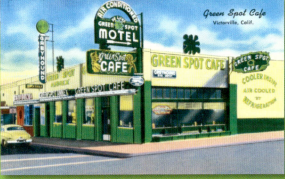

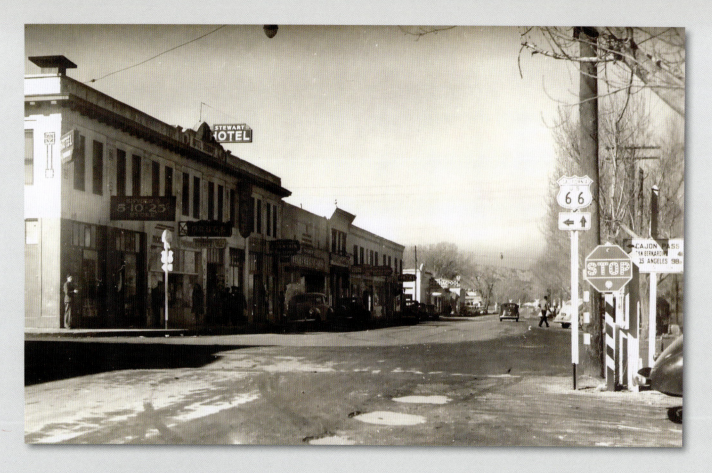

Route 66 passes through the heart of old town Victorville. This view looks east on D Street from 7th Street.

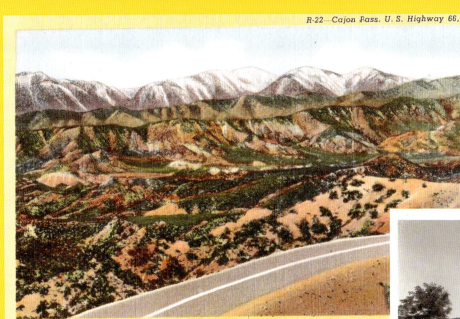

The first road through the Cajon Pass was paved in 1916. Route 66 was upgraded to four lanes in 1953, and I-15 replaced Route 66 in 1969.

Route 66 originally was on the east side of the first Summit Inn, then called "The Tops."

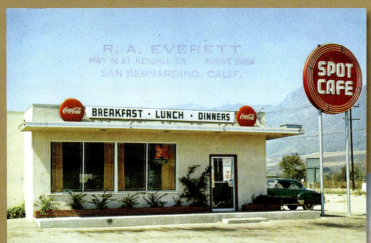

The Spot Café was located at the intersection of Route 66, Kendall Drive (City 66), and Business U.S. 395 east of San Bernardino.

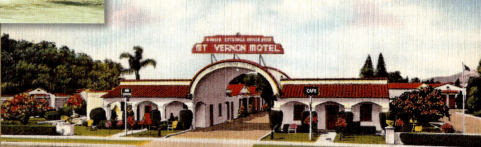

The Mount Vernon Motel was on Mount Vernon Boulevard, just south of Cajon Boulevard.

Route 66 through San Bernardino followed Cajon Boulevard to Mount Vernon Avenue, past the 66 Motel before turning west at 5th Street and curving onto Foothill Boulevard.

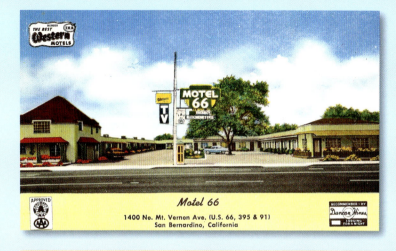

Thomas Proctor's Spanish-style Mission Auto Court in San Bernardino was constructed in 1935.

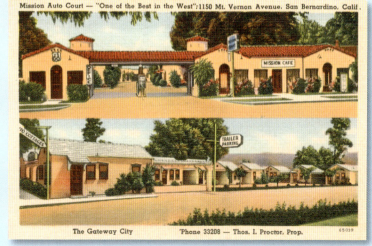

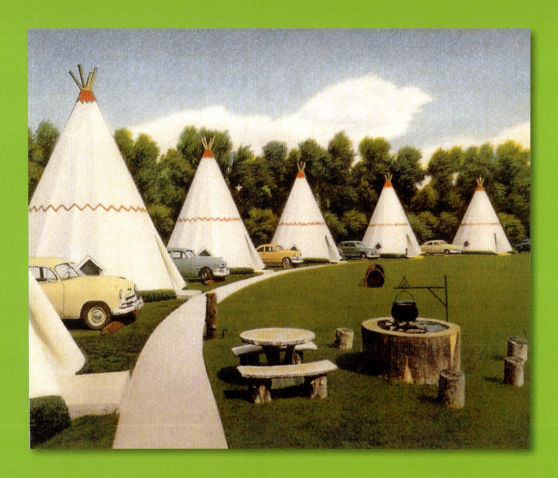

The Wigwam Motel was the last of seven to be built, opened by Frank Redford in 1949, and is still open today.

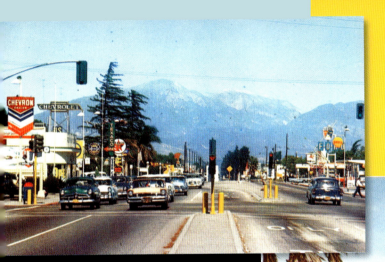

Prior to World War II, Route 66 (Foothill Boulevard) through Rialto was lined with vineyards and citrus orchards. The view changed dramatically in the 1950s.

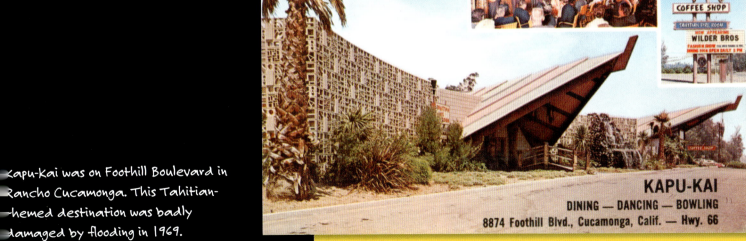

Kapu-Kai was on Foothill Boulevard in Rancho Cucamonga. This Tahitian-themed destination was badly damaged by flooding in 1969.

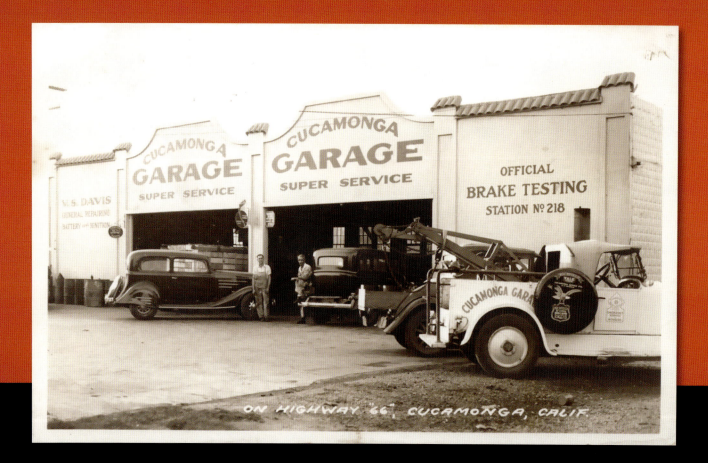

This portion of the Cucamonga Super Service Station complex is gone, but the station building in front has been saved.

The "Inland Empire" was once known for its citrus groves and orange stands lining the route, such as this one at the Albourne Rancho.

ALBOURNE RANCHO CITRUS STAND
1114 Highway #66 East of Glendora, Calif.

The Hi-Way 66 Foothill Motel in Duarte later became the Capri Motel, but was demolished a few years ago for a residential development.

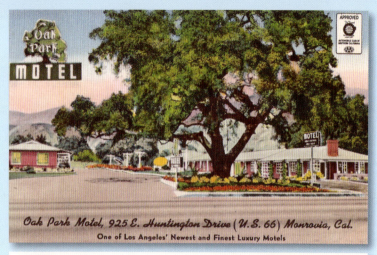

Original Route 66 followed Foothill Boulevard. The Oak Park Motel is a survivor of the motels that sprang up when the route shifted to the south over Huntington Drive.

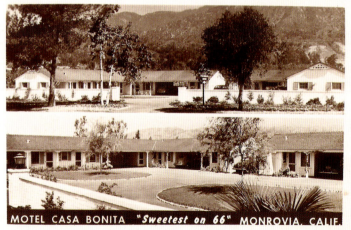

The Casa Bonita Motel billed itself as the "Sweetest on 66."

AZTEC HOTEL, MONROVIA, CALIF.

The Aztec Hotel in Monrovia opened in 1925. It is designed with both Mayan and Aztec elements, and today is listed on the National Register of Historic Places.

The Mon-Arc Motel was named for the communities of Monrovia and Arcadia.

Mon-Arc Motel
917 W. Huntington Drive (U.S. 66)
MONROVIA, CALIF.
One Mile East of Santa Anita Race Track

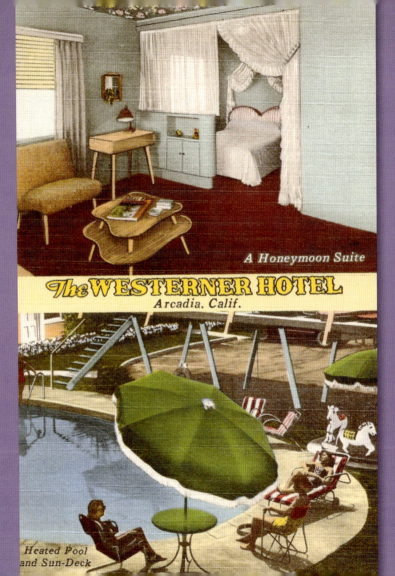

In Arcadia Route 66 turns onto Colorado Place, where the Westerner Hotel developed into the Elite Westerner Inn and Suites.

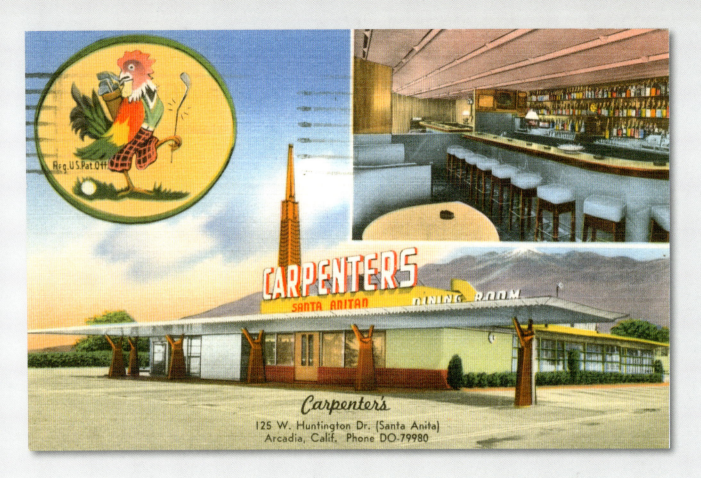

A menu for Harry Carpenter's Santa Anitan restaurant in Arcadia boasted that all their pies "are baked on the premises by a woman pastry chef."

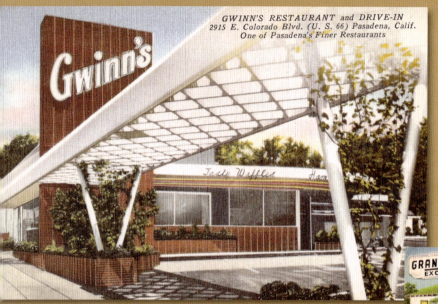

Gwinn's was both a sit-down and drive-in restaurant, open from 1949 to 1972. It was designed by Harold Bissner and Harold Zook.

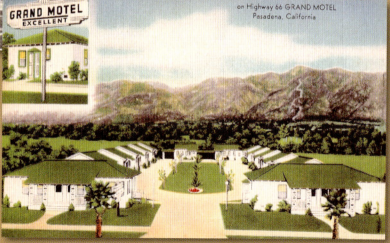

Room rates started at $2.00 at the Grand Motel, owned by Abraham Koslow. The site became the Quality Inn Pasadena Convention Center.

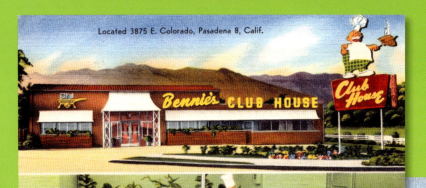

Bennie Taylor ran a restaurant at the Altadena Country Club before opening his own place, offering all you could eat for $1.75.

Owners of the Bella Vista Motor Court included Mr. and Mrs. George Farmer, Charles Sanders, and Charlotte and Frank Karbiner. The site is now an auto dealership.

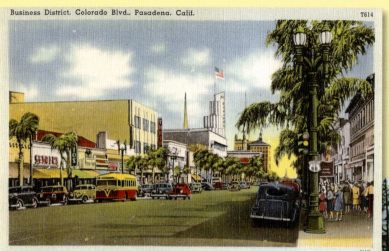

Pasadena was founded by Midwesterners looking to escape the harsh winters. At one time it had the highest per capita income in the United States.

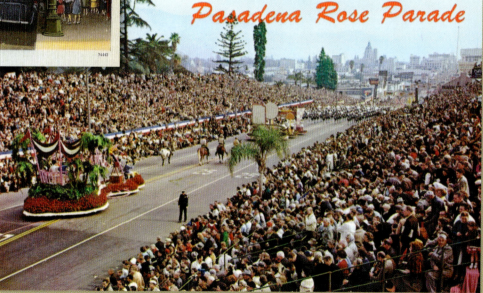

Pasadena Rose Parade

Every New Year's Day, except when it falls on a Sunday, Colorado Boulevard/Route 66 in Pasadena is lined with floats and marching bands for the famous Rose Parade.

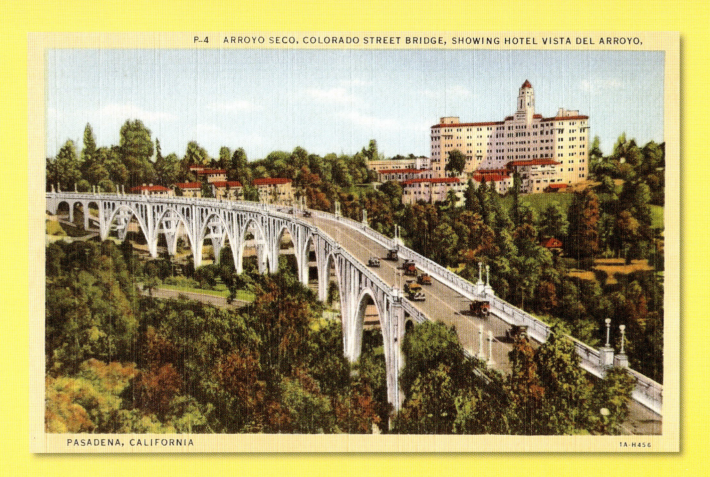

The Arroyo Seco Bridge opened in 1913 and carried Route 66 from 1936 to 1940. Eleven concrete arches span the 150-foot-deep Arroyo Seco.

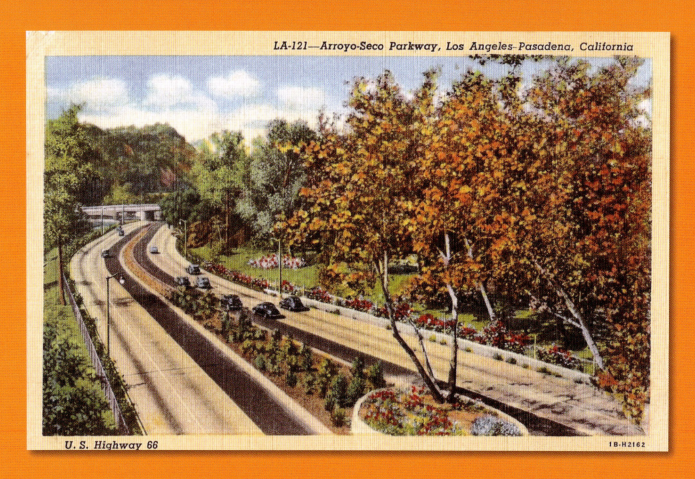

The Arroyo Seco Parkway, linking Pasadena and Los Angeles, opened on December 30, 1940. The first freeway west of the Mississippi carried Route 66 traffic until 1964.

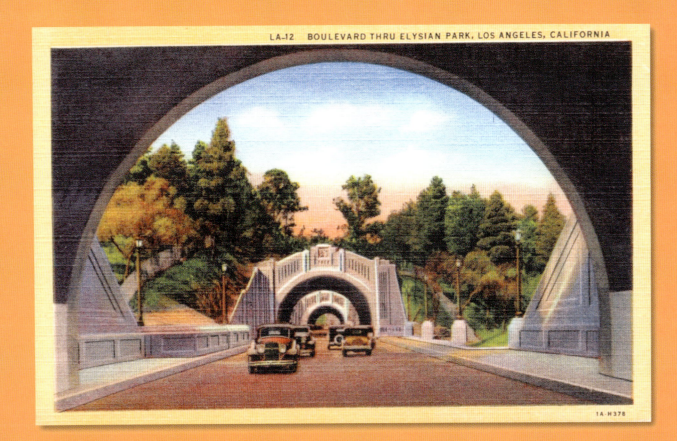

Three of the Figueroa Street tunnels were constructed in 1931, and a fourth opened in 1935. They became part of the Arroyo Seco Parkway and are now northbound only.

The Paradise Motel was constructed in 1946. The motel, with its purple neon, is still "In the center of L.A. and Everything" on Sunset Boulevard.

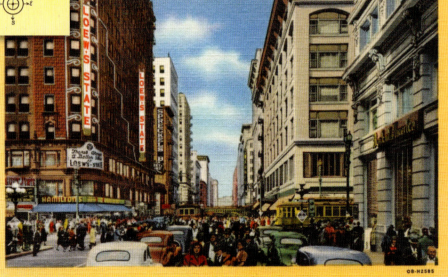

From 1926 to 1936, Route 66 ended at 7th and Broadway in Los Angeles, the heart of the historic theatre district.

LA.23—Los Angeles Civic Center, from Hollywood Freeway, Los Angeles, California

From 1936 until the Hollywood Freeway opened on December 27, 1950, Route 66 followed Sunset Boulevard and then turned onto Santa Monica Boulevard.

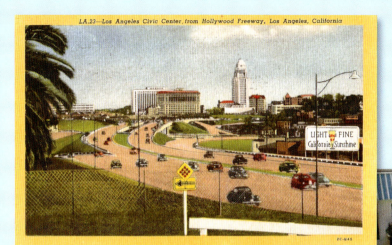

The Tropicana Motel on Santa Monica Boulevard, was owned by Dodgers great Sandy Koufax. It was a favorite with rock stars, such as Jim Morrison and Tom Waits.

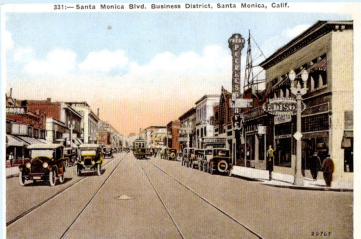

331:— Santa Monica Blvd. Business District, Santa Monica, Calif.

From 1936 until 1964, Route 66 used Santa Monica Boulevard, turning onto Lincoln Boulevard briefly before officially terminating at Olympic Boulevard.

The $1.5 million William Tell Motel and Apartments offered a lush tropical setting.

Wm. Tell Motel and Apts.
2509 Santa Monica Blvd., Santa Monica, Cal.
on U. S. 66
Will Rogers Highway

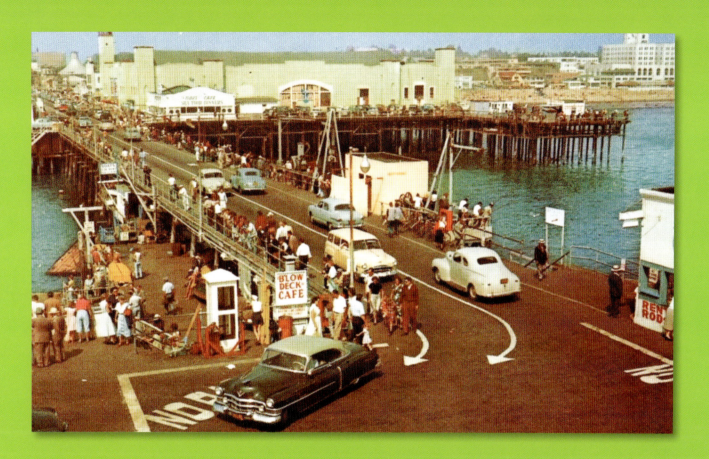

The Santa Monica Municipal Pier opened in 1909, and the amusement pier was added in 1916. Officially Route 66 never extended to the pier, but it serves as a symbolic end of the road.

INDEX

Adrian (TX), 145, 170
Afton (OK), 104, 110
Albuquerque (NM), 172, 174, 191–206
Amarillo (TX), 144, 153–167
Amboy (CA), 268, 274–276
Arcadia (CA), 270, 290–291
Arcadia (OK), 104
Arlington (MO), 46, 71
Ash Fork (AZ), 253–254
Atlanta (IL), 12, 14

Bagdad (CA), 268, 275
Barstow (CA), 268, 278
Baxter Springs (KS), 94, 99–101
Bethany (OK), 132
Bloomington (IL), 12, 27, 28
Bridgeport (OK), 102

Carlinville (IL), 41
Carthage (MO), 47, 87–88
Chenoa (IL), 12, 25
Chicago (IL), 7, 8, 12, 17, 18
Cicero (IL), 12, 19

Claremore (OK), 104, 114
Clinton (OK), 10, 105, 136–138
Continental Divide (NM), 213
Cool Springs (AZ), 263
Cuba (MO), 44, 46, 66

Devils Elbow (MO), 46, 71, 73
Divernon (IL), 36
Dwight (IL), 12, 23

East St. Louis (IL), 43
Edmond (OK), 124
Edwardsville (IL), 14, 42
Elk City (OK), 105, 139–140
El Reno (OK), 105, 133
Essex (CA), 268, 274

Flagstaff (AZ), 244–250
Galena (KS), 94, 97
Gallup (NM), 174–175, 214–220
Gardner (IL), 12
Glenrio (TX), 145, 171, 176
Goffs (AZ), 268

Goldroads (AZ), 224, 264
Grants (NM), 174, 208–209
Groom (TX), 144, 150–151

Halltown (MO), 46
Holbrook (AZ), 222, 223, 232–234
Hydro (OK), 134

Joliet (IL), 22
Joplin (MO), 7, 47, 91–93
Joseph City (AZ), 222, 236, 239

Kingman (AZ), 224, 260–263
Kirkwood (MO), 44, 57–58

Laclede County (MO), 10
Lebanon (MO), 46, 78–81
Lexington (IL), 12
Lincoln (IL), 14, 30
Litchfield (IL), 14, 36–39
Los Angeles (CA), 6, 7, 8, 270, 298–301
Los Lunas (NM), 172
Ludlow (CA), 277
Lupton (AZ), 227

McLean (IL), 12, 29
McLean (TX), 144, 148–149
Miami (OK), 107–108
Mitchell (IL), 14
Monrovia (CA), 270, 288–289
Moriarty (NM), 190
Mount Olive (IL), 40

Needles (CA), 268, 272–273
Normal (IL), 12

Oatman (AZ), 224, 265
Oklahoma City (OK), 102, 105, 126–131
Oldham County (TX), 9

Pacific (MO), 61
Paris Springs (MO), 47
Pasadena (CA), 270, 292–295
Peach Springs (AZ), 258–259
Phelps (MO), 46
Plainfield (IL), 22
Pontiac (IL), 12, 20, 24

Rancho Cucamonga (CA), 270, 285–286
Raymond (IL), 14
Rialto (CA), 270, 284–285
Riverton (KS), 94
Rolla (MO), 46, 67–70
Romeroville (NM), 6, 172

San Bernardino (CA), 270, 282–283
Santa Fe (NM), 172, 186–187
Santa Rosa (NM), 172, 182–183
Sayre (OK), 141
Seligman (AZ), 11, 224, 225, 255–256
Shamrock (TX), 144, 146–147
Springfield (IL), 13, 14, 30, 31–35
Springfield (MO), 7, 46, 83–87
St. Louis (MO), 6, 7, 10, 44, 49–54
Stanton (MO), 44, 65
Staunton (IL), 14, 41
Strafford (MO), 46, 82
Stroud (OK), 104
Sullivan (MO), 66

Texola (OK), 105
Thoreau (NM), 212
Towanda (IL), 26
Tucumari (NM), 173, 178–181
Tulsa (OK), 102, 116–121

Vega (TX), 169
Victorville (CA), 269, 270, 279–280
Vinita (OK), 112–113

Waterman Junction (CA), 277
Waynesville (MO), 76
Weatherford (OK), 135
Webb City (MO), 47, 90
Wigwam Motel (AZ), 222, 234
Williams (AZ), 11, 224, 225, 251–252
Winona (AZ), 243
Winslow (AZ), 222, 224, 237–238

Yukon (OK), 105